MW01173196

CROW CANYON

DOUG HISER

CROW CANYON

A NOVEL

2003

CROW CANYON

CONTENTS

To my mom and dad, Douglas and Annette Hiser

CREDITS

The Slia'" Young Adult Reading Circuit 2002-2003

"Chicken Night" Young Adult Reading Circuit 2002-2003

"Bite of the Mailman" Title story to out of print trade paperback Bite of the Mailman 1995

"Waiting at the Train Station" originally published 1995 as "Waiting at the Train Station until 11:45 for Mr. Evan Willis" in Bite of the Mailman

"Mayflower Café" 1995 Bite of the Mailman

"The Bee Room" appeared originally in 1991 USPS newsletter

"Camouflage Man " Young Adult Reading Circuit 2002-2003

"Montana Mist" excerpt from the novel Montana Mist 2003

A special thanks to my wife, Gayln Hiser, who inspires my writing and keeps me focused. This collection was intended as a follow up to my second short story collection, SECRET GROTTO, published in 2001. The bulk of these stories were written in 2002, so very different from SECRET GROTTO where the stories were written over a span of ten years. Many of the stories were written because of trips we took to places new and exciting. "A Night in the Sooke" was born out of our trip to Canada and "Devil's Beach" came from our trip to Key West, Florida. I would like to thank my son, Cade Hiser, for his dedicated reading of "HawkerCrow" and his valuable feedback. Also I would like to thank Judy Kunkel for her inspiration to write a story about armadillos. I would also like to thank Susan Leining for inviting me to Santa Fe High School each semester for readings. I do not know the reason that other writer's produce books and stories but I know that I write to try to create new and exciting images and situations in the reader's imagination. I need my readers and I am glad for their audience, creating inspiration for me to put out story after story. I would like to thank some of the enthusiastic friends and readers that have also kept me producing these adventures into my imagination. Thank you Janne Liburd, Cathy White, Josh Morris, Judy Kunkel, Editor Jeff Schwaner, Darla Sharp, B.K. Reeves, for all your encouragement and friendship.

INTRODUCTION

Crow Canyon is an adventure into imagination and reality. There are twenty-two stories of love and violence, mystery and fantasy. These stories begin in Galveston, Texas with a sea monster, move to Florida with a woman waiting for the Devil on a beach, a man carries a skunk into a dark bar, a new species of human giant is awakened and travels across Africa to find his purpose, a super hero lives in a trailer park, two mythological creatures co-exist in the Amazon jungle, and a odd recluse raises wolves in Montana and finds love beyond the pain and guilt of his troubled past. This book was written almost entirely in 2002. Most of these stories are much longer than previous stories and "Montana Mist" is actually a short novel. The title story, "Crow Canyon", was written to accompany a painting originally called "Raven's Moon", which is now the painting on this book's cover. The painting, "Raven's Moon", is also featured on my website: Art-Escape.com.

I reflect back on my youth in Texas and actually experience the feelings and emotions of those days, exploring the wild tallow tree forests and fields of tall brown grass. I remember grabbing snakes behind the neck from beneath rotten logs and diving into muddy water to snatch the tail of a snapping turtle. I remember chasing cotton-tailed rabbits through cow pastures and building secret forts within massive thorn bushes. The armadillos and opossums, red-tailed hawks

and horned lizards, cottonmouth water moccasins and bobcats, all enchanted my days. The mystery of the wildlife and the legends of secret creatures rumored to exist in our darkest place of wonder always enthralled me to search and discover what lie around each bend of the bayou, each cluster of thicket. My stories are the same way, a new discovery and a mystery of emotion and astonishment. These are stories about life and life is filled with violence, wonder, obscurity, sexuality, and nature. I tell stories with a descriptive image of the place and the character, creating a conflict that moves like a mystifying snake through the tall grass of each page, leading the reader into a dark hole or a rippling stream. The snake slithers through the story compelling the reader to follow its winding path seeking answers and revelations with each curve of the writing.

As a reader I have always been drawn to writers that have vivid imaginations or skillful beautiful prose. The twisted and the bizarre stimulate, but the unique and the uncanny compel me to follow the writer's path, in awe of "cool" sentences. I have always been attracted to metaphor and analogy. It is sad that the most popular books usually are all so similar. How many times have we read about her "beautiful big blue eyes," instead of her "eyes were like ice in a blue glass," or "the sky was gray and cloudy and looked like rain," instead of "the clouds overhead looked like the angry shadows of massive pterosaurs massed together preparing for a torrential onslaught upon the dry ground." My love of the language and the imagery is most important. I have been an artist all my life and my paintings and drawings create a mood or an instant taken out of time. I am the farthest thing from an abstract artist, embodying every detail into a work of art to let the viewer feel that they understand and identify with the subject matter. My stories are conceived identically the same as one of my art pieces. I

strive to create an environment where the reader becomes fully immersed, able to actually see everything in full color. I write with complexities hidden within the story and metaphors that tie pieces of the threads together. The strings and threads are woven in unusual methods, triggering almost imperceptible connections that flow like a bubbling clear stream over a myriad of multi-colored smooth stones. The story is one thing and the inner story is another.

As an author I write each day out of an urgent need to communicate the endless supply of exceptional situations and unique locations that fly throughout my creative mind. I would write even if I didn't have an audience for my work because the stories must come out and I enjoy watching the mini-movies in my head as I produce the words. Like many other artists, each piece and each story is your new baby. Each story is your baby but you have favorites and pieces that truly touch on what you perceive to be your best. Some of my personal favorites are "Alligator Salesman" and "The White Moose from <u>SECRET GROTTO</u>. In this collection my favorites are "Montana Mist," "The Slia'," "Crow Canyon," and "Jade Island." Gayln, my wife, likes "Rites of Hunter's Status" from <u>SECRET GROTTO </u>and "Devil's Beach."

I am proud to be presenting this odd and creative, imaginative and compelling journey to you. This is a work of fiction but there exists a truth in our memories and our genetic past. The many hours and hours of typing and thinking and creating has been rewarding. This past year, 2002, has brought me to conclude <u>CROW CANYON</u> and to finish another collection of short stories for young adult readers to be published soon this year. Now you may follow the twisted path into the canyon and find out the secrets. The Slia' is out there in the dark water and Mist runs through the mountain forests of Montana.

The Slia'

The dark deep water splashed loudly as something very large rolled just beneath the surface. The two fishermen both looked up from their lines and watched the ripples from the splash travel out across the water like a giant growing target. Talbot and Lars fished here on this wooden pier every Saturday evening. The two old men had been fishing at this pier for the last several months. They had already fished out their previous spot on 61st street pier in Galveston, Texas. This new pier was located also on the Gulf of Mexico but across the bridge from Galveston on the Texas mainland. On some nights they shared the pier with an older black man named Lucky. Lucky always kept any fish he caught. He never let any fish go, no matter how small. Talbot and Lars only kept a few trout or redfish. They both figured that Lucky didn't care what he ate. Lucky even kept "hardheads" Gaftopsail catfish, which weren't even fit for stray cats to eat.

This Saturday night Lucky wasn't with Talbot and Lars. They missed the old black man and his interesting stories, especially on the slow nights when the fish weren't biting. Lucky would usually come strolling down the pier whistling some ancient tune, followed always by his dog, Spot. Spot followed Lucky everywhere. The dog was a pure black mid-size mongrel made up mostly of terrier-mix. Spot seemed a peculiar name for a dog that was entirely black and Talbot had asked Lucky once about that. Lucky just said, in his gravel

crunching voice, "that dog is like a black spot on the world, he ain't good fo' nuthin' 'cept followin' me 'round and eatin'. He don't even know how to bark, just whine when he hongry. I'm still waiting for the day he learns how to bark"

Talbot was a tall lanky man with thin gray hair and liver spots dotting his wiry arms. Lars was much smaller and completely bald. He always wore a baseball cap to cover his shiny head. Lars had been bald since his early twenties and he started wearing caps back then. Most people had never seen Lars without a baseball cap covering his baldhead. Once, when Talbot and Lars were wade fishing Lars had stumbled in the waist deep water and had fallen under. He was completely drenched and his cap floated away. He scrambled out of the water and went to his tackle box and pulled out an extra baseball cap to cover his head. Lars was more worried about his head being covered by a cap than being soaking wet or anything else for that matter. His wife, when she was still alive, always bought him a new baseball cap each year for his birthday and also for Christmas. Lars had all his caps hanging from nails in his garage. It was like a garage museum to baseball caps.

Lars and Talbot had met each other on the Galveston pier years back after Talbot had lost his wife to cancer. They were fishing buddies ever since. They had become so close that they could sit and fish for hours together without saying a word. They both had been retired for many years and they had so much in common, even without fishing. Lars used to be a history teacher at a junior high and Talbot had been a science teacher in a local high school.

The water splashed more violently and the two men jerked towards the noise. Droplets of water splashed onto their pants and Lars even got out of his fishing chair. They both stared

at the circles of water emanating from the big splash as if a monster fish would stick its nose up and let them see its large teeth. The big vapor light on the tall pole near the end of the old wooden pier dimly lit up the churning water. They were watching the water, hoping for another splash or some sign of the massive fish when they heard the familiar whistling of a broken down tune. Lars turned and waved to Lucky hobbling down the pier towards them. He was carrying his folding chair and his fishing tackle. Spot trotted slowly behind him like a small shadow. They could hear the dog's claws clicking on the wood of the pier. The old man's whistling and the clicking of Spot's claws made a strange song in the evening air.

Lucky put his chair down and rigged his fishing pole. Lucky always fished with a cane pole while Lars and Talbot owned rod and reels. The old black man, nodding to the other two men said, "Fine night fo' fishin'. They's a full moon behind them clouds. A full moon in May on a Saturday night, a sure sign of the biggest creatures of the deep comin' in from the ocean to the shallows."

Lucky continued his story as Lars and Talbot situated their fishing lines once more. The old black man had a million stories and it was nice to fish and listen to his deep voice. A voice barely heard above the sound of the breeze and the water lapping at the wooden legs of the pier. He rasped along, saying, "I remember how Shelly Jackson lost her man on a pier ova' near Bacliff. It was on a May Saturday night with a full moon hanging low 'neath the clouds. I 'member his name was Samule. He was a big strong man with arms that looked like bait buckets. They was one story once 'bout how he hauled in a ten foot tiger shark from wade fishin' with a flounder gig. Samule worked as a laborer on the construction sites around Texas City and Deer Park and he had a reputation for his

strength. I heard told that he could bend welding rods and big nails with his bare hands. They say that he once lifted a flatbed truck off of a Mexican boy on a construction site. Held the truck up a few inches with one hand and dragged the boy out from under it with the other hand."

Talbot cleared his throat and replied, "Wow, Lucky, sounds more like he was Sampson than Samule."

Lucky chuckled, "Samule was a big man, almost seven feet tall. He liked to fish by hisself and one night like this he went fishin' and no one eva' saw him agin'. It was like he jes' disappeared. Shelly went down to the pier where he fished mostly and she found that the pier was tore up and broken. The police came down to investigate but they neva' found no trace of him."

Lars spoke up, "sounds like a spooky story. He probably accidentally fell in and drowned. Strange... how they never found his body, though. I have heard some old wives tales down at the VFW hall about other fishermen disappearing back in the twenties from broken down fishing piers on the Gulf Coast. Just a bunch of old gossips trying to spook everybody. Full moon fishing has produced some big fish for me and Talbot over the years. "

They all laughed and Spot whined and curled up next to Lucky's chair. They were still laughing when a big splash sounded in the water about ten yards from the pier and they looked out at the shadowy water in time to see a long scaly blue-green rolling form with long fins slink under the water. Talbot turned to the other two men and said, "Holy Jesus, did you see the size of that...that...fish?"

Lucky pointed at the churning water and croaked out, "That was a big alligator gar. Biggest gar I eva' seen. I bet he is ten feet long. I hope he don't get no idea to bite my hook cuz' he would jes' gone and break my line and pole and evathing!"

Spot stood up and bared his teeth, looking at the churning water, which begun calming down again. Talbot, exclaimed, "I don't know if it was an alligator gar or not but whatever it was, it was huge! I'm thinking maybe it is some kind of big billfish gone loco and got lost up here in these shallow waters. I'm thinking maybe it is a big swordfish or maybe even a giant marlin."

Lars tipped his baseball cap back a bit on his head and scratched his forehead, sighing, "What ever kind of big fish it is I don't think we need to be concerned that any of us will catch it. Biggest fish I ever caught was a big grouper and he was only about twenty pounds. Lucky, what's the biggest fish you ever caught?"

The three men all settled back into their chairs comfortably and readjusted their fishing lines. Lucky petted Spot and scratched the dog's ears as he answered, "When I was a young man I once caught a nine foot sawfish. A sawfish really ain't a fish but is some kind of big stingray that looks like a shark with a long nose filled with sharp cutters. The thing's nose really does look like a long saw. I caught this sawfish with my cousin's rod and reel over in Louisiana. It took me a heck of a long time to pull that scary fish in. I 'member the look on my cousin's face when outa' the water comes this long jagged saw-nose and the flapping fins all over this slick catfish body. Nine feet of saw-nose catfish and we barbeque-ed him that weekend and had all the family feasting like it was a Devil's Fourth -o-July!"

The men all laughed and Spot raised his wiry black head and whimpered. They were still chuckling when they heard something behind them on the pier. They turned and saw the small, shell and gravel, parking lot illuminated by a few lonely lights on crooked poles. Beyond the parking lot about

five hundred yards away was the bait camp. There was a small neon sign illuminating the front of Shilo's Bait Camp building. The men readjusted their eyes to the dim light and saw that standing on the pier by the parking lot was a woman.

The woman was tall and slender. She was wearing a gray dress that hung just above her knees. A gray scarf covered her dark hair that slightly dropped and tossed about in the breeze on her shoulders. She was young and beautiful. The men saw that she was a black woman with light gray eyes that shone in the subdued light of the pier. Her skin seemed radiant and her high cheekbones were almost severe in the shadows of the full moon and the clouds. She could have been a tribal princess in a jungle kingdom. She seemed out of place standing alone in a gray dress on a Gulf Coast pier under a full moon. The woman stirred the men with dreams of their manhood and the strength of youth but her presence also haunted them. All three men stood and turned towards the woman. Spot stood up, darkened by Lucky's shadow. The beautiful black woman put her slender hands into the dress pockets and spoke to the men, "It is a mysterious night. Are you having any luck fishing?"

Talbot raised his hand and shouted in a friendly voice, "Nothing yet, young lady. I'm sure our luck would improve if you decided to join us in our endeavor. Are you interested in fishing?"

She laughed lightly and her eyes sparkled as she replied, "No thank you, but it is a nice night out here. Not even the mayflies seem to mind burning up in the lights. I just came down here to see the water. Being out near the water is relaxing to me. A full moon on the water is the most beautiful thing I can even imagine. Good luck fishing! Be careful of the Slia'."

She turned and Talbot shouted back, "What? What did you say?"

Lars looked at Lucky and Talbot, saying, "What did she say? Be careful of what? The Slia'? What does that mean?"

The three men looked back at the end of the pier and the parking lot. The woman was gone. Lucky sat back down and shook his head, muttering, "most beautiful woman I eva' saw. She said, be careful of the Slia'. I've heard of that saying but it was a long time ago when I was just a lil' youngun'. The Slia' was an old African tale that came across on the slave ships. They used to tell tales of big fish that ate men in the sea. They say the dead slaves that didn't make the trip to America were dumped into the sea and eaten by big fish called the Slia'. The warriors of the coastal African tribes called the big sharks Slia'. Slia' was just a word for big sea creatures that ate men."

Lars laughed and clapped Lucky on the back and replied, "Well, my fishing buddy, let's be careful of the Slia' fish and don't get ourselves eaten."

The three men returned to their fishing but each man's mind was remembering the haunting beauty of the woman on the pier. In the next hour Lars caught two trout too small to keep. Talbot had hooked a batfish and had a heck of a time getting the hideous creature off his hook. Most locals called the batfish a dogfish but this was incorrect since Talbot had sent off for a fish species handbook and looked up the information. The handbook had come opened in the mail and Gus, the mailman, had already read half the book on his lunch break. Talbot remembered identifying the batfish as a small spiny fish with flipper-like fins that hid under rocks searching for unsuspecting prey and ambushing it with needle-like teeth in its strong clamping jaws. Lucky had kept a trout and two hardhead catfish. Lucky had just re-baited his hook and was about to cast when another loud splash happened near the pier. Water sloshed all over them. Spot jumped out of the way as

the three men stood up and backed away, startled by the power and surprise of the splash.

Lars made sure his baseball cap was still on his head and he exclaimed, "Whoa! Maybe there is a big shark swimming out there. I never saw an alligator gar make a splash like that. Maybe a giant devil ray flapping makes a splash like that but not in this shallow water next to the shore."

Lucky looked around his feet for Spot but didn't see him. He said, "Where's Spot? Where's that dog at now?"

The three men looked around searching for the black dog. Lars pointed towards the parking lot. He said, "There he is. He's at the end of the pier sitting next to your truck, Lucky."

Lucky looked back and saw Spot next to his right front tire. He looked at Talbot and Lars, saying, "That's the farthest I eva' seen that dog git from my feet!"

Talbot laughed, "Yes, I have never seen Spot leave your side by more than a couple of steps."

Lars laughed too, "Well maybe he's scared of sharks. Maybe he thinks that giant shark is going to leap out of the water up on the pier and just gobble him up."

Suddenly the pier rocked as if hit underwater by something large. The tremendous impact knocked the men to the wooden flooring of the pier. Something powerful had hit the pier and one of the piers legs cracked. The pier started to break and bend. The railings began to lean towards the water on the right side. Lars' tackle box slid off the wooden planks and fell with a loud splash into the dark water. Talbot's chair fell over and tumbled into the water just as he reached to stop it. His hand grasped empty air. The pier leaned and creaked but the water became still except for the wet, steady lapping against the wood of the pier. Creaking slightly, the pier slowly leaned sideways on its broken leg. The three men were still lying upon

the floor of the pier. Their wide eyes scanned the water for some evidence of what had happened to break the pier.

Their fishing poles had fallen in the water. Only Lucky's pole could still be seen. It was barely dangling, one end in the water and the other resting tenaciously against the broken pier. Lars began to slide towards the water as the broken pier cracked and bent even more. Talbot got up and grabbed Lars by the arm and pulled him to his feet. They balanced themselves on the leaning pier and walked carefully over to Lucky and helped the old black man to his feet. They could hear Spot whining loudly in the parking lot. The men were shaken and stood up, half wet and frightened by the breaking of the pier. They all looked to the end of the pier where the water began churning. It was as if a huge whale like Moby Dick circled underneath waiting to grab these three Ahabs and pull them down under the surface in punishment for all the fish they had caught and eaten over the years.

They watched the choppy water and then suddenly the surface exploded with a terrific force. Gallons of water burst upwards splashing them completely and knocking them down on the hard wooden planks. The three men fell and grabbed hold of the wooden slats and wiped water from their eyes. They all saw it at the same time.

It wasn't a giant shark. It wasn't an alligator gar with needles for teeth. It wasn't Moby Dick. It was a huge serpent-like thing with blue green scales and numerous fins along its thick snake body. Its hideous head was completely black and slippery like an eel or a giant salamander. The black slippery skin smoothed out for about ten feet along its sinuous body where it changed to the blue green scales and fins. Its body seemed to churn the water in every direction with about twenty feet of head and neck protruding above the pier. Talbot

screamed and shouted, "What is it? What on God's green earth is this thing?"

Lars rolled backwards away from the weaving black slippery head and he saw the dead cold yellow eyes rivet on him. He rolled as quick as could, remembering how he once rolled under barbwire in the old war. The creature shot its serpent-head at him and opened its wide mouth, exposing large yellowed nail-like teeth. Lars heard the jaws snap close by his thigh. He continued to roll and lost his baseball cap. He saw it go over the edge of the breaking pier. Recoiling, the creature swung back its slimy head, slamming into a crawling Talbot knocking him into the railings of the pier. The creature hissed and the men saw gills flapping upon either side of its black wicked head. Talbot recovered and grabbed Lars by the shirt and dragged him towards the parking lot.

Lucky was still in danger as he crawled slowly along the pier. He kept muttering as he crawled along, "The Slia'...it's the Slia'...Slia'."

Talbot and Lars reached the parking lot and Talbot started to run back for Lucky when he saw the creature raise its head above the crawling black man. Lucky looked up into the Slia's yellow, snake eyes and screamed, "No!"

The serpent-like thing drew back and flexed its gills like some weird Chinese Dragon and coiled to strike at the helpless old black man. Suddenly something black shot past Talbot and Lars. Something that was fast and small and determined, and it headed straight into the space between Lucky and the monstrous creature. That's when they heard Spot bark for the very first time. Spot ran full speed at the Slia' and leapt at its head before it could attack Lucky. The serpent creature grabbed the small dog in its mouth and shook its slimy head, cracking many boards on the pier as it swallowed the little dog and then retreated back into the water.

The broken pier leg snapped in two and the pier collapsed halfway into the churning water. The creature did not reappear. Spot was gone with the Slia' under the water. The vapor light shattered and popped and sparks drifted down on the water like dying fireflies. The three drenched fishermen held each other up as they watched the water and the wrecked pier. They stood like that for along time, dripping saltwater and staring in disbelief at the waters they would never fish in again.

They heard something behind them and the men turned to see the young black woman approaching. She stopped a few yards from them and then looked at the broken down pier. She looked deep into their eyes and could read their fear and incredulity. Lars reached for his head and found his baseball cap gone. He wiped water from his baldhead. Talbot helped him to his car. The young black woman looked into the old black man's face and said, "You're Lucky."

A tear rolled down Lucky's face as he felt deeply the loss of Spot. Spot had given his life for him. He indeed was lucky. He reached out to touch the woman's shoulder and he saw a strange smile behind her eyes as he replied to her, almost in a whisper, "Yes mam'. I'm Lucky."

He turned and walked back out onto the broken pier and retrieved his cane pole, which was still half in the water, half on the pier. The water was calm. He had a twitching catfish on his hook. He grabbed the fish and cut the line, dropping the catfish back in the water.

Devil's Beach

I have heard tell that in the Florida Keys time stands still. They say that time moves at a slower pace. I was in a hotel near Bahia Honda in the Keys and I turned an hourglass over to watch time. The tiny white granules of sand did not move. The hourglass grains of sand had stopped, the sands of time moved no more. I looked at my watch and noticed the second hand wasn't moving. This is the place in the Florida Keys where some of the people try to reach, a place where time slows to a halt. I had found the place of zero time. Looking out of the window that faced the ocean I could see the surf slowly rolling in and caressing the beach but the sun was low in the sky as if the day were ending. I had only been awake a few minutes and I knew I had not slept the day away. Getting dressed in shorts and a tank top I left my hotel and went walking down the sand of the beach on the south side of Bahia Honda. The water entranced me and I walked for several miles. The water was warm and clean and I could see many fish and hermit crabs. I thought it would be dark soon and turned around to head back. As I looked back the sun was only just rising above the horizon.

I quickly spun around searching for the setting sun but it wasn't there. This instant skewered my mind with radical chaotic thoughts. I saw a rainbow on the horizon where once the sun had rested. The sky was brilliant opaque blue and there was not a trace of moving cloud to be found. The only

thing moving was the continuous surf gently breathing like a sleeping giant at the edge of the world. I realized then that I was not alone.

She was sitting with her thin arms wrapped around her legs on a pale bone colored boulder. I took my attention away from the mysterious sun and stared at this tiny dark-skinned girl on a pale rock. Behind her was a thick impenetrable mangrove forest. She wore a white sleeveless summer dress of diaphanous material. Her long dark hair blew in the gentle ocean breeze like the whiskers of a Chinese dragon in a firework parade. I took a tentative step towards her and she did not move or look at me. I could see a far away look in her eyes, as if she were a bronze statue cemented to this place in Bahia Honda. There wasn't any sound except the slight noise of the breeze and the ocean; even the sea gulls were someplace else. I started to speak to her, but as I opened my mouth she put a slender finger to her lips to shush me.

Beyond her I could see the sky turning in on itself and the blueness was being chewed up by an immense formation of purple and black rolling thunderheads. She looked like a white and brown nymph in a surreal oil painting with a background of the deepest depths. The artist captured her perfectly with a few delicate strokes of white and bronze and then completed the painting by throwing large splashes of indigo and black, purple and gray. She was precision in the foreground and chaos ruled the wide expanse of the background.

She then looked directly at me and it was like being set on fire. Her eyes shone like incandescent light brighter than anything my mind had ever experienced. I still do not know how such intense light did not blind me. The light blast only lasted for an instant and I thought that maybe I had only imagined it. I blinked once and took a step back. The young woman spoke to me, "Are you the devil?"

I could see the scary thunderclouds rolling in the distance as I pondered her question. Everything around me, the weird sky, the out of kilter time, the strangeness of the sun, even the absence of sea gulls seemed bizarre. This beautiful young woman, sitting on a rock just asked me the oddest thing I have ever heard, "Am I the devil?" I sort of chuckled and then I realized without a doubt that she was totally serious.

I didn't reply soon enough because I was still off balance, not really sure of myself or of this situation, and she asked again, "Are you the devil?"

I looked at her and quickly answered as calmly as I could, feeling like this was some kind of test and I didn't want to fail, "No. I am not the devil."

She sighed and looked back out to sea, as she said very quietly, "I was hoping you were. I have been waiting for him."

Thinking she might be insane or maybe just playing a game with me I asked her, "Why are you waiting for the devil?"

"Oh, it's time, I think."

I stared at her beauty, and the more I looked at her the more I was taken in and I continued, "It's time for what?"

She ran slender fingers through her hair blowing in the breeze and said, "I have been waiting for a long time. I spoke to the devil many years ago and he said I would know when he would return for me. He's not really a terrible thing, you know. He isn't hideous or evil like everyone believes. He doesn't even encourage satanic worship, that's just a bunch of nuts inventing a devil of their own."

I didn't quite know how to reply to that. I stepped closer to her sitting on the big pale rock as she talked to me, "The devil has very smooth light skin and he does have a long tail but mostly he looks like any other man. His face is very

handsome and you can barely see his horns poking through his thick curly black hair. He doesn't have two horns like you have heard either, more like about five or six."

I started to interrupt her but she held up a small hand, saying, "No, don't say anything. Oh no, maybe the devil sent you. Are you his messenger?"

I smiled and sat down in the sand, unaware that the thunderclouds now rolled directly above us on the beach. "No, I am not the devil's messenger. Are you talking about the same devil that God cast out of Heaven?"

She began laughing. Her laugh was beautiful and her face even more beautiful transformed from the serious face she had been wearing. She pointed at me and asked, "Then who are you, God?"

That's when I had had to laugh, "No, no, I am not God. I am not even sure who I am anymore. I do know that I came here to find a place where time moved at a slower pace and I have found that there really isn't time here, I think. I went for a walk and saw the sun on both horizons and never saw the night in between. And now I'm sitting in the sand of a Florida beach talking to a pretty girl waiting for the devil or his messenger."

She smiled slightly as I told her this and put a finger to her lips and shook her head, saying, "You have much to learn. What is your name?"

"My name...it seems like I have a hard time remembering it. Oh, I am Sam. Zerkins, Samuel Zerkins, from...Angleton, Texas. I am a taxidermist. I stuff dead animals, you know, one step above an embalmer."

She listened but looked out to sea again and then whispered, "Sam. Sam...I like it. Texas, is that far away?"

Laughing I replied, "Everybody knows where Texas is? Yeah, it is pretty far away as the crow flies."

She did not catch my humor and just stared at me and I expected the bright intense light to burst from her eyes at any second. "Sam, do you know of angels? There are many species of angels. They are related to humans but much different. Human religions describe angels as God's people in Heaven. God is a force not a human and angels are not the people of a force. Angel's are a powerful species but they serve no one. Humans are confused about the force of God and the role angel species play. The angel is the highest form of living species on earth. Humans tend to think of themselves in this role but they are wrong. They also think of angels as spiritual beings not of this earth. Wrong again. Angels are real and they can die. They are like supreme chameleons and have many mutations that enable them to move about without being seen. Humans have never ever seen an angel skeleton because they are too far advanced and clever to ever leave evidence of their passing. They do not die easily and they do not procreate quickly. Their species are few and endangered. Some humans that have seen them have worshipped them and endangered them. I tell you this because I am one."

I stood up and stepped back a step. I almost faltered and tripped. I was disoriented. I thought that maybe I was dead. I thought that maybe I was still asleep. I thought that maybe I was mad, staring into a television screen in a room full of crazy insanos jumping up and down as Tom chases Jerry around the house and Sylvester gobbles down Tweety bird. The thunder rumbled above me and the sky was black but a rainbow shone through the darkness on the horizon and the sun was dipping low into the sea. The beautiful young woman watched me react to her statement and I thought she looked like a mermaid on the rock near the ocean.

I looked overhead and I saw a massive flock of over a

hundred frigate birds gliding on the air drafts of the storm. The flock of great birds looked like a prehistoric squadron of ramphorynchus pterosaur, the beak-snout middle sized pterodactyl from central Europe during the Jurassic period. The large black birds almost soared motionless on the great drafts of the wind and I watched them in awe. I was looking up when she said, "They have come for me. The devil's birds precede his arrival."

The girl smiled as if she were very happy and I felt her happiness radiating outward like warmth as the air actually had gotten colder with the coming of the thunderclouds. I watched the squadron of frigate birds gliding down towards where she sat, a slow easy spiral of black birds that resembled a tornado of feathers and beaks. The girl who claimed to be a species of angel said, "He comes. The devil comes for me finally and keeps his promise."

She looked back at me with shining beautiful eyes and the gusting wind in her dark hair and continued, "You are fortunate to witness this day. To think you are only a human, not a god or an angel or even a hybrid species like the nine daughters of Zeus. You should have seen those goddess's of which Hesiod claimed the muses sang. The nine daughters, Clio, Euterpe and Thalieia, Melpomene, Terpsichore, Erato, Polyhymnia and Urania, and finally the beautiful Calliope, were all impressive and powerful but the devil had many daughters too. The devil's girl children were many and you may know them. Mary Magdalene, Cleopatra, Marilyn Monroe, Mona Lisa, Catherine Howard, Empress Josephine, Azriel, Jezebel, Marie-Antoinette, Mary Countess Howe, and many more. I should warn you of your fate to be in the presence of such nobility and power. The devil has come for me and I will be enriched in his presence and learn to fly once more. I will remind you of the words

of the hawk to the nightingale as he carried her high in the clouds in his talons. Hesiod recorded the bird of prey in ancient scrolls, as the hawk said, "Goodness, why are you screaming? You are in the power of one much superior, and you will go whichever way I take you, singer though you are. I will make you my dinner if I like, or let you go. He is a fool who seeks to compete against the stronger: he both loses the struggle and suffers injury on top of insult."

I started to backtrack and decided that insanity was what was in this pretty girl's mind. I turned to go back the way I had come but just then thunder rumbled like a bowling ball in an empty alley and a crackling vein of lightning shot through the air above my head. I looked back at the girl on the rock. She was gone. The frigate birds were all perched on rocks like vultures around a dying herbivore. It started to rain. I stood there on the beach in Bahia Honda getting soaked by a sudden downpour and stared at the rock where the beautiful girl had just told me she was waiting for the devil. I knew I had witnessed what no one would believe. I knew it wasn't a dream or a hallucination. I knew more about reality than fiction. I was no longer afraid of the devil.

The frigate birds flapped their wings and all took flight as I walked back towards the rock. The rain continued to pour and the waves crashed louder than before. I left the beach and returned to my hotel.

Later that afternoon in a local tavern I sat at the bar sipping strong draft beer and eating peanuts. The bartender talked about the rainy weather as I replied in one-word sentences. I kept thinking about the beautiful girl with the shining eyes and a light-skinned devil. Someone bumped my arm just as I started to take another sip of my beer. I spilled some on my white shirt and turned to accost the person responsible. I was

surprised to see the girl from the beach sit on the stool next to me. She said, "I'm sorry. Here, let me clean you up."

She grabbed a napkin and dabbed my shirt. "Hi, oh, it's okay. It's an old shirt anyway."

I saw a man follow her and stand behind her. I continued speaking and asked, "So where did you go after I saw you on the beach today?"

She looked at me strangely, saying, "Excuse me? The beach? We just got here. I haven't been to the beach. Do I know you?"

The man following her looked at me and smiled, "Yes, I do believe we do know him, dear. Sam? Yes, Sam it is."

I looked back at her companion and said, "Yes, my name is Sam. We haven't met, have we?"

"Oh yes," the man said, " only once a long time ago. I knew your mother. This is my angelic new wife, Hope. Now... Sam...should we have dinner or should we let you go?"

Abe the Lincoln

The day it happened, San Francisco was like any other day, the Golden Gate Bridge was a red primer color, the Chinatown gate was framed by statues of Lion dogs, Alcatraz had tourist ferries going back and forth across the cold water, and Donnie was riding his bike in the hills near the Muir Woods. Donnie had witnessed many incredible things in his young life. He was seventeen, smart and motivated. Old man Budgier, owner of the corner market, often said Donnie was the most grown-up kid he had ever known. Donnie liked riding his mountain bike in the hills. He liked to exercise and the rough terrain made his legs and lungs strong. Donnie was a senior letterman on his high school football team and also lettered in track. Donnie wasn't the best player in either sport but he tried harder than most. Last year his coach had given him the "Burning Heart Award." It was the special award given to players that never got athletic scholarships but by their determination and hard work proved that they deserved more out of the sport.

The day it happened, the hills seemed bleak and gray under heavy cloud cover. Lannette was walking her dog, a schnauzer half-breed named Abe, after Abe Lincoln. Lannette and Abe walked the trails of the Muir Woods National Park almost everyday, except when it was too cold or raining. The day it happened it wasn't raining but the clouds seemed to be holding onto a massive ocean of rain just waiting for the right

unsuspecting person to walk under the right cloud to release the torrential downpour. Lannette went to college and dreamed of being a Literature teacher on the high school level. She lived with her mother and they were fairly close. Lannette had not been a cheerleader in high school and she wasn't homecoming queen material but she was intensely cute with special dimples on both cheeks. She was a typical medium in height and size. Lannette even had medium brown hair. She always thought of herself as special on the inside but average on the outside. Lannette was intelligent and down to earth. She was friendly and outgoing and didn't possess a temper. Her Aunt Lucy always told everyone at the beauty shop that Lannette was a princess waiting to happen.

Donnie came around the curve very fast on his bike, too fast because he misjudged the curve and his own speed. Lannette and Abe were strolling around the same curve, coming from the opposite direction of Donnie on his bike. The clouds parted at the same instant that Donnie and Lannette came face to face around the curve. The streaming sunlight only lasted for a second or two as the gray clouds closed the sky back up. Donnie swerved as he saw the girl and dog. Lannette screamed and pulled Abe's lease back. Donnie hit the gravel on the shoulder of the road. Lannette barely dodged the bike as it swept past her and Abe. Donnie clenched onto the handlebars as he slid over the edge of the road and tumbled down the side of the rocky mountain. Lannette ran to the edge and watched his bike bounce of a boulder and she saw the young man rolling across broken sticks and tall grass. The bike bent sideways as it hit another boulder and finally came to rest upside down leaning against a crooked short tree. Donnie rolled to a stop. His helmet had protected his head from injury. Lannette was breathing hard and kept Abe close to her feet.

The small dog barked and strained at the lease, trying to run down the mountain after the bike. The back wheel was still slowly turning.

Donnie looked back up the mountain and saw the girl and her dog looking down at him. He hurt all over, especially his right ankle. He shouted up to the girl, "I think I'm okay!"

Lannette shouted back, "Do you want me to go for help?"

Donnie grunted as he moved his legs and said, "No, I'll be okay once I get back up this hill."

Donnie tried to start climbing and grimaced as his ankle throbbed. He didn't think he had broken it but he knew it was badly strained at least. He shouted to the girl, "Hey, I think maybe I can get up the hill but my bike is history. Do you have a cell phone?"

Lannette started to climb down to him and the dog barked as they descended the hillside. She picked her way carefully down through the boulders and sticks. She shouted, as she descended, "No! I don't have my phone with me."

It didn't take Lannette long to reach Donnie and when she got to his side he was already on his feet trying to climb back up. She smiled at him and he gritted his teeth as he stepped down on his hurt ankle. Lannette supported his weight and together they began the arduous climb back up to the road. Abe smelled Donnie's leg and barked happily, as if this was a fun way to spend the day.

They slipped and fell a few times but eventually Lannette climbed up and helped pull Donnie back onto the road. Donnie knew he wasn't going to walk anywhere so he asked, "What now? I guess I wait until a car comes along to pick me up."

Lannette looked into the hurt boy's eyes and saw

something she liked. She squinted her eyes and made a face at him, saying, "I won't leave you up here. I'll wait with you until someone comes by. This road is always busy it won't be long."

Donnie sat down on the side of the road away from the curve and thought about his busted up bike that would probably stay down there until it rusted away. Lannette sat beside him and Abe licked Donnie's scratched hand. Donnie smiled at the dog and patted Abe's head, scratching his ears as a bonus. Lannette talked incessantly, trying to distract Donnie from his pain and predicament. "What is your name? Mine's Lannette. The guy licking your hand is named Abe."

Donnie finally stopped worrying about his ankle and the death of his bike and looked up into the girl's face. She was attractive to him and her eyes seemed to almost glow, like one of those vampires's in Salem's Lot. He thought they glowed but not evil, they glowed in a beautiful, good way. He shook her hand and replied, "My name is Donnie. I ride my bike on these roads everyday. You would think I wouldn't have a stupid wreck after as much time as I have spent up here. I guess I wasn't paying as much attention because I didn't see you until it was too late. I'm just glad we didn't have a collision. Then we both would have been hurt pretty bad."

Lannette liked the way his eyes crinkled as he talked. She liked the small bunch of freckles on his nose and she blurted out, "Collision? It might not have been such a bad idea, you bumping into me."

She blushed, and popped a hand over her mouth, and started laughing, "I guess I meant I didn't want you to run into me with your bike but it is okay that we met up here on this mountain. I mean, I like talking to you, that's all. I usually only have Abe to talk to. Oops, I don't mean that I think you are a dog or anything like that. I'm sorry. I keep saying all the wrong things. I just mean that, oh never mind."

Donnie just sat there and smiled as he listened to her ramble on like some talking toy with the pull string stuck. He reached out and touched her shoulder, saying, "Slow down Lannette. It's okay I know what you mean. I'm glad I met you already. Where do you live?"

She finally took a breath and slowed down her motoring mouth, saying, "Sausalito."

Donnie said, "Okay. I live just across the Golden Gate."

They both heard a truck coming around the curve and stood up, waiting for it to come into view. A black Chevy pickup roared around the curve and then broke hard, the driver seeing the two people waving their arms at him. He rolled to a stop slightly ahead of where they stood and Lannette ran up to the driver's window, which was rolled down. She said, "Hey mister, Donnie's ankle is hurt. He wrecked his bike down the side of the mountain and he can't walk. Could you give us a ride into town?"

The driver, a man in his upper forties, grimaced like a beaver sizing up an over-seized tree, and finally said, "Ayuh, I guess so. I got all this stuff piled in the front seat, you'll have to ride in the back." Lannette smiled and said, "Thanks so much!"

She ran around back and helped Donnie limp to the tailgate of the truck. She helped him slide in the back of the truck and then she patted the tailgate so that Abe would jump in. Lannette jumped in beside Donnie and Abe promptly sat in her lap as the driver slipped the truck back into "drive" and they headed towards Sausalito. The ride was rough and Donnie grunted a few times as his leg got jostled when they hit big bumps. Lannette chattered to Donnie as they rode in the bed of the pickup truck, "Donnie, does your ankle still hurt as bad?"

Donnie grunted, "I think it's worse. It is starting to swell."

She frowned, and Donnie even thought her frown was a cute look. She continued, "I think we should go to my house and my mom could drive you to the emergency room. You should get it x-rayed to see if anything is broken. My mom should be home from work by now. She is a Massage Therapist in town. I don't think her massage would fix your ankle. It does look swollen. We need to get some ice on it pretty fast."

They entered the curving street that marked the beginning of the shops of downtown Sausalito and the driver pulled over. He got out and leaned on his door, saying to Lannette and Donnie, sitting in the pickup, "Where do you want to go from here? I'm heading north."

Lannette spoke for them both, "Well, you could take us to the Bistro Café. It's one block over and two blocks up. We would really appreciate it."

The driver grimaced again, like he hated veering a few blocks away but he replied, "Ayuh, okay, Bistro Café, I can do that."

Abe barked at the driver as he swung his door closed and started down the road again. He turned at the next street and then drove two more blocks north and parked in front of the Bistro Café. The Chevy's engine idled as he shifted it into "park". The driver got out and without a word went around and opened the tailgate. Lannette and Donnie started to climb out and Abe jumped out yipping, happy to be on the ground again. Lannette was saying as she helped Donnie get out, "Thank you so much, mister. We really appreciate it. We are so lucky you came along when you did. I would be glad to pay you a few bucks for your trouble if that's alright with you?"

The driver grunted something and then replied, "Ayuh,

I guess it weren't no trouble at all, really. I was coming sort of this way anyways. He backed away as Lannette supported Donnie and Abe ran circles around them both, his tongue sticking out ready to lick anybody's hand that would try to pet him. The driver started back to his truck door, saying, "No girl, I don't need any money for driving ya'll here. Boy, take care of that hurt leg."

Just as he was walking back Abe decided to run fast between his legs as he stepped back towards the truck's cab. The driver tripped over Abe and fell hard into the truck's open door. He cracked his face on the window's edge. His neck bent backwards hard as all the weight of his body came down on the steel door. He threw his hands out to break his fall but it was not in time and they flailed about as he smashed into the steel truck door. His right arm thrust into the truck as he fell and his outstretched hand grabbed the gearshift. When his neck cracked his hand clenched and it hit the gearshift, shifting the idling truck into "drive". The truck lurched forward and the driver's shirt and left hand caught in the doorknob. The truck roared forward dragging the unconscious driver by his left arm on the open door. Lannettte and Donnie watched helplessly as Abe barked at the moving truck. The truck drove down the street for half a block before ramming the back of a Lincoln Continental sitting at the red light. The truck started pushing the Lincoln through the red light as the unconscious driver fell inside the truck's cab, his hand still hung up in the truck door, and landed with his head and shoulder on the floorboard. His head hit the gas pedal, revving the engine up and powering the Lincoln forward. The driver of the Lincoln, and elderly woman with white hair, started screaming when her foot was bumped off the brake and her car was pushed from behind into the intersection. The woman's screams were cut off abruptly

by a fast moving Harley Davidson motorcycle that suddenly impacted her driver's side door. The motorcycle rider was thrown over the Lincoln and bounced a few times in the street, coming to a halt against a newspaper machine on the sidewalk. The man in the motorcycle helmet and boots was motionless against the newspaper machine. Maybe tomorrow his picture would be on the front page.

The Harley Davidson motorcycle was stuck up to its front forks in the door of the Lincoln. The back tire still spun as its engine kept running. The Lincoln's horn blared because the elderly lady's head was lying on the steering wheel, blasting the horn. The lady did not wake up even with all the noise from the horn and the motorcycle's engine. Lannette covered her mouth in horror as she witnessed the procession of accidents taking place. Donnie put his arm around her and stared in disbelief as the motorcycle crashed into the Lincoln. He watched the motorcycle rider fly through the air like a cape-less Superman until he hit the road and kept bouncing. Donnie didn't know if his helmet would save him or not. Abe barked but could barely be heard above all the noise of the engines and the horns blaring. The driver's truck kept pushing the Lincoln with the motorcycle stuck in the door. The Lincoln began to turn sideways in the intersection and the motorcycle's gas tank was split open. They watched as gasoline leaked all over the road under the two roaring vehicles.

Donnie backed up pulling Lannette with him as he expected the cars to explode. Abe followed them but continued to bark. Lannette reached down and picked Abe up. They stood in the doorway of the Bistro Café as people started to come out of the storefronts to see what was causing all the noise. The Lincoln was pushed into a street lamp and the iron pole bent as the roaring car and truck pushing it smashed up

against the pole. The bulb burst, exploding shards of glass down onto the vehicles. The iron pole bent over the car and sparks showered down on the roof and the road. A flame leapt up from the gasoline, enveloping both the car and the truck. The truck driver tried to get out but the flames consumed him quickly and he thrashed about like a catfish on a treble hook. The people in the street could hear him screaming as the flames ate away his clothes and his skin. The Lincoln suddenly exploded. The car's roof shot fifteen feet into the air, followed by the burning woman. The woman landed on the roof like a surfer on a surfboard with the ever-expanding pool of flames resembling the ocean's waves. The image of the bizarre surfer only lasted a second as she tumbled down, breaking her legs as flames shot quickly up her torso. She fell down on the broken Lincoln's roof and burned in a lifeless heap. Donnie held Lannette and she buried her face in his chest just as the motorcycle stuck in the side of the car exploded.

The handlebars launched across the road and crashed through the window of the barbershop. The striped red and white pole kept spinning until the headlight shot like a rocket into it. The pole broke in half and fell to the cement like a melted giant candy cane. The back wheel of the motorcycle spun off into the street and rolled like a runaway unicycle for half a mile before it careened into a parking meter, knocking the red violation tag up. A police car came around the corner and skidded to a halt close to the accident. The officer got out of the car holding his hands up, shielding his face from the heat of the flames. He leaned back into his car, grabbing the radio to call for more help on the scene. As he leaned inside the truck suddenly exploded. The cab and the bed of the truck separated as fire and a black cloud of smoke rumbled into the air. The bed of the truck shot backwards like a horseless two-

wheeled cart and smashed into the police car. The officer fell to the street and the truck's tires ran over both of his legs. The police car's siren went off as the fire leapt over the hood from the explosion. The officer groaned and rolled around on the street as men ran forward to drag him away from the burning vehicles.

A red fire engine squealed onto the scene. Firemen in yellow helmets swiftly attacked the flames with fire extinguishers and hoses. An ambulance screeched to a stop and the paramedics ran to the officer lying on the sidewalk surrounded by curious onlookers. Donnie and Lannette watched the flames die down and the ambulance, loaded with the groaning officer, pull away. Police cars were at all corners of the intersection now and officers were controlling the accident scene. An officer walked up to Donnie and Lannette and asked, "Did you two see what happened here?"

Donnie replied, "Yes sir. We saw the whole thing."

Lannette, started crying, as she sobbed, "It is our fault. It is all our fault."

The officer asked, "Miss, why is it your fault? What happened here, exactly?"

Donnie hugged the crying girl close and she held tightly to Abe in her left arm. He said, "We were riding with the driver in the truck and he dropped us off here at the café. He tripped and fell in his truck and it accidentally took off down the street. His truck hit the car and that's when the motorcycle crashed into the side of the car. Everything started exploding then and the first police car got too close and the fire and explosion knocked the officer down and the tires ran over him."

The police officer held up his hands, saying, "Hold on, now, and slow down. How did the truck driver loose control?"

Lannette sobbed, "It was my fault. Abe got tangled in his feet and he fell. Abe didn't mean too."

The police officer said, "Abe? Now who is Abe?"

"My dog. Abe is my dog and he didn't mean to trip the truck driver. It was an accident. I should have been holding him. It is my fault everything happened, " said Lannette.

Another police officer was approaching them and he shouted, "Officer Beare! We've got identification on the truck driver."

He walked up to them and said, "He was Vance Michaels, a smuggler from Oakland. He was the one responsible for that heroin deal six months ago. He was also wanted in connection with those two bodies found floating near Alcatraz. I guess we don't get to interrogate him about murder."

Officer Beare asked, "what about the Lincoln driver and the Harley rider?"

The other officer checked his notes and they both turned as they saw the other ambulance driving away with the motorcycle rider in it. He turned the pages of his notebook and said, "Well, this is weird. The Lincoln driver was Agnes Hominee."

Officer Beare raised his eyebrows and chuckled, "No way! Not "the" Agnes Hominee?"

"Yes, the very one. Agnes Hominee, the whorehouse chain queen of northern California. She has so many outstanding warrants for her arrest and she stays out of sight so well I didn't think we would ever catch up to her. As for the Harley rider, he is stable. He has a concussion and broken ribs and maybe his arm is broken too. He is Larry Walluss. He already has one handcuff on and a police officer with him in the back of the ambulance. He is wanted for robbery, four counts exactly."

The officer smiled and petted Abe on the head, saying,

"Stop crying young lady, Abe did a good thing today. He nabbed three criminals with one stroke. It's not anyone's fault. I'll need full statements from you both, though. Come by the station tomorrow when you two feel better. Let me get your names and personal information and you can go home."

Donnie and Lannette sat sipping hot chocolate in the Bistro Café. Everyone there was still talking about the huge accident that had happened just outside an hour ago. The wreckers had taken all the cars away and all that remained of the accident scene was scattered shards of broken glass and black stains on the road from the gasoline fire. They talked about the accident and they thought it had been a terrible day, from Donnie's accident to all the chaos of the last few hours. Donnie took Lannette's hand in his and they both looked out the window to where Abe was leashed to the bike rack in front of the café. Abe sat staring at the café door, waiting for them to come back out. Lannette smiled at her dog and Donnie said, "Funny thing how all this stuff happened to us today and I feel like it is still a beautiful day, I got to meet you. I fell down a mountain, lost my bike, busted my ankle, saw people killed and now I'm drinking hot chocolate with you. Isn't it weird how Abe tripped a man who wrecked a Lincoln?"

"Abe the Lincoln wrecker, " laughed Lannette, and she squeezed Donnie's hand and leaned across the table and kissed him lightly on the lips. He touched her face with his hand and she felt like today was the best day of her life.

Chicken Night

Ya ever saw such pretty chickens in all yore life?"

Calvin laughed and kept up his talking, making more noise than he should, "Heck fire! Lookit how they just sit on the branches and stare at us like we wuz' their friends. I know why they say chickens cross the road cuz they don't know what's on tha' other side. If'n I wuz' a chicken I sure would hafta' be a big ass croakin' rooster. Them hens is the dumbest things I ever run into on this planet earth. At least a rooster got brains enuff' to fight back and peck and scratch ya when ya try to grab 'em."

Theodore chuckled a bit at Calvin and whispered, "Okay boy, you've been talking non-stop since we snuck out here. It is now time to hush up and catch some chickens."

The two men stood on the ground under a big chinaberry tree in Mr. Hillmon's back pasture. Once a month they would sneak into somebody's place and snatch a few chickens to bring home for their monthly suppers. Calvin and Theodore Diggs were low income and low on smarts. Their chubby old friend Sam Pellert said that they were good boys but they couldn't help it if they were slow upstairs. Sam once told Tommy Smythe, when they were both at the feed store in town, "At least Theodore got himself through junior high."

Sam Pellert owned the local barbershop. Sam knew that every town in Texas needed a good barbershop. He didn't cut hair anymore but he owned the place and took a cut in

the business of the three barbers who worked for him. Sam could almost always be found sitting in the last chair of his barbershop reading the newspaper and shooting the breeze with the many men who patronized the barbershop. The town of Da Costa had only about five hundred anyway so every man eventually came through the barbershop to get his haircut, except for Louis Frum. Louis Frum never cut his hair and lived out in the woods far away from civilized folks. Louis Frum wasn't ever seen in town during the daylight hours anyway. Most people only knew his name and little else. His name was used to frighten small children to keep them from straying too far from home.

The darkness was like a thick low floating cloud of black fluffy lamb's wool and the two men found it hard to walk very fast. The blackness of the night held their legs back by the thickness of its shadow. The moon was hiding as if afraid to show its face on such a night and the stars had turned off all their lights to go into hibernation until this strange blackness passed. The tree was a solitary roost standing alone in a treeless pasture. Mr. Hillmon had chicken houses for his birds but so many got eaten by opossums and raccoons and every other critter that felt like eating chicken meat that they decided a long time ago to roost in the safety of the only tree around. Calvin started to climb awkwardly up the tree while Theodore got the feed sacks ready to stuff the chickens in. Calvin was halfway to the chickens in the tree when both men heard something behind them.

They both looked back in the almost pitch-blackness and could barely make out a human shape standing a few feet away from the tree. At first they thought it was Mr. Hillmon but they realized that he was shorter and fatter. Mr. Hillmon would probably carried his big shotgun with him and already

shot them by now. Theodore had once seen a coyote grab one of Mr. Hillmon's chickens and take off running through the pasture but he didn't get very far. He heard the loud crack of Mr. Hillmon's shotgun and saw that scrambling coyote go tumbling to the ground. The chicken flew out of the rolling dead coyote's mouth and started squawking. The chicken's head came off its body and was still squawking while the body flopped away from the noisy head. It looked like the chicken was trying to fly but without a head it couldn't see where to fly. The coyote was lying very still and Theodore knew Mr. Hillmon was a good shot, killing a running coyote with one bullet at such a great distance.

The figure stood watching them. Calvin started climbing slowly down out of the tree. Theodore picked up the feed sacks and held them tightly in his rough hands. The figure was a motionless black shadow. Calvin was terrified and couldn't hold his terror inside anymore. He started screaming, "Don't kill me! Please, whatever you are don't kill me!"

Theodore slapped Calvin in the back of his head and said, "Shut up, you moron!"

The figure crouched a bit and then put its hands against the sides of its head. Theodore knew Calvin's screams were bugging the dark shadow that watched them. The shadow moved slowly closer when Calvin stopped screaming. Theodore whispered, "It's Louis Frum."

Louis walked towards them and pointed up in the tree at the rustling chickens, as he grunted, "Catch me a chicken."

Theodore pushed Calvin back up the tree, grabbing him by the belt. Calvin scrambled quickly up the tree and crawled out on a branch. The chickens clucked softly and fidgeted on the branch. Finally he reached out and grabbed a big hen by the legs. The chicken flapped her short wings in a violent

flurry, a few feathers breaking off and floating down to the ground. Calvin scrambled down the rough bark and handed the furiously flapping chicken to Louis Frum.

Louis reached out and took the chicken without a word. The two men watched him leave the pasture. They saw him walking slowly through the darkness, one hand gripping the legs of the suspended hen. The dark night enveloped Louis Frum and he disappeared from their sight. The two men looked around and then at each other, not sure if Louis Frum had really been there. They watched the darkness, expecting him to return. They waited for a few minutes, staring hard into the thick black air of the night. Louis Frum was gone. He had taken a chicken with him back into the mystery of the woods surrounding Da Costa.

Theodore sent Calvin back up into the tree. He came down once again with a large hen flapping in his hand. He stuffed the struggling hen into the feed sack that Theodore held open. Usually they would have taken more than one hen but the unusually dark night and the appearance of Louis Frum had shaken them. They both were nervous and disturbed. Theodore decided one hen was enough. They both thought it was better to leave, than to wait around, just in case Louis Frum decided to return. Theodore said to Calvin, as they made their way out of the pasture and onto the red clay road that ran alongside the woods, "I feel like we got off easy tonight. I heard tell once that Louis Frum twisted a man's arm off and took it home to eat it. The man's name was Rich Foughman and he was found dead in the woods. The police found his body under some leaves and twigs and one arm was missing. They never did find out who killed him. Of course they always suspected Louis Frum. They said the man's arm bone was found without any meat on it a week later. They never did prove anything against Louis Frum but everyone in town knew that Louis hated Rich."

Theodore coughed and continued, "I heard from Sam that Rich had once spilled a drink on Louis on purpose when they were in the café. Louis didn't do anything to Rich at the time. Rich was with a bunch of his buddies and Louis just got up, with the spilled drink dripping all over him, and walked out of the door. Rich followed him outside but when he got out there Louis was gone. So years later when ever they found Rich in the woods with leaves in his mouth and one arm missing we all knew he probably did it."

Calvin laughed nervously, "Yeah I heard the same story. I always thought it was a lie. Sam Pellert lies more than anybody in Da Costa. I think it was some hydrophobic panther attacked Rich and tore his arm off. Louis Frum ain't so stupid. He eats chickens just like we do. He don't eat no human arms. Heck, if he liked human meat he woulda' just killed us and ate us instead of a chicken."

Theodore slapped Calvin on the back, "Yeah you're probably right. I don't know why I didn't think about that. I was just there, and my knees were shaking when he walked up. I thought he was gonna' kill us right there. All I could think about was him pulling out some big machete' and chopping off our arms and legs. We woulda' been screaming and he woulda' been cutting off our arms. I kept thinking he was gonna' make meals out of our arms and legs."

Calvin stopped walking in the road and looked at Theodore, saying with dread in his voice, "You really thought that Louis Frum was gonna' chop us up?"

Theodore stopped walking too and switched the feed sack with the chicken in it to his other shoulder. He looked at Calvin and then at the impenetrable blackness of the woods on the side of the clay road. "He lives in there somewhere."

Calvin followed his gaze and stared hard into the darkness

of the mysterious woods that he had always been afraid to enter at night. Calvin gulped and said, "We should get going. I'm hungry and this chicken ain't getting cleaned and cooked sitting in the feed sack!"

Calvin started walking faster and kept talking, "Besides, the hydrophobic panther is probably still prowling these woods along through here. I wouldn't wanna' run into a hydrophobic panther on this dark of a night, 'specially without a shotgun."

Theodore walked fast and caught up to the quickly moving Calvin. The two men walked without talking for at least a mile when they both heard a crashing in the woods. They stopped walking and were very quiet, trying to breathe without a sound. They slightly crouched on the road next to the thick woods. They could hear something moving noisily through the close growing trees and brush. Calvin grabbed Theodore's arm and whispered, "It's comin' this way. It could be Louis Frum comin' back to finish the job on us. Maybe one chicken didn't fill him up!"

Theodore whispered back, "Be quiet! I thought you believed it was a hydrophobic panther stalking us and now it's Louis Frum. Whatever it is…it is big!"

Just as suddenly as the thing noisily moved through the woods, it stopped. The only sound was a northern wind that whistled high in the tree branches. The wind sounded like a quiet church hymn, full of portent and redemption. Calvin whispered, "I think we should run."

Theodore put his arm across Calvin's flat chest, saying between gritted teeth, "Do not move! Whatever it is it probably has already seen us and I never heard of no man outrunning a panther. It is probably a 'possum looking at us right now, deciding which way he should run."

Almost as soon as Theodore stopped speaking something

shot through the darkness and slapped right into Calvin's face. He screamed like the chainsaw killer was cutting his head off. Whatever was in the woods crashed loudly through the brush. Theodore watched Calvin fall backwards, arms flailing at his face. Theodore grabbed at Calvin and saw that the black shape on Calvin's face was a small bat. The leathery wings flapped furiously and both men tried to get their hands on it. Finally Calvin stopped screaming and the bat awkwardly but quickly flew off into the dark sky.

Calvin got up and Theodore helped him just as the brush parted and a big boar hog stepped out onto the road about twenty yards away. The men heard other hogs crashing in the brush behind the boar. Calvin put his fingers on his cheek and felt droplets of blood. The wayward bat had accidentally scratched him. The huge boar hog raised its snout in the night air and sucked in the scent of the two men. They could hear its deep grunts. The boar hog sounded like a slow chugging steam engine. Calvin shouted, "Shoo! Go on! Get out of here pig!"

Theodore grabbed Calvin by the arm and held tightly, saying, "Be quiet! That boar hog ain't your Uncle Henry's house pig! You act the fool like this all the time, Calvin! First you think Louis Frum wants to eat us and now you think you can shoo away a dang wild boar hog!"

Other hogs began to emerge from the woods and the big boar hog started towards them, shaking his snout and exposing his two large yellow tusks. Calvin took a step backwards and tripped. As he was falling to the ground he instinctively grabbed Theodore's arm. Both men tumbled clumsily to the ground.

Theodore half-landed on top of Calvin just as the boar hog charged. The other hogs followed close behind the big boar. The two men were helpless on the road as the stubby legs of

the boar pounded into the red clay road. Stream rose from the bristling hair on its back and they could see dark holes where its deep-set eyes were hidden in shadow. A few more seconds and the big boar would slam into the fallen men. In those few seconds they both conjured images of the long yellow tusks stabbing deep into their bellies and their guts being twisted out of their bodies by the enraged boar hog. Calvin began screaming and Theodore tried to get up. Theodore let go of the feed sack with the chicken in it as he fell. Suddenly the feed sack bounced open and the terrified chicken flapped out between the charging boar hog and the fallen men.

The frightened chicken squawked loudly, flapping right into the face of the running boar hog. The big hog tried to stop, startled by the interference of the chicken. He tried to stop running forward and at the same time he started backpedaling. The two motions attempted by the huge boar did not work properly and he crashed onto the road. The boar hog rolled sideways, his short legs still running in the air as he flipped over and over like an out of control four-wheeler.

The half-flying chicken bounced off the face of the boar hog and landed at Theodore's feet, stunned and groggy. Theodore reached down and grabbed the chicken by one wing and thrust it quickly back into the feed sack. Calvin had already started running and Theodore was not far behind him. They could hear the squeals of the hogs behind them as they ran. Theodore looked back over his shoulder and saw that the hogs were not chasing them so he slowed down. They finally stopped when they were a couple of hundred yards away from the hogs. They both bent over and sucked big gulps of air into their lungs, catching their breath. An occasional hog squeal would reach them from the distance and the chicken softly clucked periodically. Both men tried to breathe normally and leaned on one another to support their tired legs.

An hour later they were on the familiar road to their place. They saw Sam Pellert's house far off the road and noticed that a light was on in his tool shed. Theodore told Calvin, "I guess Sam's up late working on a new hair cutting invention. The last time he invented something, it was already invented and he didn't even know it. Remember how he hooked that vacuum cleaner hose up to the electric clippers? It was supposed to suck the cut hair into a bag so he wouldn't have to sweep and clean up all the hair on the floor. Shoot, even I knew they already had them things for years. Old man McDillin had one for his show sheep. He used that thing to cut the wool of his prize lambs come county fair time."

Calvin laughed, "Yeah, Old man McDillin came in for a haircut and busted out laughing. He said, Sam, you gonna' cut my hair with a sheep sheering contraption?"

"Let's go see what Sam is up to." Theodore muttered as he swung the feed sack with the chicken in it over a low hanging tree branch near the road. He tied the sack tightly to the tree and said, "Dinner will be safe here until we get back from Sam's."

They walked down the long dirt road leading to Sam's place and walked across his clamshell driveway to the tool shed. Both men could smell a peculiar smell coming from the tool shed. The shed was fairly large and had two wooden swinging doors taller than a man on either side. They approached and could see two bare light bulbs up on the ceiling between the wooden rafters. They didn't see Sam at first but as they neared they saw him sitting in a rocking chair near the back of the tool shed. He was smoking a cherry wood pipe and the smell was stronger as they approached. Theodore waved and said, "Howdy Sam. What in heck are you doin' up so late out here? We saw the light on and thought maybe you was working on another invention."

Calvin chuckled, "Yeah Sam we just thought we would come check out your new invention and maybe give you a hand working on it."

Sam was startled by Theodore and Calvin walking up and jumped a little in his chair. He had been deep in thought, relaxing in his rocker, smoking his favorite pipe. He had been thinking about Sherrie Lissy Garrison. He always thought about her when he sat for a long spell by himself. He hadn't seen her in forty years but her memory was still as fresh as if it were yesterday. It seems only a few hours ago that he and Sherrie were swimming naked in the pond over in the woods. Sherrie had been his first love. Sam knew there could only be one first real love. Sherrie left Da Costa and went of to college in Nebraska. Sam never saw her again. He got letters for a few years but her parents had moved off and she had no real reason to come back to Texas. The last letter he got from her was after she graduated college. Sherrie had taken a job in the tourism industry of Japan. She left the United States and moved to Japan and that was last word ever on Sherrie Lissy Garrison.

Sam's life was here in Da Costa and he later married and raised two boys but he never forgot Sherrie. He couldn't even go to that small pond out in the woods without a tear slowly making its way down his tired face. He had been remembering Sherrie horseback riding by his parent's house and that day he sat behind her on the big sorrel mare. He remembered the way her hair smelled in the wind. He remembered her soft kisses when they would recline in the fields of spring clover. He had a smile on his face when Theodore had disrupted his memories of Sherrie Lissy Garrison.

"He got out of his rocker slowly and shouted at the two approaching men, "Theodore and Calvin Diggs! What the heck fire are you two doing wandering around late at night for?

From the look of your clothes it seems you been on the ground wrestling wild animals!"

Theodore shouted back, "Well, you would be half right about that. We did have a run in with some wild hogs back on the road and nearly got a tusk rammed up our belly!"

Sam laughed, "Wild hogs? Maybe we need to go on a hog hunt soon. I been hankerin' for a taste of some good pork chops. Well boys, I'm sorry to disappoint you but I ain't working on any new inventions. My last invention was a flop, that automatic flower scooper. I really thought it would catch on with the women gardeners around here. I tried to sell it in the hardware store but only two sold and then Mrs. Harmon brought it back out here and wanted her money back. She claimed it didn't work worth a dang. I gave her money back and trashed the whole idea."

Sam walked up to Calvin and Theodore and put his hands on their shoulders, saying, "No, boys, I ain't out here working on any new silly inventions. I sometimes can't sleep a wink so I come out here and smoke my pipe and think about life."

Calvin looked at Theodore and sort of raised his eyebrows, saying, "Life? You think about life? Like what about it?"

Sam took his pipe out of his mouth and pursed his lips, "Well, Calvin, I like to reminisce about my life, you know... I think about all the things I have done and decisions I have made up to this point. I think about mistakes and choices. I think about maybe what I could have done better in my life."

Calvin said, "Oh, uh...I think about stuff like that too. Like sometimes I think I should of liked school more or I should of read more books. Me and Theodore always talk about building a big boat with sails. We talk about leaving Texas and sailing past the Equator. Life could be different if we lived on a big sailboat, catching fish from the sea instead of eating mostly

chicken everyday. I just thought, Sam, that you always wanted to be a barber."

Sam laughed haltingly and replied, still chuckling, "Well, boys, barbering always came easy. I think maybe I thought I was always needed. Every town needs a good barber and I stepped in and filled the bill. When I was a little kid I didn't think about cutting hair. I used to sit up in the big tree over at the park and dream about building bridges. I liked going to the library and looking at pictures of all the great bridges of the world. I loved the Golden Gate Bridge, and the Sydney Harbor Bridge. The famous Brooklyn Bridge is beautiful and London's Tower Bridge is a masterpiece of architecture. One of my personal favorites is the Royal Gorge Bridge. I wanted to design and build bridges when I was young but instead I ended up cutting hair. How many famous architects come from Podunk nowhere Texas? I used to sit out here and sketch with a pencil. I would draw all kinds of bridges across rivers and canyons and even suspension bridges across canals. I guess sometimes I think about the choices I made. I regret certain choices but I made a good life and now here I sit in my tool shed smoking my favorite pipe, dreaming about my youth and bridges in the sky."

Theodore listened intently to Sam and seemed to be soaking his speech up like a saturated sponge in a horse trough. He exclaimed, "Wow...Sam, you coulda' been a bridge builder. Listening to you talk about dreams makes me wanna' do something different than eat chicken and work at the oil and lube station. I like changing oil but now I'm really thinking about sailing in a big boat out in that sea, catching all the fish me and Calvin could eat."

Sam turned and said, "Well, boys, it ain't too late for ya'll. The sea is out there waiting and it ain't goin' nowhere.

I'm going back in to get some sleep. Goodnight to ya'll and thanks for the conversation. It's been a strange night. It is too dark for me. This has been the darkest night in Da Costa that I can remember. The last time it was this dark terrible things happened out in the woods...terrible things."

Sam waved goodbye as the two men turned and headed back out of Sam's place. Theodore said to Calvin as they walked, "From now on we are saving our money and someday we'll buy that big sailboat."

Calvin seconded that motion and said, "You betcha' and do you think he meant terrible things happened on dark nights like Rich getting killed by hydrophobic panthers or eaten up by Louis Frum?"

I think for sure the sooner we get out of Da Costa the better we will be. I was scared tonight by Louis Frum just showing up out of the darkness and by the wild boar hogs coming after us. I was thinking that if we was out in the ocean we would probably be safer."

The walked back to the tree where Theodore had tied the feed sack with the chicken in it. The feed sack was hanging where they left it and Theodore untied it and picked it up, saying, "Hey, the chicken is gone. The sack is too light but something is still in it."

Theodore opened the sack and dumped it out on the road. A few chicken feathers tumbled out along with a stark white section of bones. The arm bones were still attached to the hand bones. A human skeletal arm fell to the ground and it looked as if the bony finger on the white hand pointed south to the sea. It was the darkest night in Da Costa but the white arm bones shone like a bright guiding light on the road.

Calvin asked Theodore, "How far away is the ocean?"

Bite of the Mailman

The dark bar is like a cavern. It is a cavern for homeless vampires except the few drunks present in the bar aren't vampires. It is one o'clock in the afternoon, yet in here it seems like one a.m. It is the insinuation of night in the windowless, barely lit bar room. I am sitting on a bar stool with three legs and one of the legs is shorter than the other two. Each time I shift, the stool gives me a little rock to the left. As far as I can tell there are only seven people in here today. The jukebox just finished playing a Roger Miller classic where he sings about not having any cigarettes and then on the next tune Dwight Yokem starts in on a "Thousand Miles from Nowhere," which is about where I feel I am. This is my first time here and probably my last. I stopped in here on my way to Phoenix, Arizona. I have along way to go. I was thirsty and bored out on the desert highway, Interstate 10 in west Texas. I left San Antonio awhile back and I am still not even halfway to El Paso. I saw this place, SawBuck's Watering Hole, a hole in the wall beer joint with a rusty tin roof leaning against the highway like a metal tumbleweed about to blow over. The town's name is Ozona. I heard a famous women's basketball player came from Ozona, Texas, but I'm not sure about that information. I heard it from a woman that also told me she could teach Siamese fighting fish to jump for their food.

I felt relaxed, sipping my draft beer out of a cold, smudged mug but yet something inside of me remained restless and

anxious. I scanned the bar again, cataloguing the seven people, eight counting me and I don't usually count the bartender who would make nine. I am younger than most of the men here but at thirty-nine I am not a spring bird anymore. There are only two women, one at the other end of the bar and the other playing pool with two men. The two men were wearing dirt and testosterone. The woman at the bar seems barely thirty but I'm sure the light is helping her age. She has short dark hair and arching eyebrows. I imagine her as some overgrown elf girl sipping a margarita. She is attractive in a severe way. She has on jeans and sandals, a tight dark shirt, purple maybe blue, and she isn't large or very small either. The woman's eyes seemed only half open as she occasionally glances towards me. The bartender keeps one eye on her and one eye on me, I guess waiting to see which of us orders a drink next. The bartender looks about seventy and his wrinkles make him look like some sort of reptilian species of ancient human. I can almost count the few hairs on his head and if I had to guess I would say no more than twenty.

The two men playing pool with the other woman keep their eyes on her rear each time she bends to shoot. They both laugh overly loud and clap each time the balls crack as she tries to sink them into the corner pockets. She isn't very good but to hear the two men you would think she could beat Fats Domino at the Royal Billiards Competition. She is slightly overweight but in a big bone sort of way. She carries her extra pounds in sensual places. She has shoulder length dyed blonde hair with a dark stripe of brown roots down the middle part. Her large white breasts seem to barely stay put in her tight halter-top and her jeans fit too snuggly on her ample thighs and butt. One of her pool-playing partners seems about fifty, short and overweight. He carried a belly the size of a pregnancy and he

seemed wore out on living. He reminded me of an albino pot-bellied pig that knew he would soon be taken to the butcher for processing. His sleepy eyes and an unshaven face contributed to the burnt-out look of dirty coveralls and greasy black hair. The other man was the tallest person in SawBuck's and maybe the youngest but it was hard to tell, maybe mid-forties. He wore an old John Deer cap and he had pointed black cowboy boots sticking out of his wrinkled, badly faded, jeans. His shirt looked like one of my Grampa's undershirts and it exposed his large muscular arms. He had one big tattoo of a snake wrapped around a woman's huge breast, inked in green. I never looked too long in their direction. The big man scared the hell out of me. I thought it best to stay out of their notice.

I was about halfway through my beer when I noticed the three old men playing cards at the back table underneath a hanging light. They were all old timers, at least upper sixties, and all wore dark rimmed glasses. I didn't know what kind of card game they were playing but it wasn't for money, at least you couldn't tell by the way they argued. I was watching the card game when a long crack of white light pierced the bar. The door opened and the west Texas afternoon sunshine illuminated the room for a few seconds. A big man entered and made his way to the bar, three stools down from me, four away from the woman with the margarita. He was carrying a bundle of some kind in one arm. The man had a short blonde haircut, like a marine, and he had a square jaw with large white teeth. He reminded me of Race Bannon, Doctor Quest's running buddy on the cartoon, Jonny Quest. He scraped the floor, pulling up the stool. The bundle in his arm moved. My eyes had re-adjusted to the dim light in the bar once again and I realized with a little surprise that the bundle was alive. It wasn't a bundle at all.

The big blonde man was carrying a skunk. The bartender approached the man and said, "We don't allow animals in here, sorry."

The man showed his big white teeth and said in a small voice, "I didn't ask if you cared or not. I only want a shot of Tequila and a bottle beer. I'm not staying. I will leave as soon as I get my drinks down, and I don't sip. Don't mind Lucifer here, he's harmless. He had his musk glands removed and he ain't mean."

The bartender hesitated. The man was big and he looked dangerous. The bartender was thinking if he should push the animal issue or not. I saw him think fast and then turn to get the man's drinks. The elf woman at the end of the bar got up and took the last drink of her margarita. She walked slowly towards the big man with the skunk in his arm. The small black and white animal moved around, squirming in the man's hold but seemed content to not try too hard to get away. The little animal sniffed at the man's cowboy shirt and began to nibble on one of the pockets.

The woman reached out to pet Lucifer and the man grabbed her hand. "He might bite you, Miss," said the big man, "he isn't friendly with strangers."

She looked hurt that she couldn't pet the little skunk but she let the man release her hand and smiled shyly, saying, "Hi. My name is Betty, but everyone just calls me Bett. What's your name?"

The bartender returned with a longneck bottle of beer and a cold mug. He put these down next to a small shot glass filled with clear, Tequila Gold. The big man's eyes never left Bett's face as he picked up the shot of Tequila and downed it. He then reached for the beer bottle and ignored the cold mug. He guzzled the cold beer out of the bottle in just a few

seconds. He sat the empty bottle next to the empty shot glass and spoke loud enough for everyone in the bar to hear, "My name is Nick"

I saw the woman at the pool table sink the eight ball and the two men whooped, "Dang it! She won again!"

The big blonde woman smiled and I noticed she had a long gap between her front two teeth. I thought it made her likeable face more interesting. She put the pool stick on the table between the blue three-ball and the yellow one-ball. The two men held their sticks and looked in our direction as the blonde woman approached the big man with the skunk. Bett was still staring at the man and about to ask something when the other woman stepped up and said, "Howdy! I'm Melody. Welcome to happy hour at SawBuck's!"

She giggled like a teenager but only because she was half drunk already. Her eyes were a pale blue like a pool in a lost oasis on a remote planet of sand. She seemed to spill out of her clothes as she approached because her sensuous presence was so obvious and seductive in her buzzing state of inebriation. The big blonde man seemed to take no notice of the two women fawning over him. Melody laughed for no apparent reason and said, "Hi Nick! I see you've met Bett already and what did you say your critter's name was?"

The skunk's name is Lucifer," he said, bluntly. Melody's pool playing companions were approaching slowly. The bigger of the two tapped Melody on the shoulder and asked her, "You ready for another drink and another game?"

She shrugged his hand off and said, annoyed, "No I'm through playing pool. I want to watch the little skunk. Nick, buy me a drink?"

Bett had moved back a few steps and watched the slurring girl acting like a fool. Bett smiled and she looked at me when

she did it. I knew she wasn't half as drunk as I earlier thought she might have been. Nick got up from his stool and spoke to Melody but meant the words for the entire bar, "I'm leaving. Hell is a long way and I'm burning daylight."

Melody grabbed his arm and said, "Have another beer. Stay and keep me company."

The tall pool-playing partner of Melody grabbed Melody's arm and spun her around. She spun slowly but she was very drunk and slipped. She fell to the floor at the feet of Nick. She wasn't hurt but she cried anyway, sobbing, "Uh huh. You bastard! Oh I'm sick of you! Damn you. Uh, uh, oh..."

Nick looked down at Melody on the floor and his face had that same expression of disdain and superiority. He stepped over her, headed for the door. The tall man stepped in front of Nick. I stayed on the lopsided barstool and watched as the two men stared into each other's eyes. Nick seemed relaxed and at ease as he stared at the other man. The tall man with the tattooed arm was tense and angry. His nostrils flared and his temples pulsed as he flexed his arms and thick muscular chest. The snake tattoo seemed to pulse and coil tighter around the breast tattoo. I thought he would swing at Nick at any moment. The card game even stopped as the three old men watched the two men square off. You could hear the two men breathing above the jukebox's music with Mark Chesnutt singing "Bubba Shot the Jukebox."

The tension rose and suddenly the bar's front door opened to let in the returning bright crack of light, momentarily blinding everyone. Silhouetted in the doorway was a short man with a strange hat on. He was carrying a large package. I recognized his uniform and realized he was the U.S. Mailman. He was wearing one of those safari-type helmets. He walked in very slowly; carrying the big package with both hands,

and went straight up to the bartender. "Here's your priority package Lee," he put the package on the bar and started fishing in his shirt pocket for a slip of paper as he continued talking to the bartender, "How are you anyway? Sure could use a beer. It is hotter than heck out there. I'm coming straight back in here as soon as I clock off work. I got about two hours to go so I guess I'll take a quick gulp of ice-water."

Everyone was looking at the mailman and temporarily forgot about the two men who had stepped back from one another. The bartender, Lee, looked at the package and exclaimed, "Well, it finally gets here, only took two weeks. Dang snail mail, must be those dang computers you spent all our government tax dollars on, Gerald."

Gerald found the slip of paper and told Lee, "Yeah, yeah, sign here please. Don't try just putting an X on there either. The last time you pulled that joke my Postmaster had a cow. He threatened me with a suspension!"

Lee signed and glanced at the two men, still standing but farther apart, facing each other. The mailman tucked the slip of paper back into his shirt pocket and turned to leave when suddenly Lucifer, Nick's skunk, leapt out of his arm and landed on Gerald's helmet. The skunk and the helmet crashed to the ground. Lucifer immediately began biting and scratching the mailman's helmet. Gerald jumped back, pulling his dog spray can from his belt. The mailman aimed his dog spray at the skunk. He sprayed the little animal that was biting his safari helmet. Lucifer stopped biting the helmet when the dog spray hit him and he rubbed his nose with his front paws. The skunk started blinking his eyes and making little grunting sounds. The mailman kicked the skunk and grabbed his helmet, saying, "Dang animal, my helmet is ruined!"

The skunk yelped when he kicked it and it flew across the

room about five feet, landing at the foot of my stool, where it continued to rub it's snout, coughing and grunting. I looked at the poor little animal in distress but I saw Nick moving fast across the room. Nick grabbed the mailman by his neck and lifted him up, carrying him over to the wall. Gerald sprayed the dog spray into Nick's face as he was attacked. The entire cast of characters in the bar stood still watching Nick carry Gerald to the wall. The mailman was yelling, "Hey, stop, let go of me!"

The dog spray didn't seem to have any effect on Nick as he shoved Gerald hard into the wall with a loud crash. The mailman emptied the entire can of dog spray into Nick's face and he merely kept his jaw tight and his big teeth smiling that mean smile. I could see the vein on Nick's temple pulsing as he squeezed tighter on the mailman's neck. The tall man with the tattoo shouted at them, "Hey, asshole! Let the mailman down! Your animal attacked him!"

The tall man grabbed a couple of billiard sticks, one in each hand and went to the mailman's rescue. Nick never even glanced back as he choked the mailman. Gerald dropped the empty can of dog spray and I watched it roll across the wooden floor, like someone's dropped Christmas tree ornament. Gerald's face was red and he tried to breathe but Nick held him two feet off the floor with one big hand squeezing like a vise on his jugular. Lee was shouting from behind the bar, "Stop it now! I'm calling the law! Stop it!"

The tall tattooed man was behind Nick and raised both sticks up like swords. He brought them both down simultaneously like chopping swords on Nick's shoulders. Nick didn't even flinch as the billiard sticks splintered and broke into pieces. Slowly Nick turned his head back to see who had hit him. His eyes were scary and determined. He held the

mailman with one hand and with the other he grabbed the tall man by the neck. The tall man swung the sticks in arcs trying to hit Nick but their blows seemed trivial to him. Nick then swung the tall man to the wall beside the mailman. He held both men above the ground with his tremendous strength, one hand on each man's neck. The tall man dropped the broken sticks as he started gasping for air.

Suddenly Melody picked up the skunk and said, "Let them go!"

Nick turned and saw her holding his skunk and released the two men. They slid down the wall and slumped on the floor. Nick turned and smiled at her, he whispered, "Give Lucifer back to me. Walk over here and give me the skunk. You shouldn't have touched him."

Melody held Lucifer tightly and stood there as Nick pointed at her, "You shouldn't have touched him."

The tall tattooed man recovered and grabbed Nick's ankle from behind. He pulled hard and climbed up, tackling Nick. The two men hit the wooden floor hard, rolling and grappling. The mailman got up and jumped on Nick just as he got on top of the tall man. Nick straddled the tall man's chest and was about to smash his face with his upraised fist when the mailmen jumped onto Nick's back, wrapping his arms around his neck. The mailman started biting Nick in the neck. He clamped his teeth down and wouldn't let go. Nick stood up but the tall man beneath him started punching him in the stomach. The mailman bit harder and blood started running down Nick's neck and onto his jacket.

Lee was still on the phone with the local law enforcement and I figured they would arrive any second in a town as small as Ozona. Melody began screaming as Lucifer climbed out of her arms and started biting her neck and face. The little skunk

55

viciously attacked her and she tried to throw the animal from her face. Finally the skunk jumped down and trotted towards the door. Nick swung his big arm back and his huge fist plowed down into the tall tattooed man's face. The impact sounded like a sledgehammer hitting a hanging side of cold beef. The tall man dropped instantly. I don't know if he was unconscious or dead. His body was limp on the floor. Nick was bleeding profusely from the mailman biting his neck and he reached back with both hands and pulled the mailman from his back. Gerald lost his bite and Nick lifted him over his head like a hollow mannequin. Nick heaved Gerald into the air towards the door. The mailman's body looked wrong as it hit the door. Gerald's head bent back at an odd angle as it crashed into the doorframe and his torso busted the door open, shattering the darkness with the bright afternoon sunlight.

Lee was off the phone and using napkins to clean up Melody's scratches and Bett stood close to me with wide eyes watching what Nick would do next. The three men still held their cards but their eyes were glued to Nick. The only sound was Melody's sobbing as Lee whispered to her, "You're okay. It's only scratches."

The mailman was lying half-in, half-out of the doorway. His sprawled body looked broken and he didn't move. The skunk was sniffing his boots. Nick picked up Lucifer just as two Ozona police cars pulled up with their lights swirling. I took another gulp of my beer and felt my stool slightly rock as I shifted. Bett moved behind my shoulder and the card players were standing, watching the policemen get out of their cars through the open doorway of the bar.

Nick carried Lucifer and turned away from the door, walking towards Lee and Melody. He was still grinning when he said, "I told you not to touch him."

I could see the wound on Nick's neck oozing blood as he walked beside Bett and I. He looked at me for a moment and said, "Time to get back on the road."

With his left hand he held the skunk and with his right hand he touched Melody's face, as Lee backed away. Melody whimpered as Nick said softly to her, "You'll have to do."

With his big hand on the side of her face he caressed her cheek and moved his hand up into her hair where he grabbed a handful. He jerked her head forward and pulled her behind him as he headed for the back door. Melody started screaming as he jerked her head and led her by the hair like an unruly animal. Lucifer made little chirping sounds. We all watched Nick and the skunk and Melody exit out the back door into the shadowed alley behind the bar.

The back door slammed shut as they went out. I was still staring at the back door when the policemen came in the front. I could hear an ambulance's siren somewhere in the distance. Bett was standing closer to me than before and her hand was on my shoulder. Lee was talking to the policemen, as were the three card players. I saw a policeman run out the back door.

The policemen never found Nick or Melody. The tall man was dead and the mailman died on the way to the hospital. I picked up the mailman's chewed up safari helmet and I still wear it when it rains. I stay away from skunks and I have never touched one.

Crow Canyon

Joan walked slowly atop the big boulders of the canyon. She had climbed up here many times in her youth. She walked with purpose and determination. Tonight was different. Joan searched for the thing that came to her from her mysterious reoccurring dream. She had lost a husband to a scuba diving accident in the Great Barrier Reef. Joan lost the great love of her life ten years ago and she mourned that loss each day. She traveled the world in search of the adventure and discovery that she and Dean had pursued. Dean was a scientific researcher and she accompanied him all over the globe, from the tropical jungles of Costa Rico to the frozen tundra of Alaska. They dived with giant Manta Rays in the Pacific Ocean and studied Kodiak bears fighting over salmon in the ice-cold rivers of Alaska. Joan and Dean traveled to Borneo to study Orangutans and traversed active volcanoes in the Hawaiian Islands.

They met in college, two teenagers with dreams in their eyes and itchy feet ready to run the distances of the world. UCLA brought them together, Joan from Seattle, Washington and Dean from across the nation, Sarasota, Florida. Dean grew up photographing the birds of the Florida waterways and tracking down the fabled Florida panther. Joan did drawing and paintings of the Pacific Ocean wildlife, Orcas, seals, otters, gulls, and the titanic crashing of the deep blue waves against the cliff-like shorelines. Joan and Dean's pairing was like the

meeting together of the deep Pacific Ocean with the clear hot shallows of the Florida west coast. They complemented each other as much as they differed. Love was instantaneous and perfect. On their first date Dean had arrived with a single white rose and kissed her hand. Their courtship had always been romantic and special. Dean had given her a beautiful charm made of diamonds and emeralds fashioned into a tiny globe of the world. He told her the small globe would symbolize their love for eternity and reflect their travels throughout their life. She never removed the charm from her neck after that day.

Joan stopped all work in the field after she lost Dean in Australia. He had become trapped underwater while scuba diving and ruptured his hose on the sharp coral. No one could get him to the surface until it was too late. Joan returned to the home of her parents and lived there a year until the grief settled down inside her bones and lie hiding there these past ten years. The grief was like a black plasma creature that lived inside of her bones, replacing the marrow. It lived down inside her, always waiting to surface unexpectedly and slither out of hiding to fill her soul with pain. Dean and Joan had built a summerhouse in the canyons of west Texas and she stayed away from there for a few years after Dean's death. Finally after a few solitary years at home she moved to live in west Texas permanently. She sold their California house last year and she had plenty of money to retire. She liked the isolation of living in the canyons, high above the world. The nearest house to her was at least ten miles away on the state highway.

With a black shadow of grief curled up in her stomach she would walk at night in the canyons. The moon seemed closer to the earth out in west Texas, as if it wanted to get closer to hug its mother earth like a little wayward child wanting affection. The canyons of west Texas loved Joan as if she had

been born there, as if she were a hatched daughter of the boulders of the region. Sometimes she walked only a step away from diamond-backed rattlesnakes and they didn't strike or even rattle at her close passage. The coyotes sang at the bright moon until they scented Joan walking among the big rocks and then they would scurry to the highest vantage points to watch her gracefully walk in the moonlight as if they were lost puppies admiring her from the back yard.

During the day in the hot west Texas sun roadrunners would walk slowly up to Joan sitting on her large covered front porch, sipping herbal tea, and eat right from her hands like tame chickens. Every morning Joan would open her eyes and look out of the big window of her bedroom. She could see the lonely, slender tree thrusting itself up through the sand defying the sun and the harsh land to deny it life. Each morning she would roll over and prop her head up, her long blonde curls tangling in her fingers, and with eyes made the whitest blue by the searing brightness of the sun she would see a solitary giant black raven at the top of the tree. The bird had been there every morning since her return to living in this house permanently. She looked forward each new day to seeing the large jet black bird perching and cawing at the top of the scraggly tree. She named him Dean, after her husband, and she imagined Dean watched over her through this large black raven.

She would wake up and look out the window and say, "Good morning, my love. How are you today, Dean?"

It was a way to let just a tiny bit of grief leak out of her bones like releasing a little bit of air out of a balloon each day until maybe someday the balloon would totally deflate. Maybe someday Joan's grief would leave her and Dean would become the raven and she could go out into the world again with passion and desire.

Tonight, walking across the huge boulders, Joan pursued the edge of her dream. She thought about the images and their hidden portent. She walked in the night air desperately searching for answers to her dream and her life. The dream had come to her each night these last few weeks. Each night the dream was similar but never the same. She sat on a flat rock and stretched her arms over her head. She tossed her hair in the breeze and fireflies flickered around a bush with night blooms below her. The dazzling lights from the lightning beetles reminded her of the strobe effect of the memories of the dream. She pulled her legs up, her knees touching her breasts, and rested her chin on her knees. Joan felt the familiar surge of the black grief emerging from her bones. She shuddered as the slithering black pain emerged and touched her skin. Tears began streaming down her face as she looked out over the canyons. She sobbed, saying his name, "Dean. Dean, I miss you."

A Texas horned lizard peeked out from under a rock as if he could feel her deep pain. Joan looked through her watery eyes across the landscape and imagined that the big cacti were large scarecrows without heads marching like an army towards her. The cacti army of scarecrows had come to take her to Dean. She reached out, sobbing uncontrollably, and tried to embrace the silhouettes of the desert. The coyotes heard her pain and sang a chorus of mournful woes that pierced the canyons and the crisp air like sorrowful opera cast members behind thick curtains. Joan finally put her head down on her knees and cried softly to herself. The coyote's song ended as they curled up against one another and closed their eyes. The horned lizard crawled deeper under the rock as Joan grew quiet. She fell asleep soon. Joan drifted into a half-sleep, where dreams are the most real and vivid. She left her body sleeping on the boulder and revisited the dream world.

She was walking in an underground cavern. The air was cold and moist and her arms and legs shivered. The cavern was filled with bizarre shadowy shapes cast by stalactites and stalagmites. The only light came from walls of phosphorescent stones. She walked slowly in the gloomy cave and touched the walls for stability, her hand feeling the icy coldness of the bare rock. She heard a scraping sound from around a cluster of huge pointed rocks. The sound was steady and consistent. She rounded the corner and discovered a black crow scratching on the floor of the cavern. The crow looked up as she came into its view. Joan stopped at the edge of the pointed rocks and watched the big crow as it resumed scratching with its sharp talons. The crow ignored her and seemed unafraid of her presence. The crow was digging in an area covered with soft dirt and had scratched around an object that was still buried in the dirt. She could see the edge of a small wooden box, which looked like a miniature pirate's treasure chest.

She walked towards the crow and the little buried wooden box. The crow watched her and stopped digging. She took another step and the rocks beneath her feet gave way, crumbling and crashing into a black abyss. Joan fell for along time until she plunged into an underground pool of cold water. She slipped deeper into the cavern's pool and tried to fight her way to the surface only to feel the cold water pulling her down. Usually her dreams ended as she sank and fought for air in the deep pool but this time the water pulled her deeper until she could see huge rocks on the bottom. She saw blindfish darting about her and albino salamanders with bright red flowered gills swimming near the bottom. As she drifted slowly to the bottom she realized that she no longer needed air to breathe. Water flowed in and out of her lungs and she floated downward getting closer to the bottom of the pool. She watched as a giant

white catfish swam from beneath a flat rock only to disappear under a low hanging bank of phosphorescent stone. The catfish had whiskers longer than her arms and she marveled at their beauty in the glowing cold water.

Something moving caught her attention at the bottom of the pool. She saw a severed air hose with bubbles pouring out of it. Joan screamed underwater. She was pulled towards the inevitable. She saw a dented oxygen tank wedged under a large boulder. Thoughts of Dean trapped underwater, Dean drowning before her very eyes, terrible thoughts scattered her emotions as she sank in the depths. She saw the air hose pouring bubbles and dancing in the water like a trapped sea snake. Below the oxygen tank was a huge wooden chest half buried in the pebbles of the bottom. She calmed down as she realized Dean was not here in her dream. Joan stood on the bottom and reached down to open the wooden chest. The lock was broken and it opened easily underwater.

Joan looked down into the big wooden chest and saw only one small object inside. A round black sphere with a crow's head carved on its lid. She picked up the crow carving and opened the sphere. Joan fell backwards as she dropped the crow sphere. The tiny charm made of emeralds and diamonds in the shape of a globe fell out of the sphere as Joan reached about her neck and felt an absence of the chain on her skin. Joan swirled her arms and clutched the empty space where her missing necklace should be. The black crow globe fell down under the boulder and it sank deeper down into a crack in the rock. Joan panicked and tried to swim deeper in pursuit of the sinking charm. She flailed in her sleep and fell sideways on the big boulder. The impact of falling on the hard rocks woke her from her nightmare.

Joan blinked her eyes and then clutched at her neck. The

necklace was still there. The coyotes had stopped their sad song and the cacti were as still as guards outside the Queen's Palace. A crow cawed far off and then a burrowing owl flew overhead with a rustle of feathers. One of the owl's feathers drifted down to land beside her fingers and she reached out to touch it. The feather turned black in her fingers, as black as a raven's. She thought of Dean and the raven of her mornings. Joan picked up the feather and held it close to her heart.

Tears welled up in the corner of her eyes. She fought to stop from sobbing deeply and swallowed her sorrow. The slight breeze pushed the teardrops from her eyes. She looked at the bright moon across the canyons and saw a silhouetted figure, standing upright, flanked by the moonlight. A tall man wearing a long overcoat that flapped in the breeze stood on a pinnacle overlooking her house. She rose to her feet and walked towards the figure. It seemed he was only about a hundred yards away. As Joan grew closer she could see the man more clearly. The figure was turned away from her looking at her house. She bent down and approached more cautiously, worried that he meant to rob her home or worse. She stayed behind large boulders as she worked her way closer to the silhouetted figure in the long coat.

Joan stopped when she was suddenly close enough to see him more closely. She ducked behind a huge rock and breathed heavily, frightened. Terror coursed through her mind as she tried to rationalize what she had seen. Joan thought that maybe she was asleep, lost in her dreams again, but she could feel the rock on her hands and the breeze thrusting invisible fingers through the moving strands of her hair. The tall man in the long coat wasn't a man at all. The silhouetted figure seemed like a man in his overcoat but his head was shaped like a bird. The man's head was a giant black raven's with a long

dark beak and slick feathers on his forehead. The large black bird eyes looked down at her house. She saw the bird headed man open its beak and utter a single loud cawing sound, a sound like something between a cough and a cackle. Joan remained hidden behind the boulder and clutched the black feather in her hand next to her chest. She could feel the frenetic hammering of her heart against her hand.

The raven headed man turned and stared at the boulder behind which Joan was hiding. The tall birdman kept its hands in the coat pockets and walked down the canyon into Joan's yard. Stopping at her gardens the birdman picked a single white rose from near her front door. The bird-headed figure put the rose on Joan's front porch and walked off into the canyons.

Joan never looked over the boulder again. She had stayed where she was until daylight. She had fallen asleep and the first heat of the day had awakened her. Joan slowly got to her feet and peered over the boulder at the place where she had seen the raven-headed figure. The figure was gone and she thought maybe she had dreamt the whole episode. Her grief had once again consumed her in the wild Texas night and she had slept in the canyon instead of her house. Last night's dream had been the most real dream of the summer. Joan stood up slowly, her body sore and tight from sleeping on the rocks most of the night. She made her way down the rocks towards her house. She saw a little horned lizard basking on a flat rock. The lizard flattened its body like a flounder trying to blend in with the flat rock. Joan looked down at the small lizard and stopped in front of it. She knelt down to look closer at the horns all over its scaly head and the lizard realizing that the flattening camouflage wasn't working, darted quickly across the sand and into a crevice in the rocks.

Joan reached the rear of her house illuminated by the early morning sunshine and noticed the tall tree in her backyard. She immediately looked up in the branches and felt uneasy. She did not see the big raven. Her morning crow was not in the tree. Dean was gone.

She walked around her house searching the ground, thinking maybe Dean was perched on the railings of her fence or on the ground pecking at grubs. Joan walked around to the front of the house and the big crow was not to be seen. She put her hand up to shade her eyes and squinted up at the sky, hoping to see her crow flying towards her. Dean was gone.

Joan slowly smiled and realized Dean was gone. Her body felt lighter than it had in many years. She felt the warmth of the sun on her skin. Her feet barely touched the sandy earth as if a thick breeze moved beneath her feet and carried her along above the ground. The grief that waited inside the marrow of her bones seemed weightless, as if it had been borne away in the night. The black grief had merged with the darkness and slipped from her body and taken flight. In the light of this new day, Joan smiled, and spoke his name out loud, "Dean."

She walked briskly with an energized step towards her front door. She stopped a few feet from the door and noticed the tall white rose leaning against her door. Joan bent down on her knees and picked up the rose. She did not cry. She merely smiled and turned once to look out over the canyons. A single crow flew high in the sky.

Misery Morning

This was a morning of Misery. Misery lives out in the Arctic Circle, underground. She is like black ice and has a cold chill that she can send out, project, perfectly distribute, towards unsuspecting people's hearts. She doesn't direct chills at the physical heart. She isn't a calamity of physical dysfunction. Misery directs ice and freezing sleet at the heart of a soul. Misery is a creeping, crawling, malicious child. She is not a good girl. She never played with sweet rolling eyed dolls or plastic ovens.

Once, I was holding hands with Happiness who is a sister to the sun, in a golden meadow. Misery crawled out of the ground from her secret tunnels and pointed at the sky. She squinted and strained a bit and turned a pretty white cloud, black.

She obscured our friend, the sun, and then she poured her cold water down like a torrential storm. She saturated Happiness and I with the chilling cold water from an ancient glacier. The rain was cold and Happiness screamed and fled. I sat down in a puddle of mud and cried.

Waiting at the Train Station

Here comes Lard-ass Richard, now." Jerico said to Manny as they waited outside the train station. The two men were dressed in expensive suits and they waved as the other man walked towards them. Richard also wore an expensive suit but he was on the heavy side of fat and looked sloppy compared to the other tall well-proportioned men. Richard was thirty-seven years old, while Manny just turned thirty-five and Jerico was the baby, at twenty-seven. Their careers were great and they were all very successful, each owning fine homes and cars, plenty of money coming in, gold cards, fine dining, plenty of vacations all over the world. Richard and Manny had been in the business for about fifteen years while Jerico had only been working for Sminn Inc., for five and a half years. The business had taken them all over the globe, it was exciting and lucrative, and they were well-respected professionals.

Jerico shouted, "Hurry up, Richard, the train will be here in any minute!"

Richard huffed and gulped air as he approached the other two men. "I'm here already, you asshole. What time is the train supposed to arrive? 11:30? Do you even know, Dogshit?"

Richard slapped Jerico lightly and laughed. Manny combed his thick black hair straight back and said, looking like an Iranian, even though he was Hispanic, "Look man you were supposed to be here at 11:00, not 11:05, not 11 fuckin' thirty. Shit."

Jerico asked Richard, who had stopped his silly giggles after Manny had scolded him, "Did you bring the sign? We gotta have the sign."

Richard reached into his coat and withdrew a white cardboard flashcard with the name, MR. EVAN WILLIS, written boldly on one side. Jerico, asked, "That's the guy's name, Evan Willis? Are you sure you got the right sign? I thought his name was Earl or Eddie or some other mother fucker, not Evan."

"Shut the fuck up, Jerico," said Manny, who was clearly in charge of the other two men and he continued, "It is the right name, now all we have to do is wait for the damn train and hold the sign up for Evan Willis to be on our merry way and get on with business."

Jerico cracked a smile and said, "Hey Richard, you get laid last night? I bet you did. I bet you still got dried pussy juice on your face. I think I can smell it."

Richard smiled but pointed his stubby finger at the military cut hairstyle of the younger man and said, "Don't start with your marine bullshit mentality, you need to mature to be good at this business. Now cut this clowning out, get serious."

Manny rubbed both of their heads affectionately and whispered, "C'mon guys let's all get along and do this thing right. This Willis guy is very important, so therefore we need to be impressive. Now, Richard, go see why the train is running late. It should have been here at 11:40."

Richard walked to the information window while Jerico cleaned his fingernails with a toothpick. Jerico leaned against a pole while Manny sat on a bench and read the comics in the newspaper. "Manny, you hungry?"

"Nope. My wife, she gets up early every morning and

makes me a big breakfast. This morning I had three eggs, bacon, and hot chocolate. Why? You hungry?"

"Naw, but I was watching that blonde lady over there in the red business suit. I like how her dress splits up the front and exposes some of her thigh. I can see a little bit of her tit peekin' out of the low cut top under the jacket, too. She is making me hungry."

"I see what you mean, Jerico, but my wife done cured me of eating at other women's tables. She feeds me too well."

Manny, Manny, don't you ever get tired of eatin' at the same restaurant? Shit man, I like to go to Baskin and Robbins and taste all thirty-one flavors. I mean, c'mon Manny, when you go to the buffet line do you just get the same thing are a little bit of everythin? There is all different kinds of pussy in the world, you gotta try 'em all."

Manny smiled, exposing the wide gap between his large front two teeth, and replied, "Yeah, I used to think like that. Used to be a horny motherfucker. Damn I did some ugly bitches and some crazy bitches, but even the worst fuck was still good. I know what you're talking about, but Jerico, my wife is the best for me. She is a tiger in bed and that's all I need. I done sampled enough pussy to know she got a lightning trap that clamps me just right."

Richard returned on Manny's last words and said, "The trains are running behind, some kind of scheduling problem. I guess we'll just have to wait a little longer to earn our money."

"Fuck," said Manny, under his breath, "I told my wife I'd be home by at least one o'clock. The kids are gone at school and we were planning to spend the day in bed. Damn. The kids get out of school at 2:45. That don't leave for much of a day in bed with the wife."

Richard started in, "Hey what was you guys talking about while I was gone? I heard somethin' about, sampling pussy."

Jerico laughed, a deep rumble in his muscular chest, "Whoa-Hoha, woppa tusee! Richard tell us some of your sex fables. Tell us about you and the wifey last night humping in the shower."

Richard blushed but smiled and said, "I ain't gonna talk about Debbi but before we were married I sampled plenty of poontang. Let me tell you, I had this little Asian girl I used to date in college. She knew how to do everything. My friends told me that Oriental women had slanted slits but I found out there just the same as all the other women. But, maybe you don't know this, Asian woman have smooth, straight, soft pussy hair. It's soft as the hair on a rabbit."

Jerico's mouth formed an "O" and he exclaimed, "You're shittin' me Rich. Straight pussy hair? I never heard of such a thing."

Manny laughed and pulled out his comb, combing his hair back again, his little ritual to keep his nerves steady. "It's true Jerico, it 's true. I fucked enough Vietnamese girls to know. What time is it you Assholes?"

Richard and Jerico both looked at their watched and they said, together, "12:15."

Manny looked at both of them and started to chuckle, "You guys are so beautiful, man. A couple of dumbass mother fuckers but I love working with you. You're both so fuckin' entertaining. Richard, c'mere. What you got on your tie, coffee?"

Richard looked down and saw the dark stain in the center of his yellow and blue tie, grimacing, "Damn, I must have spilled it trying to hurry over here this morning. I would have been here on time but I had to take the kids to school because my wife had to leave early for work."

Jerico punched Richard in the arm and smiled a mischievous grin, "Sure, Rich, sure. Your wife probably left early to meet her lover. She is getting fucked right now by some Latin stud Gardener over on the South side."

"Shut up, Jerico. Fuck you!"

Manny got up from the bench, "Shut the fuck up! Both of you! Talk about somethin' else, would you? Jerico, you go bowling last night?"

Jerico tucked his hands in his trouser pockets and said, quietly, "Yeah, so."

Manny continued, "Well, how did you do?"

Jerico raised his eyes and smiled, "I knocked 'em all down. We drank a few pitchers of beer, slung a few black rocks and destroyed the alley. I mean it seemed every time I let go of one...STRIKE! Kicked Ass!"

Manny looked at Richard and asked, "What did you do last night, Rich?"

Well Debbi wanted to see that movie with Demi Moore and she is in love with Patrick Swayze, so we rented "GHOST" and it was great. The movie kinda of made me think about what if there is a God and when you die, if you were bad, those black things would come up from Hell and carry you off. The movie kind of scared me but Debbi thought it was so romantic."

Manny grabbed Richard by the shoulders and shook him, "Don't worry about it, man. You are one Angel motherfucker. God is gonna take one look at your Lilly-white ass and pat you on the head and say, GET YOURSELF UP HERE IN THESE CLOUDS, BOY!"

Jerico started laughing and snorting and holding his stomach as he struggled to say, between laughs, "God ain't gonna let you in, no fuckin' way, Richie. The demons are

coming. I think I hear them. Look over there! See that black one coming out of the sewer. Run, fat boy, run before the black things get you, HAHAHA!"

Suddenly lights began to flash and the whistle pierced the air, drowning out all the voices of the people in the train station. It was twelve forty-five. Jerico stopped laughing and his face grew serious. He looked at Manny and Richard. Their faces were smooth and their eyes stared at the approaching train. The loudspeakers announced the time of arrival and the time of the next departure but the three men did not even listen. Richard held the sign up, facing the exit ramp of the train. Three men in suits, one holding the sign, which read, MR. EVAN WILLIS, faced the passengers as the unloaded from the train, one by one. A mailman walked between them and received a package from the railroad delivery service. Two fat women walked between them and they could see one of them wore thong panties showing through their tight spandex pants. Each person looked at the sign and turned away, to be embraced by family or to disappear into the shadows of the station. Heading in their direction was a tall man, in his late forties, with tortoise-shell glasses on his balding head. The man had an important carriage, a regal air about him. He shifted his eyes to the sign and then to the men. The man exuded power, Richard held the sign higher and the man started walking towards them. He stopped and announced, "I am Evan Willis."

Manny reached inside his coat, as did Jerico and finally Richard. All three men produced automatic weapons and began firing into Evan Willis, point-blank; the bullets tore through his chest and legs, ripping his neck and shoulders. Sprays of blood rained upon the floor of the train station. The dead man collapsed in a wet pool of thick slippery fluid that

continued to pour from the shredded flesh of his body. Manny emptied his gun and put it away, turning and walking swiftly out the exit. Jerico and Richard emptied their guns and ran for the other exits. The train station was quiet except for the bubbling sound of blood gurgling up from Mr. Evan Willis' mouth.

Mayflower Café

1. Jane, that was her name, sat outside on a wooden chair.
2. Common name, that Jane.
3. She had long legs to be so short, but those shiny red pumps with the needle-like heels were a nice touch.
4. I came around the corner.
5. She sipped a daiquiri, pineapple, I guessed.
6. My suit was clean but my hair had a little trouble in the wind.
7. Mayflower Café, with open sidewalk seating, was busy today.
8. All the details of Jane I absorbed within the ten feet of my approach to where she sat.
9. I just wish that I had some flowers for her.
10. White roses would match her dress. She would need at least a dozen.
11. "Hello, you don't know me but..."
12. Not a good opening line.
13. So I did not use it.
14. How about, "I know your cousin and she told me you were single, shy, and sexy. Mind if I sit with you?"
15. That line really sucks!
16. I have got to think quickly, another step and I'll be beside her table.
17. "Hi! Jane! Penelope Russell, told me all about you. I'm Trent Eveberry, nice to meet you!"

18. That's what I said and she smiled nicely but I could tell she was puzzled.

19. She was thinking, "How can this strange man know who I am just walking down the street when I have never seen him before? He is kind of nerdy but also kind of cute."

20. This close to her, I became as nervous as a baby fruit bat learning to fly from the top of the cave. It's a long drop to the bottom, you know, rejection and all that male ego crapola.

21. Bombing out now and I might not have the courage to approach another woman for months.

22. "Well, Jane, I know what you think but don't worry, Penelope told me you'd be here today and I've seen enough pictures of you to recognize you anywhere!"

23. She giggled like a young girl, you know, bubbly and squinting her beautiful eyes.

24. She was so damn cute!

25. Line number twenty-five.

26. A gray and maroon pigeon be-bopped up and down on the sidewalk, unafraid of the giant human's feet.

27. "Nice to meet you, Trent. It would be lovely to eat lunch with someone for a change."

28. The pigeon, with beady little red eyes, kept staring at me.

29. That bird is such a rude A-hole to be eavesdropping on us.

30. I guess the little bastard's waiting to see if we drop a few crumbs. The scavenger.

31. I study Jane's face.

32. Not much makeup. She really doesn't need it, natural beauty that she has.

33. I get interrupted by a waiter who seems to be on the effeminate side of the testosterone scale.

34. He says, his eyes looking over our heads at a jogger without a shirt on passing by our table, "Anything I can get you to drink, Sir?"

35. We are now ten lines after line number twenty-five. We will add it up and it equals line number thirty-five. My age.

36. How many lines did I think a story about a couple at a restaurant could go?

37. Remember that little baby fruit bat back in line number twenty?

38. I wish he would grow up with big fangs and fly to Mayflower Café to attack and kill this A-hole pigeon with the intruding red eyes.

39. The waiter returns with my Peach Passion Screwdriver, a twisted concoction of rum, peach schnapps, and assorted fruit juices.

40. I drink it down in one gulp.

41. My throat almost froze.

42. I looked up and the merry waiter smiled at me. I think he is a blatant homosexual.

43. I returned my eyes to Jane and was surprised to see her staring openly at me. She was dreamy looking and with a lot of color in her cheeks.

44. In that moment I knew that she wanted me.

45. A green light, a crack in the door, a chance that I had never had at finding true love.

46. I momentarily got carried away on line forty-five, so let's calm down a smidgen.

47. Jane said, catching me off guard, "Hey, Trent, let's cut all the bullshit. I know that Penelope told you that I am

a thousand dollar a night prostitute. So, do you want to make it or not? I tell you what, for you, a blowjob will be a bargain."

48. A bunch of things going on in line forty-seven.

49. I didn't know what to say, but I thought to myself, there goes my chance at true love.

50. Line fifty. I saw many people go past just now, a fat lady walking a skinny dog, a blind man with a German Shepard, and a mailman walking briskly with both dogs barking at him. Oh no, I will not give up on my true love theory because...

51. Maybe when we make love she will fall in love with me.

52. Just a little love at first, not enough to keep her from being a prostitute.

53. But then maybe in the not so distant future she would come to cherish me and we would be married.

54. The pigeon again, I can tell by the way he's looking at me that that A-hole bird is thinking that I am an imbecile expecting her to marry me.

55. Finally I replied to her blunt question, "Well, Jane, actually I would pay more money for you but I thought maybe the first time we could just go to a movie? I would still pay you though."

56. She wrinkled her forehead and brought her eyebrows down as she said, "Did you ever think that you would be asking me out on line fifty-six?"

57. Two people looking over my shoulder are reading this and they like the part about the pigeon and the baby fruit bat.

58. Maybe I should have written a story about animals.

59. I met her eyes with mine with all the sincerity that I could and blew her a kiss of air that was slightly peach scented.

60. So, Jane and I are at a table and there is a pigeon about to die from the bite of a baby fruit bat...

61. Do you think I should accept the blowjob?

62. Most men would but remember I'm the sensitive guy looking for true love.

63. Suddenly Penelope walks up to our table.

64. Too bad she's married. I could drown in here eyes alone.

65. Cling free panty hose and a purple leotard...yes...up the crack in the back.

66. She says, in that whispery voice oozing sexuality, tossing her blonde curls around, "Hello, Jane, I see you've met Trent. Hello, Trent."

67. She sat down upon a wooden chair with carved turtle-heads on the legs.

68. We talked for hours, until it got dark. Penelope had a wonderful idea.

69. Line sixty-nine...Yes, that's what we did, at Penelope's place, on the floor in front of the fireplace.

Jade Island

It was just lying there beside the curb. It wasn't broken or scratched. I picked it up and examined it more closely. I was thirty years old today and this would have to be my birthday present to myself since I believe in the law of "finders keepers, losers weepers." It was green. Ten strange wings protruded from it. Four different feathered wings, two scaled, two of leather, one of stone, and one smooth with symbols under the polished surface. It fit in the palm of my hand. It was an odd shaped oval. I figured out that the ten wings closed up into the oval and I began closing each wing down inside it like a pocketknife's blades. With all the wings tucked away inside, it resembled an egg, a jade egg. I slipped the green oval curiosity into the front pocket of my jeans.

I walked slowly along the sidewalk watching mockingbirds fly and land on the surrounding fences, chattering their weird calls and chirps. I passed the mailman delivering to each mailbox along the fence line. He walked fast like he was on a mission. His white socks glared brightly on his tanned legs. He reminded me of one of those fast walker racers in the Olympics. I laughed when a mockingbird dive-bombed him and he ducked deftly like he was ready for the attack. I guess he knew there was a nest nearby. I walked faster towards home and forgot it was my birthday.

When I reached my apartment, which is tiny but organized neatly, I unlocked the door with a skeleton key. I

turned on the stereo but I didn't turn on the lights because it made the place seem smaller than it actually was. I was not in a very upbeat mood so I opted for atmospheric music, the new age collection of waterfalls and tinkling pianos with occasional Indian flutes calling to the wild loons. My apartment was filled with the melancholy notes of the somber music. I pulled a cushion out of the couch and reclined on the floor, reaching into my pocket, I pulled out my special birthday find.

It was so smooth. It felt good in my hand. It was cool and comfortable to hold. The tucked away wings fit so perfectly flush with the surface. I just held it and closed my eyes, letting myself relax, and unwind with the influence of the surrounding music. The phone began ringing.

I jumped up, trying to remember where I left it and it rang again. I quickly grabbed it from my antique rocking chair. I was minutely angered to be so rudely pulled from such a relaxing position. "Hello."

The voice sounded as if it came from deep within a tunnel and said slowly, "I want it back."

"What? Who is this?"

"I said, I want it back. Now!"

"What are you talking about? Who is this?"

"You know what I am talking about and I want it back."

"You must have the wrong number."

I hung up on the strange caller. I put the phone down feeling upset. I felt anxious. I thought to myself, "Was that really a wrong number?" Yes, it had to be. I couldn't relax anymore so I turned off the music and flipped on the television. Scanning channels I clicked past MTV, the Home Shopping Club, Nashville Network, some old guy preaching for dollars, Andy Griffith reruns in black and white, and I stopped on the Jetsons, on the USA Network. It was one of my favorite

episodes. It was the show where George buys a robot dog to protect his house from the dreaded cat burglar. Astro, George's son Elroy's dog, gets his feelings hurt because he is replaced with a robot. I settled back onto the floor and tried to get into the show, rolling the jade egg in my hand. The colors on the television began to blur and I soon fell asleep.

I jerked awake, disoriented, and looked at my digital clock. The numerals glared back at me in bright blue-green light, 3:13 A.M. I felt stiff and awkward from sleeping on the floor. There was a movie on the television on USA Up All Night about a monster fishman. I glanced at the television and the monster fishman was raping a nurse. I rubbed my sleepy eyes and my brain wasn't functioning right. I seemed to have forgotten something. I tried to clear my mind and wake up better trying to remember what it was I had forgotten. I thought about Astro, the Jetson's dog, mumbling about the burglar and then I remembered a dream. The floor wasn't there anymore. I was standing in the sand, white granular sand, next to the ocean. I could hear the surf crashing on the beach. I was on a lush tropical island, with beautiful coconut trees and jagged rock formations out in the big waves that hurled into the lagoons. The sky was cloudless and pale. It almost seemed like another planet, everything was so perfectly gorgeous. The temperature was comfortable, not hot like the settings seemed to imply. I was wearing a white cotton shirt and white cotton drawstring pants. I did not have any shoes on and the sand felt cool between my toes.

I surveyed the beach in both directions and spotted two curious structures a little way down the curving coastline. I walked towards the structures to get a better view. I knew strange things happened in dreams but this dream was so perfect, I knew I must have been sleeping well. The only sound

was the waves and the wind. The jungle behind me did not have any birds chirping or monkeys chattering, only the rustle of the big palm fronds. I neared the green marbled structures. They were like two columns from the Roman Coliseum but different. The tops of the columns were carved into two monstrous green jellyfish, with their carved tentacles draping down twisting and winding on the columns length. I stood about ten feet in front of the two jellyfish columns and watched the jungle swaying behind them. I heard crashing brush and saw the jungle part between the two jellyfish columns. I took one step back afraid of what might come through the jungle foliage and step out onto the pristine beach.

A naked man walked out of the jungle. I recognized him instantly. It was a man who looked exactly like me. It was I. I could see myself through his eyes. It was as if we were in both bodies at the same time. In the man's hands were thick leather cords leading back into the brush and I heard low rumbling growls from the jungle. He slightly jerked on the two long cords and clucked his tongue as two enormous jade green tigers came out of the jungle on the ends of the man's leashes. The tigers growled like earthquakes and the ground shook. The man was strong and invincible. I felt strong and invincible. The man's face was painted or tattooed with two rainbows intersecting across the bridge of his nose. I felt like a god and like a madman being within two bodies at once. The man with the tigers led them down to the ocean and let the huge beasts play in the surf. He dropped the leashes as the big cats wrestled and growled in the crashing waves. He stood like a statue in the sand, feet shoulder width apart and hands on his hips as he watched the green tigers play.

He walked down to the edge of the ocean and watched the green tigers playing in the crashing waves. I watched him and

he glanced back at me and smiled. I heard a loud scream come from the jungle behind the giant jellyfish statues. I approached the statues with caution. The tigers stopped splashing about and looked towards the scream. The other man that was also myself turned and watched the jungle part behind the statues. At first I thought it was only a big dark cloud of sand ripping through the foliage on a large gust of wind but then the trees parted and he stepped into view. He was tall and well proportioned. The man was very dark; with almost pitch black skin like a shiny seal. He stepped in between the two jellyfish statues and stood, feet braced apart, arms folded upon his massive chest. Everything on the jade island stopped. There was no wind, no sound, no birdcalls, nothing, just silence and stillness. The tigers stood as still as green frozen sabre-tooths and the man who brought them to the beach did not move as he watched with his mouth open and his eyebrows raised. The dark man had dark eyes and they saw me, and everything on the beach, without even moving. The dark man's eyes turned my blood to ice and I felt immense fear under his gaze and in his presence. He was danger. He was a warning. The beach was still and silent for many minutes until I felt a small breeze whisper in my ear and touch my hair. The breeze felt cold on my face and I realized a tear had slipped down my cheek.

Suddenly the dark man curled up into a ball, like an eerie embryo, and swiftly rolled into the jungle, disappearing into the thick tropical foliage. Between the jellyfish statues where the dark man had stood, the sand bubbled up like a hot geyser. The green tigers roared together at the bubbling sand and the man grabbed them up, hooking the leashes to their necks as they continued to roar and growl. I started to back away from the bubbling sand and away from the man holding the two green tigers. I could see the jellyfish statues through my eyes

but also from the eyes of the man that was me holding the tigers. I had acquired a double persona and a double vision. I was disoriented and afraid but at the same time curious and exhilarated. The sand bubbled higher and resembled a flowing flame of fire made out of granules of sand. Something suddenly exploded from beneath the sand.

I could see the giant wings, fifteen feet across, protruding from the sand. Another set of wings emerged from the geyser of sand and another and another. A gigantic jade object housed the ten monstrous wings that flapped and stretched in the wind from the ocean. The green object connected to the wings shimmered and began an eerie metamorphosis.

I thought it was the jade egg grown to giant size. I thought it was the jade egg that I had held in my hand. I looked at my mirror-self as he held the tigers that strained and roared, trying to attack the shimmering shape with the ten flapping wings. The intersecting rainbows on his face shone like the aurora borealis. The shimmering shape began to mold into human form as the wings folded down into the broad back, reminding me of how the ten wings had folded down into the jade egg so perfectly.

The human shape was hairless and naked. He was long armed and long legged with a shiny smooth head and black eyes without any white around the pupils. His smooth black skin seemed wet like a salamanders. The man was without sex organs and without ears. At first sight I thought he was a man but as I stared I realized the human shape had breasts like a woman. Traits of masculinity and femininity were both present in the sleek form of a human. I clenched my fists as I felt tears streaming down my face, conflicting emotions of fear and rage, sadness and power, surged through me. The sand stopped bubbling and the sleek amphibious-looking human

turned his shiny head this way and that, looking at first myself and then at the man holding the green tigers. The big green tigers ears were pinned back in anger on their heads as they growled with barely controlled ferocity. I could see their canines dripping with saliva and I could even see the reflection of the strange human in their big yellow eyes.

The smooth human shape raised one long arm corded with wiry thin muscles and pointed an elongated finger at me. The tigers backed up and rumbled deep within their chests. The jungle parted and the rolling black powerfully built man rolled up to the sleek human and stood. He was shorter than the shiny human shape but twice as muscular. The long finger still pointed at me and I saw his head open where he should have had a mouth. Words emanated from the large aperture, as he spoke in some unusual way to me, "I want it back!"

It was the same voice on the phone earlier today. I was silent and stood very still, as if by being motionless I could be invisible. He kept pointing the long finger at me. I saw movement nearby and looked through my other self's eyes. The tigers were released and they charged with power and fury at the two figures on the sand between the jellyfish statues. The short broad man rolled into a ball again like a huge black bowling ball towards the charging tigers. The tall human-like salamander figure stop pointing and put his hands on his narrow hips. His black eyes stared at me and he did not even turn his head as the tigers jumped upon the rolling black man. The big cats bit and scratched at his hard black skin but he stayed in the shape of a ball and their efforts had no effect on him. They growled as they attacked and then both big cats leapt back quickly as the black ball exploded back into the shape of the muscular black man. The tigers attacked again, this time both of the big cats leaping at once at the stout black man. He

crouched down on his powerful squat legs and extended both of his thick arms before him. He caught the tigers by their necks in his outstretched hands. I was dumbstruck at his sheer strength and power as he held both five hundred pound tigers in the air; their roaring mouths level with his face. The black man held the combined weight of a thousand pounds as easily as if they were house cats. The tigers clawed at his arms but I never saw any blood or any lacerations from their efforts.

He held them and squeezed until they stopped roaring, stopped growling, stop trying to claw him. He slowly lowered the unconscious tigers to the sand and then dropped them in a slump upon each other. I saw their tongues lolling out of the sides of their large mouths as they drooped, one upon the other, in a pile of striped fur. The black man was not even breathing hard, as if no effort had taken place. He crossed his arms once again on his chest and stood with a wide stance before us. My other self, his rainbow tattoos brightly shining on his face, took a step forward and I could see the pain on his face as he looked at the unconscious tigers. I could see the tigers through his eyes and almost felt his pain. I could feel tears flowing down my face and didn't know why. He turned towards me and I felt strange looking at myself from where he stood through his eyes. He smiled and winked at me. I watched as he strode directly towards the black stout man blocking the way to the slender tall human-like form with the black eyes.

I waved to call him back and yelled loudly, "No!" but he kept approaching the dangerous man who had subdued the green tigers. The black stout man unfolded his arms and waited for him. Suddenly the two men jumped up into the air and flew across the ten feet that separated them. They met in mid-air, locking fingers and hands, and they struggled, suspended in the air, ten feet above the sandy beach. It was

like watching the positive and the negative, two opposites reverse magnetizing and they neutralized each other. The rainbow tattoos glowed and the black skin shimmered like the darkest shadow. Their hands disappeared in a merging of light and dark. I watched as the two forms merged together, almost as if each was absorbing the other. Their arms went inside each other's and then their shoulders met and merged. Their foreheads struck together and each skull assimilated into the other. I was in amazement as I watched the two airborne forms clenched in combat devour each other's forms until they were completely invisible or disintegrated. I didn't understand what I had seen but I felt as if my double vision was gone. I felt more alive and complete than before. The tigers were still slumped in a striped heap and the tall human-like salamander skinned form still stood between the jellyfish statues, like he was patiently waiting for me.

He took his hands from his narrow hips and opened his head again, releasing that strange voice, "I want it back, now!"

I stood my ground and replied, "I don't have it!"

When I said that, I felt warmth in the pocket of my trousers. The warmth grew more intense and I thrust my hand into my pocket to find out what was causing it. My hand closed around the jade egg, which was hot to my touch. I did not pull it out of my pocket as I said, "Is it yours?"

The tall salamander form said, "I want it back, now! Come closer."

"No, I think I'll stay right here for now. Is the thing yours or do you just want to steal it? Even if I did have it why should I give it to you? What do you want it for?"

Inside I was so afraid of him but I did not let it show and continued, "Look, I want you to explain what it is you want, and why?"

He stared at me and I noticed he didn't have any eyelids. He stretched out his long arms and touched the two jellyfish columns. The giant green jellyfish sculptures began moving their tentacles and they slithered with sucking sounds. The tentacles pulled back from the front of the columns and I watched as the two cylindrical sculptures opened panels in their frontage pieces. I saw large stone tablets encased inside each column. The two tablets looked ancient. I stepped closer to see them better. My heart beat frantically as I got closer to the salamander form- humanoid and I tried to read the deeply carved ancient text in the stone tablets. It was a strange language that I could not read but I waited only a few minutes and then white light from within the columns shone on the tablets and I saw a screen pass over each tablet. The screen decoded and interpreted the ancient language.

I read the converted language in English, "You shall have no other gods before me. You shall not make for yourself a graven image, or any likeness of anything that is in heaven above, or that is on the earth beneath, or that is in the water under the earth..."

I stopped reading and my face was wet with tears. I didn't need to read any more. I knew these were the tablets that Moses had carved and the Lord God had written with infinite power the Ten Commandments. I was in awe and disbelief. I looked down at the sand at my feet and saw that the wind had blown the sand away to reveal hardwood flooring. My hand held the jade egg and it had cooled. I looked away from the tablets and the ocean and the sky was gone replaced with walls and a white ceiling with a whirring ceiling fan. I looked back to the two columns and saw my television's screen was only gray static and the static sound filled my apartment.

I had been dreaming. I went to my bookshelf and found

my HOLY BIBLE. I opened it to Deuteronomy 5. I started reading about the Ten Commandments. I read, "33 You shall walk in all the way which the Lord your God has commanded you, that you may live, and that it may go well with you, and that you may live long in the land which you shall possess. I want it back!"

I blinked my eyes when I read, "I want it back!"

I looked again at Deuteronomy 5. The line, "I want it back." was gone. My forehead was sweating and I wondered what the heck did I eat earlier to make me have that dream. The phone rang.

I hesitated, wondering if it was another call wanting "it" back. I laughed nervously and reached for the phone. I held the jade egg in my hand and I accidentally triggered the mechanism. The ten wings opened up and I noticed the tiny symbols under the polished surface of the last wing. The phone rang again. I stared at the symbols and knew I had seen them before. I became afraid. The symbols were the same as on the tablets inside the columns. The wings were the Ten Commandments. I tried to close them down again but I couldn't figure out how. The egg was warm in my hand and the phone rang again. The HOLY BIBLE was on the floor open to Malachi 4. I read aloud the last line as the phone rang again, "lest I come smite the land with a curse." The Old Testament had ended with a warning. I thought about all those Sundays I stayed home from church and the sins I thought were white sins. I looked at the television and the gray static cleared, showing sky and waves on a sandy beach. The scene faded in and out with static trying to obliterate the image. The screen faltered and was replaced with a close up view of the salamander human form's face. All I could see were black eyes in slippery skin. The image pierced into my mind and I closed

my eyes to get away from it. I turned from the television and answered the phone. "Leave me alone! You can have it back! I will give it to you now!"

I turned back around and faced the static of my television and threw the jade egg with all my strength at the screen. The voice on the phone said, "Butch? Are you okay? Did I do something wrong?" It was Brenda. The television screen had exploded and glass shards filled the room. The jade egg was inside of the open hole in the front of the television. I said, "Yes Brenda I'm okay I just had a nightmare. I'm sorry about that."

She replied, "Butch, thanks."

"For what?"

"Thank you, I knew you would do the right thing."

"Brenda, what are you talking about?"

"Thank you for giving it back, remember, lest I smite the land with a curse."

She hung up. The jade egg inside the shattered television set was gone.

The Bee Room

He closed the door to his room and locked it behind him. He always locked his door. He made an agreement with his parents a couple of years ago and they both had respected his part by staying out of his room. He entered his room and listened to his parents talking in the other room. His room buzzed slightly when he walked slowly to his bed. William turned on his radio to a place where there was no station. He liked to listen to soft static while he did his reading. The bees liked soft static, too.

He was fourteen years old and kept to himself, a teenage loner. William made straight A's in school and was well behaved. His parents were very proud of him even though they let him keep to himself most of the time. Bob and Sally Pervius were so involved in their individual careers that they barely had time for each other much less spend time with William, their only child. He had shown he could be self-sufficient at an early age and so they adjusted to him that way. On the rare occasion when his Dad would be in a position to spend any time with William, he would playfully call him "Willy."

William lay down upon his bed and the bees made room for him. He opened his library book and began reading softly. The bees were quiet, listening to him read. William's room was sticky with dripping honey. The walls were covered with thousands of honeybees. The bees had coated the walls with honeycomb. The ceiling was a mass of worker bees tending the

hive. William's room was a giant active living beehive. The bees loved him and he was their friend. The Queen bee loved him. William always left his window open a slight crack so that the bees could come and go on their pollen journeys.

William always locked his room when he wasn't in it. He locked it when he went to school and even when he went to the bathroom. He kept his room key around his neck on a chain and he kept a spare key hidden in the guest bathroom. His parents hadn't been in room for over a year.

The bees were usually quiet, except when they were angry. They would start an angry buzzing that hummed throughout the house during those times. Once a purple spider wasp intruded into the room and was quickly attacked and subdued. Another time a honey stealer beetle tried to make off with their precious golden honey and the swarm overwhelmed him quickly. When the bees would start a noisy angry hum his Mom would yell from the kitchen or the living room and tell him to turn down his radio. At night when William went to asleep he never used blankets or sheets. The bees would always cover him and keep him warm.

Bob and Sally Pervius had gone to Europe for a two-week vacation and William had to stay with his Grandparents down the street. He missed his room. He missed his friends, the bees. His missed the big bright eyes of the Queen. She always stayed on the ceiling in the biggest cluster of honeycomb, near the light fixture, except when William slept then she went down to be close to him. Before his parents left for Europe they had hired an exterminator to spray the house while they were gone.

At his Grandparent's house, William sat up in bed the first night. He had been here since six o'clock this morning. His Grandmother had made him a breakfast of pancakes and

honey syrup. He was restless all day long wondering how the bees were doing back at his house. This evening he watched television with his Grandparents and then went to bed. Now he was wide-awake, missing his bees. He felt like something was missing when he didn't sleep in the bed with them. Finally he decided he would sneak out and go check on the bees.

He peered out of his Grandparents spare bedroom window into the dark of the night. There was something within him calling him back to his own home, back to the bees. He was careful and quiet as he crawled out of the window, stepping onto the moist lawn. He trotted down the street toward his house, feeling anxious and desperate as he neared it. He reached his bedroom window and tried to peer inside but the room was too dark to see anything.

He lifted the slightly open window higher so that he could easily climb inside. He eased himself slowly and quietly into the dark bedroom. Searching for the light he felt a cold chill enter his bones. He felt something was terribly wrong. He felt guilty towards the bees and he should never have left them. The bees had worshipped him and he had loved them back. He felt as if he had deserted them. He found the light switch and turned it on. He stepped back quickly into the wall, gasping for breath. He gasped as he stared at the dead man lying on the floor.

He was covered with red welts and his hand held a can of bug spray. William knew that the bees had stung him, over and over. He saw many of the valiant bees dead on the floor around the dead man. The man had an exterminator uniform on and William knew what had happened. He knew his Dad had planned on exterminating the house while they were gone. The beehive was gone. The bees would think it was William's fault. They were gone and his friendship was over. William

stayed away from the dead man and looked only at the dead bees lying on the floor. Tears formed at the corners of his eyes. The dead man's open eyes stared at the ceiling and his open mouth expelled silent screams but William had no compassion for him, feeling only the horror of how the bees had died. He knew it must have been a valiant battle with the entire swarm attacking the man. After the man had died they must have gathered and abandoned William's room.

William walked over to his bed and sat down. He sat there for a long time. He was lost in thought, remembering the closeness of the hive and the safe comfortable hum of their buzzing. He could hear the bees buzzing in his mind and he closed his eyes to bring it back. He heard a tiny buzz in the room. William opened his eyes and a bee flew in circles around him. William smiled as the bee tightened its circles of flight. He watched the bee as another flew in through the open window. He was smiling as more and more bees swarmed in through the open window.

The bees were like a miniature dark swirling cloud, flying around him. William reclined on the bed as the bees poured in through the open window. He looked at the swarm circling around him and searched for the queen. He finally saw her on the ceiling and his smile grew. She must still love him. Somehow the bees knew that he was their friend, not their enemy. He was happy again, until he felt the first of their stings.

A Night in the Sooke

There is something different about the waters of the Juan de Fuca Strait near Sooke, on Vancouver Island, British Columbia. There is something mysterious and unsettling in the region that very few people notice or care to remember. The few people aware of it only want to forget. The people think of it as only an imaginary experience or a disturbing dream. The Juan de Fuca Strait is full of marine life and deep, cold, blue-green waters connected to the mighty Pacific Ocean. Resident pods of Orcas, Killer Whales, frequent the coastlines along Washington and Canada and the many islands in the strait. Seals and sea lions also swim in these cold waters near rocky shores and cliffs. The Pacific White-sided Dolphin darts in the currents between the many islands and the rocky beaches along the coast of Vancouver Island.

The feeling of isolation lures visitors from around the world to these remote temperate rainforests that border the waters of the Juan de Fuca Strait. The isolation and the mystery of the Sooke rainforest still haunt me.

Sooke takes its name from the T'sou-ke native people. The T'sou-ke people were the first inhabitants of this area of British Columbia, Canada. The people were named for a stickleback fish that once were incredibly numerous in the Sooke Basin. Salmon fishing has played a large role in the history of the region, as had the Leechtown gold rush of 1864. The combination of resources like forest and ocean, the fishing

and the lumber, made this place an ideal settlement for the first explorers, the Spanish.

The harbor village of Sooke now has 11,600 inhabitants, miles of unspoiled beaches and thick unexplored temperate rainforest. In the heart of this beautiful place lies the mystery that is hidden from most people's eyes. This is the mystery that always seems near the surface of my waking dreams as I relive those days on the boulders over the crashing waves of the Juan de Fuca Strait.

I was visiting my Aunt Jane that summer and I decided I wanted to hike the forests and the beaches of the Sooke wilderness. I left her home on the Esquimalt Lagoon about ten o'clock in the morning and drove my truck along the coast, heading towards Sooke. I was eighteen years old and ready for adventure. I had always loved to hike in the woods and mountains back home in Durango, Colorado. British Columbia was a different world, with different types of forests and different kinds of wildlife. I was excited as I drove along the winding highways of Canada. I had packed some food and drink in my backpack and I had told my aunt Jane that I would be gone all day. I wanted to hike deep into the forest and also make my way along the cliffs that overlook the ocean. I loved being alone in the forest. There is no other feeling like it. It is a primal emotion that brings out the primitive natural yearnings for becoming closer to nature and the true spirit of our origins. My mind looked forward to new discoveries and the special feeling of the depths of the Vancouver Island forests.

I left my truck in a shady spot along a lonely road and started off down a narrow trail into the Sooke wilderness. Before I took a step into the darkness of the shadowed forest I glanced overhead and saw a bald eagle soaring above the

trees. I watched his magnificent form smoothly flowing in the air above me. He probably looked down and could see me clearly with his incredible vision. Eagles can spot a mouse twitching its tail in tall grass from probably five hundred yards away. I wished I had that kind of vision. I felt the bald eagle sighting was a good omen and I disappeared from his view as I entered into the forest. The temperature dropped about five to ten degrees in the eerie green-gray of the realm of trees. The ground was covered in vegetation and dead leaves, rotten branches and fallen tree limbs. I had to climb over many huge root systems and tangled vines. I liked it in the forest. I liked the way the shadows created striped haphazard patterns on the foliage and the large rocks. What little sunlight that made its way into the forest floor filtered in like a scary particle mist. The blinks of sunlight seemed almost like swaying ghosts penetrating the shadows. I hiked for about an hour seeing only forest vegetation and an assortment of birds.

My Aunt Jane knew all about the different kinds of birds of this region. She identified a couple dozen species from her balcony on the lagoon just the other morning. She rattled off, " Over there is a Great Blue Heron, and beyond it is a White Heron. Of course there are many Canada Geese followed closely by Mallard Ducks and near the trees over there are a few Mergansers. The House Sparrows are everywhere but those are Field Sparrows sitting on the fence. The bird house back there is filled with Purple Martins and the little birds that look sort of like baby Martins are Common Swifts."

She went on like this all the time. The Esquimalt Lagoon is a bird sanctuary. Up here in the darkness of the forest the birds were fewer, blackbirds and robins mostly. Later that day I heard a commotion in the trees. The blackbirds were chattering and screeching loudly. I watched through the leaves

and saw that they were excited because a Spotted Owl was sitting on a branch with a dead rat in its claws. The owl saw me and flew about fifty yards away. I saw it land and followed to get another look at the big owl. As I approached I noticed two other large flying shapes land beside the big predatory bird. I stood there amazed as two young owls landed beside their mother and began feeding off the dead rat. The owls watched me cautiously but continued to eat. I wish I had remembered my camera but I had left it at Aunt Jane's house.

As I watched the owls I felt the ground shimmer, like a small earthquake. The tremor only lasted a minute but it had unnerved me. I tried to recall if there had ever been any earthquakes on Vancouver Island. I didn't think I had ever heard of anything like that, not even an active volcano that I knew of. I waited for the ground to shake again. I glanced up at the owls and saw that the mother had flown away while I wasn't looking but the young owls were still eating the rat. The forest was quiet and still. I stood there wondering if I should turn back or just forget about the tremor and push on with my hike. I stayed where I was for a few minutes watching the owls eat and then a squirrel darted across the clearing. I saw him stop for a second and look at me. I saw him stare with those little rodent eyes and then he was gone, dashing like a blur into the thick foliage. I heard his tiny feet stirring up the dead leaves of the forest floor for a few seconds and then everything was quiet again. I felt like maybe the ground had never shaken. I shrugged it off. I pushed ahead, deeper into the forest, continuing my hike into the Sooke rainforest.

I entered a spacious clearing but the sunlight still did not penetrate very much because of the heavy canopy of the huge trees extending overhead. I realized I couldn't hear any of the birds in the forest anymore and I felt more isolated

than ever. I wondered if I had somehow walked through a warp or wormhole to another planet where only plants and rocks existed. I leaned against the huge bole of massive tree with the palm of my hand steadying myself and something slowly happened. My hand touching the tree's bark began to tingle almost like the feeling that it was falling asleep. The tingle turned to a shock, a jolt of power coursing into me and I couldn't pull my hand away from the tree. My head jerked back violently and my eyes rolled back as I was filled with hundreds of images flooding into my mind like a machine gun scattering of film clips. I saw the forest in all of the seasons and I saw strange people and events. I couldn't decipher what I was being infiltrated with. I only knew that the tree or the forest or the region bombarded my mind with this chaotic knowledge through the bark into my flesh. I was connected into this infinite recorded history and I was powerless to stop the inundation of images into my mind.

I saw countless people die in the forest. I saw terrible deaths, horrible murders, and evil things that transpired within the Sooke wilderness. I kept trying to free my hand from the tree. I wanted to sever this connection to stop the stream of images into my consciousness. I saw pirates raping and murdering women and boys. I saw the helpless men hung by the pirates from this very tree. I saw a brutal man bury three young women beneath the soil in the clearing. I saw a large bear maul a young man and bite him in the face, killing him and dragging his body into the woods. I saw police chasing two men through the forest. I was given images of the police beating the men with clubs and breaking their hands on rocks before they shot both men in the head. I saw an old man carry a goat into these woods. The old man had a long beard and green tattoos on his arms. He held the goat up by its horns

and then used a machete' to chop into the goats throat. The blood poured out and the old man knelt down and drank the spouting blood from the dying goat. There was so much terror and so much death in the images I shut my eyes and pulled as hard as I could to be free of the tree.

Suddenly the images stopped. My hand came free. When I opened my eyes I could not see anything before me. I was blind. My mind was filled with the memories of the chaotic blasts of violent visuals and I couldn't see anything but blackness. I began to breathe heavily. I started to panic and my heart hammered rapidly in my chest. I blinked my eyes quickly trying to will them into seeing. I shook my head violently and stumbled. Falling over a branch I fell sideways onto the ground. As I propped myself up and began slowly to rise, my vision gradually started to clear. My eyes could see black and then gray and finally shapes and colors. I stood up and after a few minutes my eyes finally could see clearly again.

I rejoiced in the illuminating shades of green and brown that surrounded me. Losing sight and then regaining sight is an experience that rocked my mind. I could cherish all the beauty of the forest but at the same time I was still shocked by the gruesome death images that had been interjected into my consciousness. I stood there trying to understand what had happened to me. I was very disoriented. At this point I knew I had to leave the Sooke wilderness and get back to my truck. I no longer liked the feeling of being alone in this forest. I now felt endangered and violated.

Just as I made this realization I heard something. I heard an eerie whispering coming from beyond the trees. I searched in the direction of the sound and could see nothing but trees and shadows. Abruptly, the foliage parted and a woman strode forth into the clearing. I was struck by her beauty and by

her complete nudity. The nude woman's skin was very pale and her hair was almost white. She seemed to be young and athletic. The trees shadows criss-crossed her body giving her the appearance of a striped being, almost like a human female tiger. As she walked closer to me I saw her eyes. They were not the eyes of a young woman. Her eyes were yellow and sparkled like gold. She stopped about twenty feet from me.

I was rooted to the ground as I stared at her. I couldn't decide if I should run or move towards her. The nude woman with the golden eyes opened her luscious mouth and I saw white light inside, shining from her throat. The light basked me like heat from the sun. I felt hot and cold at the same time. I fell to my knees crunching the dead leaves on the forest floor. I couldn't take my eyes off of the woman and she finally closed her mouth. The light shut out and I fell forward on my face. I was unable to move and all I could see as I looked up from lying on my stomach on the ground was the nude woman with the golden eyes striding eerily towards me.

She stopped, her bare feet inches from my face, and reached down to touch my head with her hand. I strained to move, to get up and run, but I was paralyzed. Her hand caressed my hair and my neck. Her skin was hot but her touch very gentle. I felt her squeeze the back of my neck and then everything went black.

I must have been unconscious for a long time because when I woke up it was dark. Night had fallen as I slept dreamless in the forest. I stood up and searched the darkness. There was no sign of the nude woman with the golden eyes. The back of my neck was sore and I rubbed it. My fingers felt a strange bump in my flesh as I touched the back of my neck. I thought that maybe I dreamed the images of the nude woman. I realized that maybe something had fallen from the trees and whacked

me on the back of the neck. Whatever fell on me must have hit hard enough to knock me out. I still felt slightly dizzy. I continued to rub my sore neck and started to retrace my way out of the forest. It was extremely dark and I soon discovered that it would be impossible to figure out in which direction to go. I had only traveled about fifty yards when I saw a low light coming from behind a ridge. The glow from the light was eerie and I recalled scenes from the X-Files and Close Encounters of the Third Kind. I moved cautiously through the thick forest and slowly approached the area of the light. I climbed higher into the mountainous forest and finally reached a place where I could look down onto a lagoon and a pebble beach. The weird low light illuminated the beach. The light was almost like a hanging vapor in the air. I watched the water slowly wash up on the shore and then I saw her.

The nude woman with the golden eyes stood on the beach near a stand of twisted weather worn trees. A large conglomeration of driftwood was piled high next to her and resembled a lost stranded whale skeleton. She stood like a crucifix, her arms extended and her feet together. The woman's white hair blew in the wind like a shimmering pale banner. She was compelling as she stood there like some earthly icon. I could see the glow of her golden eyes as she stared out to the ocean. I followed her gaze and saw the water rolling as if huge forms surged beneath the surface. I felt the ground beneath me shudder as if holding back an earthquake and I grabbed onto the closest boulder. I watched the water as six tall dark fins broke the surface, bathed in the low blue light. Whales! Six Orcas! This was incredible! I watched mesmerized as six Killer Whales swam into the lagoon and into the shallow water towards the beach. The whales swam in as far as they could until they seemed to be stranded. Their huge black

and white bodies were pointed like disarmed torpedoes at the woman with the golden eyes. The whales flapped their large tails, splashing the dark water. The woman still did not move. This was amazing and I thought about how no one would ever believe any of this. I felt special. I was chosen to witness this scene for some odd reason. The woman had picked me and now I must be calm and figure out why later.

The forest was filled with the blue light all around me. A low humming began in the trees. It seemed as if the trees themselves were moaning as the woman lifted her arms higher. Slowly, scarily, the trees surrounding the lagoon all began to bend forward towards the water. The long branches twisted and their limbs moved like sluggish snakes stretching towards the water of the lagoon. It was like watching hundreds of thick snakes in the trees as the branches moved and writhed, bending in close to the lagoon. The earth rumbled beneath me.

The water was bubbling and I watched as something else emerged from the water's of the lagoon. I saw a human head appear above the water. Other human heads emerged as many people began coming out of the deep water of the lagoon. All of the people were naked and covered in the blue light. I watched the dozens of people walk in the water and as they approached the whales I could see that the people were not real. I could see through their flesh. Some of the people walked right through the whales. My body felt cold as I witnessed ghosts coming from the ocean. The people walked past the woman and into the forest. I watched as each of the ghosts walked right into trees, disappearing into their bark. When the last ghost was within a tree the humming and moaning of the forest ceased.

The ground beneath me gave way and I was funneled with the ground and rocks down towards the lagoon on a landslide. I tumbled and crashed, falling a few yards away from the water

and the nude woman with the golden eyes. I could see the six whales staring at me like black and white police cars with fins. The woman approached me and with one hand on my shoulder picked me up. She held me without effort, my feet a few inches off the ground. She opened her mouth and the white light shone onto me again.

My clothes fell from my body like wilted paper. She held me up by one hand. My body was once again filled with chaotic images. This time I was filled with sexual images. Everything copulated in my mind and I became extremely aroused. I was held there, naked and aroused, by the woman of the Sooke with the golden eyes. I witnessed the creatures of the forest copulating, trees bending into other trees inserting engorged sex organs beneath their bark. I saw butterfly orgies, boulders climbing upon other boulders grinding into sexual excitement. I felt my neck began to get hotter and hotter. My sore neck began to pound as the woman pulled me closer to her. When our skin made contact I screamed with pleasure and pain. It felt like my skin burned from the inside out. I was inserted within her sex and the pleasure could not be described. I was witness to flowers spreading their petals as pistons pumped into their open regions. I saw dolphins in sexual ecstasy and octopi twisted in a series of tentacles copulating beneath the sea. The sky was bright with the light and the earth rumbled and shook beneath us.

I thought I would explode with the immense pleasure and intense pain. I was hanging in the middle of a nuclear fire and consumed with the pleasure of the earth's copulations. Suddenly I thought I might die here.

I felt sore and stiff. I was naked, wet and cold, lying here on the pebble beach by the water. The morning sun was barley rising upon the Sooke. I searched for my clothes and could

barely remember the night. The only thing I could remember seemed to be an awesome sexual experience and a beautiful woman with incredible eyes. I couldn't even remember her name.

I stood up and touched the back of my neck. It was sensitive to my fingers and I touched a large bump about as big as a dove's egg. I rubbed my neck and started back through the forest towards my truck. I had extra clothes in the truck. Before I left the lagoon I looked back at the water and was amazed to see six Orca fins cutting through the water.

The Last Morning

She thought about dying. Her feet wouldn't hurt anymore. She heard the soft rubber sound of the nurse's shoes coming down the hall and she closed her eyes, pretending to be dead. The curtains surrounding her bed were like the sealing walls of a coffin. The walls of a coffin that kept out light, kept out life.

Entertainment was only an arthritic fingertip touch away, the television remote control. Elizabeth had even forgotten how to cry back around her eighty-sixth birthday. The nurse had opened the door to her room quietly, but a short squeak still echoed in the room. Lights slowly flickered on and the noise of the curtain parting helped to awaken the room to life. Elizabeth faked death, breathing slow and keeping her eyes shut.

The nurse's warm fingers took hold of Elizabeth's wrist as she took her pulse. The ruse was over. Elizabeth opened her eyes and smiled. She was so tired. She tried to speak. Nothing came out. The words formed in her mind like beautiful landscapes but they never left her mouth. She thought, "Good morning, nurse. It is so nice to see you." Only air escaped her mouth, a whisper of nothing.

The nurse patted her wrinkled hand and said, "Good morning, Ms. Myerson. How are you feeling today? Here is your breakfast."

The nurse produced a new IV bag and began attaching

the cold plastic tubes. New liquid flooded Elizabeth's veins. She felt like winter. The sky was white and bleak and her body was a vast landscape of snow and ice. Her arms and legs were like brittle branches and her neck was a rotting stump in a lost frozen forest of thick snow banks and dead animal carcasses. The nurse turned to leave and smiled, closing the curtain like the end of a play.

Elizabeth drifted to a place that was not sleep. Her mouth slowly dropped open. Most of her wrinkles smoothed out and in her mind she saw visions of a little girl. She saw a handsome man, a night without a moon, and summer trees with a cottage near the lake.

Elizabeth no longer felt the arthritis jabbing away like burning sticks in her joints. She started to feel like she was mist or fog. She felt as if she were early morning dew draped on cloverleaves. She saw a winding road ahead.

Out of her mouth, invisible, emerged her soul. She drifted away, walking down the road. She saw the minutes of her past upon thousands of movie screens, lined up one after another, on either side of the winding road. She cried as she watched her past play out before her. She laughed and she worried, she smiled and sobbed, and then she took one last look back. She looked back and saw herself, dead in the bed.

Mirror

The Ruler of children and flowers kissed the stones beneath the nest eggs. Children burst through my mirror with flecks of glass in their eyes. They were odd and born that way. Those wild children, one delicious girl and two dingo boys broke the nest eggs open. The Ruler, furry and thorny, became upset. The Ruler's tears dropped, like white syrup, upon the bending pink daisies. I walked away from him and watched the children, laughing and screaming like spotted hyenas at a midnight orgy of bloody zebra. The children ran down the cobblestone path towards the fountain, where they did not belong and upset the Wisherman's sundial.

The unbalanced sundial fell into the bubbling fountain with a loud splash disturbing the albino ravens that sat high in their rookery in the sycamore tree. I watched from behind the broken mirror where the Ruler sobbed on his knees spilling tears like syrup over the clipped lawn and the bending pink flowers. The three wild children ran from the fountain chased by albino ravens, cawing raucously in the smooth sky above them.

The Wisherman, tall as a giraffe with blue skin and salamander clothes, ran to the fountain to retrieve the sundial. I watched his long bony fingers reach into the fountain and take hold beneath the water. He pulled and he pulled but the fountain wanted to keep the sundial. I left him still pulling and followed the flight of albino ravens north. Staying behind

trees I spied a young girl sobbing on a boulder. Her black hair was straight and extended to the ground, a length twice as long as her body. She had smooth skin the color of milk and her nudity was as natural as a mimosa tree flower floating in the breeze. I noticed she had butterfly wings of gold and silver growing from her ankles and her eyes were not oval but perfectly round and black as her hair.

I stepped out and ran towards her and asked, "Why do you cry?"

She looked up with eyes like black balls and sobbed, "I cry because the mirror is broken and I can never see myself. I have already forgotten what I look like."

I tried to smile at her but I couldn't so I said, "I will tell you what you look like. You are like sex. You are like desire. You are a magic shining light in the forest of the Ruler of children and flowers."

She cried harder and her tiny breasts were wet with the flow of her tears. I heard the far off cries of ravens and laughter of the wild children. I looked at the crying girl with butterfly ankles and said, "I am sorry but I must go."

I ran into the concealment of the trees reluctantly because I really wanted to stay with her. She was like pure enticement and I am sure when she stopped crying she would return to sexual frolic and fantasy with the many woodland nymphs and satyrs that roam the Ruler's woods.

I followed the sounds of the ravens and saw a clearing ahead with a giant statue of the Lion God in the center. The dingo boys danced around the statue laughing while the delicious girl sat in a clover patch entwining clover flowers in her long thin yellow hair. The flocks of albino ravens were sitting in the trees surrounding the Lion God statue cawing a strange song. I heard a sound from the Ruler's forest and the

tall blue-skinned salamander clothed Wisherman came out into the clearing holding his broken sundial, still dripping water from the fountain.

The Wisherman pointed at the dingo boys and the luscious girl and shouted a burst of air at them. Flowers fell out of the luscious girl's hair and the dingo boys hollered and fell tumbling in the weeds at the foot of the Lion God statue. The ravens stopped singing and flapped their white wings nervously. The Wisherman was furious at having his precious sundial broken and wanted revenge upon the wild children.

The tall Wisherman expanded his skin and grew in rage and anger to a new height of thirty feet. His hair swirled like tentacles and he puffed great blasts of air. The dingo boys crawled against the powerful air and reached the claws of the Lion God statue. They clung to the stone while the luscious girl ran through the clover with the speed of a cheetah. She reached the giant statue of the Lion God and climbed up the stone like a baboon. With a flower in each hand she smashed her palms together grinding flower petals and then she ate the vegetation ruins. Wisherman put down the sundial and grabbed a dingo boy in each long hand. He would eat them like chocolate leaves for dinner.

The luscious girl opened her mouth and out flowed a stream of rainbow-assorted flowers that fell down upon the Lion God's surface of stone and sparkled magically. The stone shifted and the luscious girl wrapped her arms around the Lion God statue's neck. The ravens began to caw worriedly. I stayed out of sight behind a maple tree as a midget squirrel with suction cup fingers climbed above me in the branches.

The Lion God statue came to life and stood up with the luscious girl riding upon its back. She spoke to the Lion God and he turned towards the thirty-foot, blue-skinned

Wisherman holding the wild screaming and laughing dingo boys well above the ground. The Lion God roared and the ravens flew high into the sky like a white fluffy cloud with dozens of wings. Charging, the giant Lion God, caused the ground to tremble and shake. The Lion God crashed into the Wisherman and he dropped the dingo boys. The Wisherman turned and ran, stopping to pick up his broken sundial, and dashed off into the Ruler's forest. I saw him shrinking in size as he ran. The dingo boys had stopped laughing because their heads had hit together and busted open like the nest eggs they had broken. Their brains spilled out like yellow yolk. The Lion God returned to stone and rested as the luscious girl slid down his massive neck.

She did not look at the dingo boys but walked off in the direction of the albino raven flock. She went north away from death and sorrow. I saw her stop to pick flowers and put them in her hair. I looked at her once more and I saw her shimmer and then fade away as she turned north into the snowfields of the mountains.

I went back the way I had come and saw that the boulder of the sobbing girl was vacant and I knew she must have been wildly cavorting with satyrs in secret grottos. There was a rusty mailbox stuffed with flyers about the Ruler's Dance near the fountain. The Wisherman was sitting in the water of the fountain while chickadees flew around his head like bees. I went back to where the Ruler still sobbed and saw my broken mirror. I wanted to cry about it but too many others had already cried today. I picked up a few shards of the broken mirror and looked at my splintered reflection. The mirror had been my favorite.

Nautilus

You ain't ripping me off today, Mister!" yelled the man in the yellow coat as he strode forcefully off the lot of Harry's Used Car Dealer. The big sign out front read, "Harry's Used Car Dealer, Bargains That Feel Like A Stealer!"

The angry man got in his blue truck and drove away while Harry Orchin snapped his fingers and spit on the cement, watching his customer drive out of sight. "He'll be back," said Harry under his breath. Harry's car lot was run down and shabby but a great place considering the part of town he was located in. He always called it The Little Asia. Houston has plenty of used car dealers but not as many with the cracked asphalt and weeds popping through like Harry's place. His office doubled as his house. He had a bed, kitchen and small bathroom behind the office room that was located on the rear of the property. The big sign out front was the nicest piece of property he owned besides what he kept hidden beneath a tarp in the dilapidated garage on the right of his office.

Harry snapped his fingers as he walked back to his musty office but stopped when he saw another customer pulling into his lot. He turned and went out to his rusty old rural mailbox and checked his mail while a VW van pulled in. Harry had about twenty cars for sale or rent on his dealership. Most of his cars were ten years old or older but he did have two recent models, a blue 1999 Ford Taurus and a white 1997 Dodge Ram truck with a long jagged crack in the front windshield.

Harry frowned when the mailbox was empty and he knew the mailman was late as usual. A woman hopped out of a small VW van and walked briskly towards the old rust colored VW Beetle parked out near the road. The red sign on the VW Beetle's windshield announced the price as $1200. She walked all around the car looking it over carefully. She paid no attention to Harry as he slowly walked in her direction. "It's a steal!" Harry said as he tipped his cowboy hat back on his balding head. Harry was a thin man of fifty-four and he always wore faded blue jeans and the cowboy shirts complete with the rhinestone snaps on the pockets. His eyesight wasn't very good anymore but he mostly refused to wear his black "Buddy Holly" glasses unless he was filling out sales papers.

"Oh, really." Said the young woman as she studied the VW Beetle. The girl was probably a college student, thought Harry. She was probably an Asian, more than likely Vietnamese or maybe Korean. She was fairly attractive but not a beauty queen. She walked quickly with short steps and she barely stood taller than the small car. Harry guessed she couldn't even be five feet tall standing on her toes. "So you think twelve hundred dollars is a great deal for a 1969 rusty old bug with bald tires?"

Harry scratched his head and replied heartily, "Why Miss, this car is a classic! Babe Didrickson once owned it, down in Beaumont. This car runs great. It has the original eight-track player and comes with eleven of Babe's own personal eight tracks. You know you can't find stuff like that anymore."

The girl laughed and her face was very pretty as she exposed her white teeth and cute dimples. Harry liked this girl and decided he would swing her a good deal, even for him. She said, "So, you think I care about getting eight tracks? Which eight tracks are they?"

Harry raised his eyebrows and said, with a cough, "Let's see, Aretha's Greatest Hits, Jefferson Airplane, you know before they were Jefferson Starship, Uh, Bread, America, the one with Horse with No Name, Dick Dale and the Delltones, Elvis and the Blue Christmas, Moody Blues Live, and I think the other one is, uh, Patsy Cline. Quite a collection I would say. I thought about selling them on the Internet but they came with the car so I figured they should stay with the car."

She listened to his talk about the tapes but kept her eyes roving over the used car. She was quiet for a few moments and finally said, "I'll give you seven fifty cash."

She caught Harry off guard for a second but he scratched his chin and looked deep into her dark eyes, as he replied, "Seven fifty cash. Seven fifty cash? I tell you what, make it nine hundred and I will wash it and inspect it for you today."

Suddenly a blue truck rumbled fast into Harry's used car lot. The woman turned and smiled as the man in the blue truck got out and Harry muttered, "I knew he would be back."

The man came straight up to Harry and the girl and said, loudly, "Okay, so I'm back but you ain't gonna fool me with your con man stuff!"

The small girl was still smiling and said, "I remember you."

The man was very large with a massive chest and thick legs. He was an imposing figure. The man in the yellow jacket turned to her as she said this and stared at her, saying, "You do? From where?"

"Hell."

The man just stared at her like she was a crazy person. He looked at Harry and then right back at her. Finally he said, "Oh really. I remember you too. Pretty hot down there huh?"

"You think I'm joking don't you? Look Mr. Riggins you

and Harry evidently have some business but it can wait." She opened her purse and took out a roll of one hundred dollar bills. Her dimples showed as she continued to smile as she counted out nine hundred dollars and handed it to Harry. "Here is the money for the VW Bug and I also want to buy what you have in the garage back there."

Mr. Riggins, the big man from the blue truck, yelled, "Now just wait one dang minute here! That's what I came back for!"

Harry rubbed his hands together and smiled before he spit on the ground. He eyed the roll of bills that the girl held and watched as Mr. Riggins produced a roll of bills of his own. Harry held up his hands as he whispered very quietly, "It is not for sale."

The girl put her nine hundred dollars in Harry's hand and went over to the VW Bug. She yelled back over her shoulder, "This is my bug now."

The girl opened the driver side door with a loud creak and crawled inside, leaning across the seat. The two men watched her and wondered what she was doing. She fished around under the passenger seat. Harry and Mr. Riggins walked over to the car and peered inside to watch her. The girl pulled up the floorboard underneath the seat and then found a knob almost flush with the floor. She turned the knob like a combination lock, this way and that way. She opened a hidden compartment under the floor.

She got out of the old bug and held something in her small hand. She smiled at the two men and stuck whatever she had found in her pocket. "Hey, you two, how about we go look at what you got back there that we both are interested in?"

Harry became very nervous and the big man in the yellow coat seemed angry. "Well, don't just stand there, let's go have a peek."

Harry said, "How do you know about what I have?"

The big man also chimed in, "Yeah, who the hell are you and how do you know about it?"

She paused for dramatic effect, and then smiled beautifully, saying, "Well, well, well, you both seem way to worried for all this. So much drama and trepidation just because of me and that little old relic you have covered up in the garage. I will tell you this much, though, you got to promise not to tell anyone else." She laughed a merry laugh and walked closer to the two worried, shaken men. Harry was sweating and wringing his hands. He had set up a deal with Mr. Cheng and didn't need any of this. Mr. Cheng had warned him that others would come. Mr. Cheng had also warned him that he had better keep it safe for him and not let anyone else near it. Mr. Cheng had already purchased it from Harry for fifty grand. Harry already had plans for that money. This car lot was history and he was off somewhere more pleasant and relaxing. He knew he couldn't let these two pressure him anymore and he had to get rid of them somehow. If Mr. Cheng found out that he let these two people near it Harry would be made to pay. He knew Mr. Cheng's reputation. He had heard the stories of the dead boys found in the river.

Harry put up his hands and said, "Just hold on now! I told you both that it ain't for sale! So you two can just go back to wherever you came from. Thanks for your business little lady but you can clear out and take both them VW's with you."

The small woman moved so fast that Harry did not even see her move towards him, her face inches from his own. She whispered slowly through clenched teeth, her nostrils slightly flaring as she pronounced each syllable clearly, "You do not have a choice. Forget about Mr. Cheng. I come representing the Establishment. The money with me is only a deposit. You

will turn it over to me and an account in your name is set up in a Cayman Island bank with a final payment to you of Four hundred million dollars. This is the money earned by generations of your family for the secret keeping of it."

The big man tried to lean in and hear what the small foreign woman said to Harry. Without even making any motion she spun instantaneously and planted a devastating kick in his stomach. The spin kick and results took less than an eye blink but the man landed ten yards away, face down, almost unconscious. She looked back at Harry who was standing as if he had been the one kicked and said, "Now pick him up and bring him inside the garage."

She moved as if she were a graceful ice skater and walked smoothly flowing towards the garage expecting her request to be carried out. Harry decided he had better do what she said and grabbed the big man under his arms and helped him to his feet. The man groaned and could barely stand but Harry half carried him towards the garage. Harry unlocked the door with a small key and walked past the girl, leaving the big man leaning against the garage wall. She pushed the big man inside as she entered and he fell down on the concrete floor hard. Harry flicked on the light, a small bare bulb hanging from the dark rafters. The room was filled with shadows as the bulb slightly swung on a frayed electrical wire. The sun was setting outside and a heavy wind had begun to push the weeds northward on the car lot cement. In the center of the small wooden garage was a large object, as big as a van, completely covered by a dark green tarp.

The woman looked at Harry and he thought he could see her eyes changing colors from green to brown to blue and then back again. She bared her teeth like a smiling leopard and whispered in a reverent tone, "Harry, have you ever looked

under the tarp. Have you ever seen it? I think not. You would not be able to handle what is under there. You were told to stay away and that is just what you have done. A good boy you have been. Did you know your Great Grandfather was not a good boy? Did you ever here about what happened to him? They probably told you about how he was killed in a collision with a train. I will tell you the real story. A train didn't kill him but I know he wished it would have. He looked at it. He peeked. He wanted to see what he was keeping safe. That's what got him in trouble. His curious eyeballs got him in big, big, trouble!"

She spun around like an excited ballerina and continued speaking to him as the big man lie on the floor groaning. She walked around the tarp touching it with her slender fingers. She almost sang his name, "Harry, Harry, you didn't peek. Harry, Harry, what a good boy you have been."

She was making Harry nervous and he liked to talk when he was nervous. He spoke up as he wrung his hands together, "I never peeked. I did what I was told to do. Mr. Cheng is gonna kill me now because of you. You say you're gonna pay me millions of dollars but how can I use the money if I'm dead floating in the river? You gonna protect me now?"

The small woman stopped walking and stood still, like a bird of prey watching from high in the trees. Her face didn't move but her eyes whirled onto Harry's eyes. He felt like her gaze was enough to kill him. Harry's legs began to shake wildly and he could barely stay focused on standing. She invoked such fear without even a threat. She shouted at him, "Shut the hell up! You vermin! You miniscule spineless creature! You incomprehensive organism! You infuriate me!"

As she screamed at him she ran across the floor and grabbed the big man who was still groaning on his stomach on the floor. She grabbed a fistful of his hair and picked him

up with one hand. The man's eyes rolled back in his head and she held him up with her one hand while his feet dangled like wooden puppet shoes. She pulled a long steel blade from somewhere in her pants and pulled back his neck, exposing it to the flashing blade. The small woman sliced his neck open from the back of his right ear to his left shoulder. The attack was so swift and ferocious that at first there was no blood. Harry only saw a flash of metal and the blur of her arm motion. She held the big man by his hair and then his neck opened up and his head snapped back.

The big man's mouth tried to speak but only a bubble of blood popped out and then his neck wound opened a torrent of spewing blood. The woman tossed aside his body like ridding herself of the morning trash bag. Harry urinated in his pants. He didn't even feel the warm liquid running down his legs as he watched the big man die. The concrete floor of the garage filled up with the pooling blood. He watched as the blood flowed towards him and began pooling around his boots. He was too afraid to move away from it so he stood there surrounded by the crimson flow and watched the woman as she turned back towards him. Her face was unemotional now and she said in a low voice, "Harry, don't worry, the big bad Mr.Cheng won't get you. The Establishment owes you, so," and she shouted at him again, "quit being such a baby!"

"Now Harry, Mr. VW salesman, why don't we conclude our business?" The petite woman smiled again and brushed past Harry, stepping in the blood as she walked by. She reached the edge of the tarp and flipped it back. She continued rolling it back until the tarp lay in a heap in the corner of the garage. Harry just stared uncomprehending at what had been hidden under the tarp that he had never dared to look at. There was nothing there. He couldn't comprehend what

had supported the tarp when there wasn't anything beneath it. He could see the garage floor and the far wall. Whatever was under the tarp was now gone. It had completely disappeared when the tarp was removed. He expected the girl to become enraged and attack him and he held up his hands, saying, "I didn't do it. I haven't ever even looked at it. I don't know where it could have gone!"

She smiled that strange smile and shook her finger at him, and she replied, "It is still there you just cannot see it. Notice how the floor is slightly blurry. It is transparent. The device has been in "safe" mode all these years waiting to be awakened with the key."

They both turned towards the garage door as they heard a car pull into the used car lot. The woman looked at Harry and said, "Hurry, see who it is and get rid of them. I don't have time for this."

Harry, glad to be away from the woman and the dead man pooling blood, went outside the garage. Harry immediately knew he was in more trouble when he saw the big black car stop. Four men in dark suits with black sunglasses stepped out of the car. One of the big men rushed to open the back passenger door and Harry saw Mr. Cheng get out. Mr. Cheng was shorter than five feet but he carried and air of power that wafted on the air like a strong stench from a rotting carcass. He was not really or young. It was hard to tell his age but his shiny baldhead made him seem more mature. Mr. Cheng also wore dark sunglasses. The four men in suits stood next to the long car as Mr. Cheng walked towards Harry, saying, "Ah, Mr. Orchin, how are you today? I hope all is well."

Harry stepped forward and said, with a hitch in his voice, "Mr. Cheng, so good to see you. Everything is just roses. What brings you by my place?"

"I am here to pick up what you have been keeping for me. We had an agreement, Mr. Orchin, remember? You had better hope you have remembered our agreement. I would hate to think what would happen to you if our agreement isn't kept."

Mr. Cheng smiled; exposing his pointed little stained teeth. He reminded Harry of a silly weasel. Harry threw up his hands and started spouting off at the mouth. He was so afraid of Mr. Cheng he didn't know what else to do. He was losing his composure and he laughed in between sentences like a lunatic. Mr. Cheng raised his eyebrows and frowned at Harry's spouting off. Harry laughed weirdly and was saying, "She came in here and bought the VW bug. She was driving a VW bus. The other man wanted it too. Not the VW. He wanted the thing. She knew about it too. She got something out of the VW bug and then she killed the other man in the garage. She threatened me too. I was standing in his blood. He's dead. Blood everywhere. It was pouring out of his neck. She is dangerous. She is fast and knows too much. I didn't know what else to do but stay out of her way and do what she said. I warned her about you Mr. Cheng but she didn't care. She kept talking about them. She kept saying it belonged to the Establishment."

Mr. Cheng nodded to the men in the dark suits and they walked towards Harry grabbing his arms and pushing him towards the garage. Harry kept babbling, "No, Mr. Cheng, don't take me back in there. You don't understand. She is dangerous, I told you. Please, please..."

One of the men holding Harry's arm slapped him backhand across the mouth and Harry yelped in pain. He hung his head and stopped shouting but he was breathing hard and fast as they dragged him to the garage door.

Two of the men held Harry by the arms and the other two

approached the door, waiting on instructions from Mr. Cheng. He said, "Open it!"

The big men in dark suits opened the door and went inside followed by the other two men dragging Harry Orchin, the used car salesman. Mr. Cheng was the last to enter and he pushed his way forward in front of his men to confront the small unusual woman. She was across the large garage with her hands in her coat pockets. He spoke to her, trying to insinuate congeniality, "Hello, I am Lo Cheng. Harry tells me that we both want the same thing."

He glanced down at the dead man on the floor and continued, "I see that no measures are too extreme to get what we want. What is your name?"

The woman smirked and barely replied, "I am Jiko. This business is not your business. I am sorry that you have imposed yourself into the Establishments realm. You realize that you will now not be allowed to leave this place. Ever."

Mr. Cheng threw up his hands and laughed loudly in his squeaky voice. He pointed a crooked finger at her and said, "Ha! Miss Jiko! I surely think even if you have a gun concealed in your pocket you could hardly kill all of us before we kill you."

The four men in dark suits all produced weapons, two short machine guns and two heavy pistols. Jiko was watching the men all aim their weapons at her and then she smiled. She laughed loudly and then said, "I don't have a gun in my pocket! Here, I'll show you."

She withdrew her hand very slowly from her pocket. She held up a small odd key. I have the Establishments key. The thing would not do you any good without the key. You want it?"

Suddenly she was gone. She smiled and held out the key

in front of her and then she vanished. The invisible object shimmered and the men could see that there was something in the room with them. Harry thrust himself back against the garage wall. The armed men looked at Mr. Cheng for instructions. The shimmering started a low hum in the garage and Mr. Cheng started to approach the large blurry object.

Jiko had opened the thing with the key and jumped inside. She activated the ignition with the Establishments key and the panel instructions lit up inside the shell. The thing was visible from the inside even though the outside was semi-transparent as it hummed into life. The thing was a huge Nautilus shell with secret technical capabilities bestowed by a long forgotten race. The Nautilus macromphalus lives within a spiral shell containing up to thirty chambers. The creature has tentacles and propels itself in the ocean by jet propulsion, pushing water through the chambers. The chambers also hold gas that enables the creature to have buoyancy in the sea. The chambers of the thing, the advanced form of Nautilus shell, contained superior circuitry and components beyond mankind's capability. The key, safe inside the VW bug and many other hiding places before that, was the only remnant of a dead people from a volcanic island. The sea had claimed the island long ago. Only a reef filled with sharks and crustaceans remain where once a small but diverse intelligent people thrived in isolation. The thing in Harry's garage and the key was all that is left of that lost tribe of ancient people.

Jiko turned the key to the farthest position. The humming sound intensified to a smooth roar. The Nautilus became visible and within the clear chambers the men could see Jiko adjusting controls. Mr. Cheng shouted, "Stop! Stop her! Shoot the woman!"

The men began firing their weapons and bullets bounced

off the hard shell of the Nautilus. The shell vibrated and then the roaring stopped. The men emptied their guns into the Nautilus and smoke filled the garage as the men watched helplessly as the Nautilus slowly lifted off the ground a couple of feet. Jiko, reading the panel with superior intelligence, twisted a long slender knob and the Nautilus turned to face Mr. Cheng.

Two silver cylinders moved slowly out from the pearl-white shell like pistons. Lo Cheng could see the eyes of Jiko inside the space of the Nautilus shell. She winked at him and pushed a button in front of her. A thick gray gas erupted from the cylinders and filled the garage. Lo Cheng and his men stumbled about choking on the thick gas. Jiko watched as they fell to the ground in coughing fits. The Nautilus hovered higher in the garage as the men stopped breathing, poisoned by the Nautilus. The top curve of the shell pointed straight ahead and the opening produced a slender mechanical arm that ended in a needle-like protrusion. Jiko pushed another button and white light shattered the garage walls in all directions. Jiko was thrust backwards as the Nautilus shell thrust forward like a speeding fighter jet out in the used car lot.

The Nautilus crashed full speed into Harry's Used Car Dealer sign and smashed it into hundreds of pieces. Jiko gained altitude and circled the burning pieces of Harry's garage and car lot. She saw five black cars pulling into the car lot and knew the Establishment had arrived too late. She had deciphered her ancestor's controls and shot into the clouds. She left the VW bus and VW bug as souvenirs for the hated men of the Establishment.

Each of the thirty chambers of the Nautilus powered up and the objectives of the ancient science smoothly activated under Jiko's control as the shell shot into space. Jiko initiated

data retrieval and language stimulation proceedings on the head panel. She put earpieces on and relaxed as the Nautilus shifted into orb buoyancy. Her speed increased and the Nautilus stabilized pressure for deep space travel. Jiko smiled and drifted into a cryogenic sleep, safe within the spiral shell of the Nautilus. The frozen tubes of embryonic significance were secure. She was the hope of her lost race. She would find another island under another sun.

Louisiana Luke

They say there are weird things in the world. I have heard tales of the strange and bizarre. Wise old men used to whisper the truth of what lies out there, in the dark, in the unexplored regions of the world; the thickest impenetrable jungles, the highest inaccessible frozen mountain peaks, and the hottest wasteland of the infinite desert. I would expect that only about ten percent of the educated civilization believe in any of the strange and bizarre truths of the world. The civilized population lives their frantic lives with blinders on. The busy life of Joe Blow is like a racehorse on a curving track, seeing only what lies ahead and the sidelines go by in a hazy blur. It is what lies in those hazy sidelines that we need to stop and examine. The tales are true and the stories, the myths, the dreams of the ancient: all mirror the truth like the reflection of a mountain in a vast lake.

The truth is always in the shadow. The fallacy lies in plain view under a noonday sun and a crowd of people with wide-open eyes, seeing an illusion of our perceived reality. I have to say there are weird things in the world. You better believe it.

The forgotten sailors of the world told tales of the giant squid. They drew maps of the flat world and penciled in monstrous creatures, sea serpents and leviathan red squids. The valiant armored knights of Europe were depicted in paintings in the royal courts battling massive, hideous dragons, breathing fire and belching smoke. Mermaids surfaced in the

dreams of the ocean going men of many generations. For centuries witnesses have encountered the large hairy man-like creature of the lonely woods, the secluded swamps, and the high mountain regions of the world. I am here to tell you that there are weird things in the world that will always be out there. Just because you cannot touch them does not mean they are imaginary or invisible. The truth always lies in the shadow. You better believe it.

The legends will never die. Each time a story fades from the public a solitary man will be walking a dark path on a road he didn't mean to take. The man will search the darkness of the woods on either side of that dark moonlit road and he will hear the call of something almost human and almost animal. In the flickering of an instant when he stands in the place where he was not supposed to be he will cross the line of fate and become a witness. The man will momentarily stumble into this hidden region, this rare origin of the unexplained. He will hear the calls and he will see the shadowy shape step from the trees. His breathing will stop and he will see, only for an instant, the massive creature of dream and legend. He will join the small minority of the believers.

Another man will be fishing off a remote island, reeling in hooks devoid of fish and watching the setting sun melt into far off waters. He will see the line grow tight and pull hard, tugging his pole. The man will stand in his boat and stare at the evening water reflecting the fading light as darkness creeps closer to the sea. He reels his line in and in a fleeting instant he is witness to the breaking of the water's surface. The man sees the glistening, slippery wet skin and the powerful splash. He blinks his eyes and the vision of the legend is gone. He sees one more flash of the elusive swiftly moving shape beneath his boat. He pulls his line in and stands in silence, listening to his

own breathing as he tries to register what creature he has just witnessed. He saw it. He has become one of the believers.

This scene takes place all over the world in the secret places where fate has forgotten to warn its visitors. The miniscule number of believers has no impact on the truth. The masses would rather live with heads buried in the sand of the hottest desert. The masses would only destroy the truth.

Luke Gowens became one of the believers last summer, ten days before his thirteenth birthday.

Skinny Luke happened to be far away from the road and far away from his house on that hot humid summer day. He liked roaming the swamps outside of the suburbs of New Orleans. Every Saturday morning since he was old enough to go exploring by himself he had been journeying into the swamps in search of solitude and adventure. Luke could shoot his pellet gun like an expert marksman and hit a dragonfly landing on a rotten tree stump at twenty yards. Armed with his pellet rifle and fishing pole, a backpack filled with cupcakes and cokes, tackle and string, fish knife and compass, he would walk to the edge of the river and launch his old canoe. Luke loved to paddle out of civilization and into the vast waterways of the Mississippi River.

He would paddle leisurely through the tributaries and into the creeks that wound like mazes into the depths of the swamp. Luke always had a keen eye for observing the myriad of wildlife that inhabited the Louisiana swamps. The warm water lapped at the sides of his canoe and the ripples spread out slapping up against the many dead trees that thrust up from the green water. The deep swamp was like being in a tropical jungle where all the land was covered with water. Luke tipped his baseball cap back on his blonde head and slapped a mosquito away from his face. Blue and red dragonflies landed

on the front of his canoe and hitched a ride down the waterway. He paddled close to the wooded bank and watched skater bugs scurry across the surface of the water like Jesus insects.

He watched the Great Blue Herons standing motionless in ankle deep water, waiting for small perch and minnows. He paddled around a curve in the waterway and disturbed Louisiana's State Bird, a big brown pelican. The pelican spread its huge wings and blasted into the air out of the water like a prehistoric pterosaur. The startled pelican frightened flocks of white egrets and roseate spoonbills into flight. Luke watched the brilliant blue summer sky as it filled with white and pink birds flapping hurried wings towards a safer landing place, away from his canoe.

He paddled slowly past a big eight-foot alligator sunning on the muddy bank almost blending in to the brush like a fallen tree trunk. Every now and then he would see alligator heads, eyes and nostrils poking up out of the green water. The alligators kept a safe distance between themselves and the canoe. Luke kept his pellet gun close by in case one of the reptiles got any ideas of eating the canoe but he knew alligators rarely attacked people. He did hear of a story his Gramps had told him about a boy named Stevie Johanson that was eaten by a big alligator. Gramps talked real slow and made every story sound scary, even if it wasn't supposed to be. He remembered his Gramps and wished he were still alive. Gramps died of a heart attack two years ago. Gramps had taught him a lot about fishing and navigating the swamps. He could still hear Gramps talking about little Stevie Johanson.

Gramps would say, "Luke, son, most people say gators won't eat people unless they is provoked. Well, I can tell you most people is wrong. There ain't much difference in a big hungry gator and a big hungry crocodile and crocodiles for sure

eat about a dozen Africans a month. The swampland is where a lot of big-ass bull gators live and most people never run across them. Not many people ever go deep enough in the swamp to see those monsters. Ask the Cajun families that live way back in there and they'll tell you 'bout gators eatin' anything that ain't bigger than they are. I remember little Stevie Johanson out fishing only a hundred yards from the family houseboat. He was on a flat bottom raft near the far shore with a cane pole in the water trying to haul in sunfish perch and black bullhead catfish. His father, Paul, was on the houseboat watching him fish as he fixed his damaged crab traps. Stevie was pulling in his line hollering that he had a big catfish and then suddenly the water exploded in a terrific splash. A big bull gator leapt out of the water onto the flat raft and grabbed little Stevie by both of his legs. The gator dropped back in the water with little Stevie screaming and holding onto his cane pole. The gator and little Stevie disappeared instantly and his father, Paul, stood watching helplessly as the raft drifted away. The ripples from the incident fanned out over the water and lapped against the houseboat. Paul got his shotgun and ran to the edge scanning the surface of the green water. There wasn't anything the man could do. A big gator had taken his son and he never saw him again. A week later they found his broken cane pole washed up on a small swamp island about two hundred yards away from where he was attacked."

His Gramps had paused here for almost a full minute before he continued on, "When you go back in the swamps you remember to respect the gators and keep an eye on the big ones. Never trust those big reptiles. Maybe they don't get as hungry as crocodiles but they still like the taste of human flesh."

Luke smiled remembering his Gramps words. Luke had

been around alligators all his life and maybe he didn't fear them much but he respected them. Luke was more afraid of another killer that populated the swamps and the river. Luke feared the deadly black snake, the highly venomous, cottonmouth water moccasin. When Luke would see one of those snakes swimming through the thick water he would try to kill it with shots from his pellet rifle. More often than not he usually hit the snake and it slunk beneath the water. Luke's father had been bitten once by a water moccasin and almost died. The snake that had bitten his father was already dead when it attacked. His father had killed the snake and cut off its head with the garden hoe but the decapitated head was still snapping and bounced on his father's leg. The biting head thrust the two poisonous fangs into his father's leg, injected the toxic sauce from the snake into his blood stream. Luckily he received the anti-venom soon enough to counteract the deadly poison. Luke was already afraid of poison snakes before that happened and now he fervently hated cottonmouth water moccasins. He vowed to himself that he would try to kill each black snake he encountered on his forays into the swamp.

The canoe glided easily through the narrow waterway. Ripples spread out behind Luke like a smooth velvet rug with wrinkles. The suns rays barely touched Luke and the canoe now as the waterway narrowed and trees on both sides bent over to shade the water. Big ancient willow trees stood like forgotten guardians along the banks and marsh reeds lined up like drinking straws in a box. Luke watched a giant bullfrog flop headfirst into the water, belching a loud croak before diving ahead of the canoe. Look stopped paddling and let the canoe drift as he watched both banks for signs of the bullfrog. He hoped the big frog would pop back up out of the water so that he get a shot at it with his pellet rifle. Luke usually

brought home quite a few bullfrog legs for a Saturday fish fry. The narrow waterway that his canoe was drifting in was dark and the water was getting too shallow. The canoe finally hit bottom and stopped. Luke sat very still watching for bullfrogs with his pellet rifle ready. That is when he heard the snapping of twigs and the sucking sounds of mud back in the trees.

At first he figured it was Cajun hunters back in the trees, probably hunting wild hogs or alligators, or maybe swamp deer. He ducked down low to hide from their sight. Cajun's weren't the friendliest people and most didn't like people coming in here and hunting or fishing. Most Cajun people believed that they owned the deep swamps and made their own rules. Everybody figured they could kill you in there and your body would never be found anyway. As the noise got closer it sounded as if there was more than one person or animal moving through the trees and the mud. It didn't sound like a big alligator and if it were a swamp deer it was the biggest, noisiest swamp deer he had ever encountered. Luke thought that if those noises were coming from deer they must be big as a moose.

He got down on his belly in the canoe with only his head sticking up and watched, breathing quietly. He watched through wide-open eyes as a huge dark shape slowly came out of the trees towards the water. At first Luke thought that it was a big buffalo. His mind reeled at the thought of some escaped Wyoming buffalo wandering around in the Louisiana swamps. It was large and brown and covered in thick hair. As it got closer he saw it wasn't a buffalo at all. It was something else not even close to a buffalo or a bull or even a wooly mammoth. It was a giant man-like hairy "thing." Luke ducked lower in the canoe, scared as a rabbit hiding from a coyote. The hairy swamp man-thing was taller than Shaq and was even uglier.

Luke knew this must be one of those Fouke monsters, the Yeti, Sasquatch, Bigfoot, big everything hairy creature-man. Luke saw that the massive swamp man-thing was dragging something huge behind him through the swamp. Luke watched the creature and noticed that his big fist was curled around the fat tail of one of the biggest alligators Luke had ever seen. The swamp-man was dragging the big alligator by the tail as it struggled and hissed and thrashed back and forth. The alligator was at least twelve feet long or more and the swamp man pulled it by the tail like it weighed about as much as an old bean bag chair.

Suddenly the swamp man stopped about ten feet away from the canoe and looked directly at Luke. The creature's eyes stared into Luke's eyes. Luke felt a cold feeling spreading all over his skin. The swamp man's eyes were ice blue set deep in his black wrinkled hairy face. The swamp man looked sort of like a gorilla but different. His mouth was smaller and his nostrils larger. Luke couldn't see his ears because they were covered in the shaggy brown hair. The swamp man's hair was extremely long, strands hanging down from his arms almost two feet. The alligator stopped writhing as the swamp man stopped to stare at Luke, but it continued to hiss loudly. Luke was terrified, expecting the monster to drop the big alligator and run towards him. He thought that any second the swamp man would grab him and bite his head off. He knew he would be easier to kill and eat than a twelve-foot alligator.

Those intense seconds that the two beings stared at each other across the space in the swamp seemed like hours. Luke's thoughts raced to escape but he remained motionless sitting up in the canoe. The swamp man suddenly threw back his head and let out a loud sound that pierced the swamp for miles. The bellow of the swamp man sounded as if a wolf was trumpeting

like an angry bull elephant and it wound down to a mournful whine as the swamp man looked back once more at Luke. He then turned and ran off into the thick growing trees, dragging the hissing alligator behind him.

He disappeared instantly, so quickly was he gone that Luke doubted he had ever been there. He sat back down hard in the canoe and started shaking. He stared at the dark swamp. He listened for the sounds of splashing. Even the birds had stopped chattering. The only sound was the water lapping at his canoe and the slight breeze rustling the weeping willow trees. Luke sat there for a long time. He sat there staring straight ahead and he didn't realize that the sun was beginning to set. Hours had passed as he sat there in the canoe, dazed. Finally, as dusk touched him on the shoulder Luke snapped out of his daze and he grabbed a paddle. He looked back once into the mud of the swamp and saw a large footprint as he paddled. Luke backed the canoe out into the waterway again, heading for home.

Yesterday Luke paddled the swamps with confidence and knowledge of all creatures within his realm. Today as he paddled for home, he had transformed into a man instead of the boy that traveled through the Louisiana swamps. Luke had seen mystery and legend, and he was now one of the believers.

When he got home it was dark and his mother scolded him for being late. He ate very little of his supper and didn't really want to watch the television with his mom. He never said anything about the swamp-man-monster-thing to anyone. He knew he was special to be in the right place and the right time. He had been given a gift by Fate. He had become a believer and nobody else needed to know his secret truth.

Luke graduated with his Doctorate in Zoology from LSU. He travels the world working for animal conservation and

environmental studies. Luke Gowens never saw the swamp man again but on dark nights when he cannot sleep he stands on the edge of the swamp and remembers those bright ice blue eyes. He stands in the cool breeze of a Louisiana night and listens for that far off sound of something that sounds like a wolf but isn't.

Boei

The lion roared. He opened his mouth and bared his large yellow teeth, slimy with saliva. The lion was as big as a small horse. He roared at the jackals and hyenas that circled around him and his kill. The massive male lion did not actually kill the gnu but had chased off the female leopard that was responsible. She had leapt out of a small tree and onto the young gnu's hairy back. The gnu is a herding cow-like antelope and is a favorite prey of almost all African predators. The female leopard had killed the gnu an hour before dawn and scattered the resting herd. The big lion had smelled the scent and charged towards the leopard while she was trying to drag a part of the carcass into the tree. Scattering the yipping wild dogs and jackals and bursting through the ranks of snarling spotted hyenas, the rogue male lion rumbled onto the scene like a great white shark into a feeding frenzy.

The lion ate with bloody crunching jaws. He kept his eyes on the growling creatures that circled, waiting and watching for an opportunity to rush in and steal the meat. The hyenas were big enough and ferocious enough to organize when they were hungry. They cackled and growled while they gathered their courage up to rush the rogue male lion. The lion grew agitated while he ate and tried a couple of times to lift the entire carcass in his massive jaws, trying to carry it away from such dangerous, hungry company.

Suddenly another loud roar came from over the hill that

looked down onto the grassland. The lion was eating the gnu carcass shadowed partially by a wide tree. The few trees that dotted the grassland were starting to fill up with large African vultures. The white-blue vast sky was dotted with soaring black forms, more vultures. The big lion dropped the hind leg of the dead gnu and looked towards the hills where the roar had originated.

Another roar, louder than the first, penetrated the air. All the frenzied animals grew quiet. They stopped their circling and pacing to turn and look towards the crest of the hill. A huge shape appeared on the peak of the grassy hill overlooking the gnu feast. The animals had not smelled this intruders approach because the wind blew his scent in the opposite direction. The roaring started again and the hyenas scattered, running in all directions with their short tails tucked between their hindquarters. The jackals and small hunting dogs disappeared almost instantly into the sea of tall grass. The huge male lion stood his ground, covering the gnu's carcass with his massive belly. He roared back a challenge to the intruder.

The huge shape on top of the hill roared back. The lion coiled his hind legs preparing to attack. His ears flattened down on his dark mane. The intruder was not another lion. The intruder was a man, a different type of man. The rogue male lion had killed men before. The African warriors with black skin, painted like rainbows and skeletons had hunted him many times. He had killed a few of them and dragged their screaming bodies off into the brush. When he was younger he had once ambushed a family near the dry riverbed during the drought, when food was scarce. He had killed and eaten a man and a woman. The child had been killed by hyenas and ripped to pieces in a matter of minutes. The lion had seen men kill hyenas with a loud noise before.

The lion remembered that men could kill with noise from a long distance but this man was not the black painted kind. The man was extremely large. This man was as tall as two of the native men standing on each other's shoulders. This man's skin was not as dark as the other men. The lion growled and bared his teeth, wrinkling his nostrils and exposing his black gums. The man on the hill slowly walked towards the lion with his arms outstretched. The man was baring his teeth too. This man did not have one of the sticks that kill. He was a giant but he was still a weak man without the noise that kills. The lion charged when the man reached the bottom of the hill.

The man stood his ground. He was naked. His skin was brown and smooth. He was completely hairless. The big rogue male lion roared and ran swiftly at the giant man. The man met the lion's charge with open arms. They both went down in a tangle of flesh and hair. The giant man encircled his arms around the lion's throat and wrapped his legs in a lock around the lions back and belly. The big lion rolled on the ground trying to get his sharp claws and canine teeth into the naked flesh of the giant man.

On the crest of the hill the hyenas watched and eyed the dead gnu. The jackals and wild dogs were already creeping closer to the carcass as the male lion and the giant man fought. The man was choking the big lion and with superhuman strength he bore down on its neck.

The giant man that fought with the rogue lion was not a natural man. He was larger by far than any human ever to walk this earth. He had lived his entire life without speaking to another human. This giant man emerged from the earth after a hibernation of thousands of years. He was new to all life forms. He was a new species. He had climbed from beneath the root system of an ancient tree near a waterfall and walked

into the pouring water, rinsing off the dirt from thousands of years of sleep. He was not human but he was a man. The lion was slowly being choked to death. The giant man did not have a name or a family or even a homeland. He had never even seen a human before. He had been walking on the earth for only two days now and had killed three lions, two leopards, a dozen hyenas, and a warthog.

He was buried in the ground in a hard sac as an embryo and had been nourished by the tree and the soil. The sac had grown as he slept for thousands of years. Two days ago he had climbed out of the hard sac that had grown brittle. He dug away at the loose soil and pulled himself up into an African night. The first sound he heard was a massive waterfall near his tree. The giant man plunged into the water as if he had been in water all his life. He gulped mouthfuls of the water and felt invigorated. Growing hungry and needing fuel for his large frame he stalked out of the river near the waterfall and killed a sleeping warthog, dragging it from its muddy den. He ate the lean pig raw, ripping off chunks of flesh with his teeth and his bare hands.

The giant man began roaming and exploring his birthplace, eating and drinking and killing. He had been clawed by the first lion he had fought and also by a leopard but his wounds had already healed. His skin revealed no evidence of the scars. He was pulled in a northward direction by some internal instinct. Anything aggressive that was in his path was doomed to be killed. He tightened his grip on the struggling lion and finally he heard a loud crack. He broke the rogue male lion's neck with one surge of power. Dropping the lion from his hold, he stood up and walked towards the dead gnu. He pulled a leg from the carcass and began eating the raw, stringy muscle from the bone.

He carried the leg with him as he walked away from the dead lion, leaving both dead animals for the scavenging hyenas, wild dogs, jackals, and finally the dozens of flapping vultures. His mind was young and fertile. With each passing moment he learned many things. He absorbed all of the noises around him and began to understand what animals made what sounds. He learned to sort and select which plants and vegetation was edible and he learned that all creatures were afraid of him. Dusk approached the land once again. This would be his third night since he clambered from beneath the tree. He did not sleep. He never rested. He never stopped moving in a northward direction.

The moon was full and the African sky was violet filled with billions of stars, twinkling like the scales of a thousand glittering lizards in a sand pit. The giant man looked at the moon and he was drawn to it. He tried to reach into the sky and pull it down to him. The giant wanted to hold the beautiful moon in his hands. He had even tried climbing trees to get closer to the moon. The strange giant man wanted to touch the moon but it was always too far away.

He saw a bright light far ahead of him to the north. Walking faster with curiosity motivating his legs the giant strode boldly through the tall grass towards the light on the ground. He thought that maybe it was another moon that had fallen from the sky. He began to run towards the light, hoping he could finally touch a fallen moon.

Noise reached his ears. Noise unlike any he had heard so far. He heard a thumping sound. He walked closer and saw many creatures built like him, with two legs and two arms flailing about a fallen light. The fallen moon blazed like the waterfall with beauty. The forms danced around the fallen moon. Many of the forms pounded their hands on round

objects and created the thumping sounds. He saw a dead animal burning in the moon's fire. The smell of cooking flesh stirred his hunger again. He was always ravenous. Deciding to eat again he strode towards the dancing forms and the fallen moon's fire.

He walked directly into the center of the campsite of the dancing natives before they had even realized an intruder existed. The flames glistened off his smooth skin. His pale blue eyes glowed in the reflection of the big fire burning in the center of the camp. The painted natives stopped their dancing and ran away from the circle of the fire's light. The natives grasped their crude spears tightly and stared at the giant. The many eyes, glaring white out of their dark faces resembled the myriad stars in the dark night sky. The giant walked to the fire and its flames seem to not inflict pain on him. He reached within the fire and pulled a hunk of hot meat from the cooking animal. The native tribe continued to watch him with fear and backed farther away. He chewed the hot meat, with juices dripping down his face and his chest. He watched the natives with curiosity and saw that they resembled parts of his body.

The warriors of the tribe bunched together and began discussing this intruder with their chief. The men of the tribe had decided with the suggestion from the rune-witch man that this intruder was a god. The rune-witch man had proclaimed that this giant was, Boei, the god come down from the fire mountain to bless the tribe for their sacrifices to the mountain. This god would need gifts and he should eat their food and drink their fermented brew. The chief ordered his nephew to bring a large pitcher of the brew to give to the giant fire mountain god, Boei. The giant man watched as a small black man with ribs painted like a skeleton walked from the crowd and held something out to him. The giant bared his strong

teeth, dripping with saliva and fat from the hot meat and took the object from the small man. He looked within the pitcher and smelled it. He dropped the piece of meat back into the fire and began quenching his thirst, gulping down the bitter liquid. He finished the pitcher and turned it upside down trying to find more. He looked back into the crowd of natives who now were all on their knees.

The chief shoved another young boy from the crowd carrying another picture of the fermented brew. The giant man grabbed the pitcher and the boy ran quickly back into the safety of the crowd. The pitcher full of brew was empty again in minutes. The chief stood up and was followed by many of the strongest and bravest warriors. He came back out into the area of the camp lit by the large fire. He stopped about ten yards from the giant man. The chief spoke with fear and authority in a strange mix, "Boei, our greatest god! Boei has come to bless our people. We offer our gifts of food and drink. We have shown our respect for the god of the fire mountain and now you come to bless us with your presence. What other gifts would you take from our humble people?"

The giant heard the strange sounds coming from the black man with gnu horns on his feathered headdress but he could not understand their meanings. He only heard more noises. He looked past the skeleton painted warriors and the gnu headed man. He saw another strange man with a lion face and lion claws hanging around his neck. The giant scanned the crowd and then threw back his head and roared. The sound was tremendous and was louder than a bull elephant's trumpet. The natives all immediately fell to the ground in fear. The natives began to chant as they lay face down trembling in fear. They chanted, "Boei, Boei, Boei."

The giant man was fascinated by their actions. He wanted

more drink and he searched the praying natives for signs of the liquid carrying objects. He saw one by a large grass hut. The giant walked to the hut and picked up the pitcher and began drinking the bitter fermented drink again. He glanced inside of the hut.

The hut was the camp's gathering hall. It was the largest hut in the village. On the night of the hunter's dance all the women stayed inside until called for at the apex of the dance. This night was such a night, the hunter's dance of the full moon. The giant man knew that the warriors resembled him. He had thought at first that they were his people but he instinctively knew they were not. Inside this hut was another type of human form. The giant did not know what a woman was. Inside the hut were all the women of the tribe, forty - two painted females. The giant saw the nude painted females and felt something other than hunger, thirst, or violence. He looked in the hut and felt compelled to learn more about these painted creatures.

This was the first time he did not heed the instinctual call within himself to move northward again. The tribe's women huddled up in a corner as he ducked his large baldhead inside the hut. The queen stood in front of the rest of the women, painted like a leopard and adorned with peacock feathers and ostrich plumes on her head. She was old and afraid but she tried not to show any fear. She spoke to the giant man, with a trembling voice, "Boei, fire mountain god, you have come to bless us. This is a hunter's dance, perhaps you desire to hunt for something other than food or drink?"

She turned slightly calling out a name, "LuTi Ko Lo! Come forward! LuTi Ko Lo, you will be honored among the tribe and your family given blessing of cattle and goats for many generations! You will go with the fire mountain god,

Boei. You are our gift to Boei. Now, do not be afraid. Come forward and offer yourself to Boei."

A very young black woman with small breasts and athletic legs slowly, timidly walked towards the giant. He saw the small black girl. He watched the bounce in her breasts and hips as she came forward and something shimmered inside his blood. His heart pounded and he grew excited. He became aroused and he stood like a massive tower of manhood over the tiny native women. The northward pull within him was obliterated when he felt the tiny black woman reach out to touch him. A slow spreading feeling of pleasure, beyond eating, beyond drinking, beyond killing, overcame him. He reached down and picked the small nude woman up and impaled her on his manhood. The women of the tribe all breathed heavily as they watched a god plant his seed within one of their mortal sisters. The men were crowded around the entrance of the hut, watching this amazing spectacle unfold before their eyes. The story of how the fire mountain god came down to bless their tribe and spread his line of godliness among their people would be told forever in the generations to follow.

The giant stood with his knees bent thrusting into the tiny woman straddling his waist. The painted nude woman threw back her head and howled. The giant held her up with his massive hands beneath her arms and he roared like the fire mountain itself, pounding out boulders and fire from within its rumbling depths. He was consumed by a pleasure so intense he felt as if his skin was on fire. He felt like he was growing closer to the brightness of the full moon. Suddenly he trembled and his knees buckled. The giant dropped to his knees on the dirt floor of the hut. He lifted the tiny woman off his body and put her weary body in the arms of the queen, who rushed out to catch the exhausted woman.

The men and the women of the tribe all lay flat on the ground and quietly chanted, "Boei, Boei, Boei."

He waited for his breathing to resume to normal before he stood again. He felt the familiar instinct within him pull again towards the north. The giant man walked slowly out of the hut, without looking back. He walked out of the village in the direction of the mountain range to the north. The natives watched him go, murmuring about how they were blessed by Boei, the fire mountain god.

The giant man walked out into the darkness away from the fire of the other moon. He looked up again and found the bright full moon was still there waiting for him to continue his journey. The pleasure that had filled him in the hut with the tiny woman was almost all gone but he still felt a tiny residue that clung to his skin. He could also still smell the sex of the woman. Walking with purpose, northward, he scattered many creatures of the African grasslands. Suddenly a cobra reared up in front of him. The poisonous snake flattened its sleek head in a fan shape and hissed a warning at the approaching giant. He crouched down so quickly that the snake never saw his big hand sweeping through the air to grab it by its neck. He cracked the snake's seven-foot sinuous body like a whip, killing it. He bit into its shiny, scaled body and ate most of it during the next couple of miles that he walked. Tossing the half-eaten dead cobra aside, the giant hairless man began climbing big rocks heading up into the mountains.

Never tiring and never sleeping, the giant was a relentless force moving towards the unknown in the mountains. He was forever pulled by an internal force that he could neither fight or control. The giant man accepted his destination without knowing the final goal. His thoughts were simple but growing more complex by the minute. He was incessantly learning.

After climbing into the sunlight from under the tree and emerging into a new world, he had catalogued each new sight, each new smell and sound. The giant was propelled forward to the north but with each step his thoughts broadened from food and drink to beauty and violence, and now to pleasure and desire. Instead of each thought absorbing details in his surroundings and wondering in awe at each new thing, he now had acquired new thought processes, including, memory and reflection. The mountain path grew steeper and was filled with many large jagged boulders. A herd of Klipspringer antelope scrambled over the rocks like miniature mountain goats, only two feet high at the shoulder, as the giant disturbed their sleep among the boulders.

African sunrise lit up the side of the mountain and the moon fell from the sky to be replaced by the hot blinding new moon. The giant tried to stare at the moon like he did during the night but he found out again, each day, that the fire burned his eyes and he was always forced to look away. He skirted around the edge of a massive boulder and startled a small child. The boy was only nine years old but already hunting small animals with his spear. The little boy had dark brown skin and a red piece of cloth around his waist. He had hair like a porcupine's quills and small claws and teeth from various animals were tied around his neck. He had been scratching something into the boulder with his sharp pointed spear. When the giant man rounded the boulder and startled the boy he had fallen backwards, almost landing on his back. The boy stared with wide eyes at the giant man with the hairless naked body.

The giant man watched the boy, thinking that maybe he had the containers of fermented brew that had quenched his thirst before. The boy was afraid but now he grew bolder as he

saw that the giant did not seem to be threatening him. The boy lowered the point of his spear, which he hadn't realized had been aimed at the giant. Speaking in a high-pitched voice the young boy said, "Hello, what is your name and why do you come into the Ezula's land?"

The giant heard the strange high-pitched voice and he merely stared at the boy. The boy continued, "You must not climb this mountain anymore. My name is Kee and my uncle is chief of the Ezula. Go back down to the land of the WaHila."

The boy scratched his head and waited for the giant to respond. Noticing a small bag tied on the boy's belt, the giant could smell water inside of it. He stepped towards the boy to take the water from him. The boy jumped back immediately and hustled quickly about ten yards away, up the path. The giant bared his teeth and growled. The boy saw the giant staring at his water bag and he decided maybe the water would calm him down. He took the water bag from his belt and approached the strange big man. The brave young boy extended his hand out holding the water bag and the giant walked slowly towards him. The boy opened the water bag and the giant took it from him. He drank the water greedily and it was all gone in a matter of seconds. He held out the water bag to the boy. Frowning, the boy said, "Thank you so much for drinking all my water. Now I have to return to the village for a refill if I want to finish searching for the YooKiye mushrooms. Would you like to follow me to the village? You can only if you promise not to growl like a lion anymore. I don't think you know how to talk but maybe my uncle can help you."

The boy showed the giant man the empty water bag and motioned for him to follow. At a slow trot the boy wound his way up the steep mountain trail. The giant was pulled northward by the inner guidance and now he followed the

boy for more drink that he needed. They hadn't gone very far when the boy stopped and the giant man stopped beside him on the rocky mountain path. There were a group of six Ezula warriors coming down the path and they paused when they saw Kee and the extremely large hairless man. The lead warrior shouted, "Kee! Step away from the monster demon! Quickly! Run to us now!"

Kee held up his hand, shouting back at his people, "No! No, Weh Ju, the giant is not an evil monster demon. He is thirsty and only needs drink. I warned him not to climb these mountains but he must be very desperate for water because he follows me to the village without fear. I do not think he can speak and he doesn't understand our tongue. He can growl, though."

Weh Ju and the five warriors did not lower their spears but walked slowly forward taking in the immense size of the unusual giant man. Weh Ju saw the giant's cold blue eyes and pointed at him, shouting, "Eyes of the god's, eyes of the god's! He is not a man! He is not human!"

The warriors dropped to the ground and Kee followed them, not really knowing why. He did not think the giant was a god. He placed his face on the ground and chanted with the other warriors! The giant had seen humans act this way before and he searched with his eyes for containers holding liquid. All of the warriors carried water bags. He strode towards the warriors on the ground. As he moved closer their chants grew louder. He reached Weh Ju and pulled his water bag from his belt, ripping the belt and spilling the water. Kee looked up and saw the water splash on the ground. The giant was surprised and stared at the torn, empty bag. Kee got up and came over, asking the other warriors to remove their water bags. Kee brought the remaining water bags to the giant man.

Kee opened each bag and handed it to him. The giant guzzled each bag of water quickly. He needed the water but he still remembered the taste of the fermented brew. When all the drink was gone the giant started up the mountain path again.

Kee looked at Weh Ju and motioned them to follow. The giant seemed not to notice or he didn't care if the warriors and the boy child were following him. He traveled fast and they had to struggle to stay within sight of him. Suddenly the last warrior, Haka, screamed! They all turned around looking down the path. The giant had picked up the new scent long before he heard the warrior scream. He knew something was following them. The giant, propelled by his violence, ran past the startled warriors and Kee, towards the screaming Haka. He was flailing on the ground as a black panther had his ankle in its mouth. Haka had dropped his spear when the black mountain panther had ambushed him from the top of a boulder. The black panther had landed on his back jumping down from behind. Its sharp claws had ripped long jagged tears in his flesh. He had shrugged off the big cat from his back but the panther was too quick and had knocked him down, lunging at his throat. Haka had dodged the panther's teeth and the big cat grabbed his ankle, crunching the bone within and started dragging him backwards down the trail.

The giant roared as he jumped across Haka's kicking body and landed on top of the black panther. The big cat immediately let go of his hold on the warrior's ankle. The giant man grabbed the black panther by its neck with his large strong hands and picked it up, holding the squirming, growling cat away from his body. He looked at its yellow shining eyes that stared back at him with fury and rage. The giant man held the panther up over his head and swung it down against a solid boulder, cracking the panther's skull with the impact.

The giant's chest was splattered with blood. The black panther stopped struggling, killed by the tremendous force. The warriors watched in awe and Kee shouted in triumph. Holding the dead black panther by the neck, the giant extended the animal to Kee. The boy walked forward and stabbed the dead panther with his spear. The giant dropped it to the rocky ground at the boy's feet.

After the battle with the black panther, the giant had turned and once again resumed his journey up the mountain. The warriors helped Haka limp along with his injured leg and Weh Ju carried the dead black panther over his shoulder. They could not keep up with the giant and soon they were left behind. Kee told the story of the giant and the black panther for many years to come.

The pull on the giant was getting more powerful. He was also hungry again. He had traveled all day in the mountains and now the bright African sun was fading, replaced by a gray sky and the first hazy glimpse of the moon, low in the sky, almost touching the mountain's peaks. He felt like he was getting closer to the luminous globe in the sky. The giant man kept his eyes on the sky as the gray ceiling turned to black and the stars once again returned to delight him. He traveled for two more hours in the darkness, moving lithely and gracefully among the steep rocks. The higher the altitude the more he was pulled by the internal force. The air grew steadily colder but his skin was thicker than human skin. He could withstand intense cold and heat. This part of the mountain was up high enough to be in the clouds and he traveled in a thick fog. The moon and stars were obscured from his eyes because of the increasing clouds. He trudged along through banks of snow. His bare feet did not feel the cold. The wind had increased and whipped and surged against his powerful body. He scrambled

up an almost vertical rock wall like a gecko with suction cups on its fingers. When he reached the apex, he pulled himself over the jagged edge and clambered onto a flat snow covered stone.

He could faintly hear a unique sound. It was unlike any other sound of the grasslands or the jungle. He followed it through the snow, walking on a huge flattened stone, extending for over one hundred yards at the top of the mountain. A black jagged tower of stone protruded from the side of the mountain. It rose over fifty-feet high above the flattened surface of the snow covered stone. The giant stopped and admired the beauty of a sculpture created by nature. The jagged tower of rock sheltered a dark cavern from which emanated the unusual sounds. He approached the cavern and the sounds came to him clearly over the wind. He stepped foot into the cavern and saw a small black man sitting cross-legged on the bare rock.

The sound was coming from some type of instrument that the little black man held with both hands and his mouth. He looked like he was eating a slender wooden stick with carved decorations on it. The little man was blowing into the carved flute and the sounds filled the cavern, echoing deep into the earth. The giant was drawn to the music. The little black man was wearing a large coat made from giraffe skin. His legs were covered in the calico colored African wild dog furs. The music was soothing and mysterious and the man played with his eyes closed. He was not yet aware of the giant man's presence. The flute player wore a quaint hat on his head made from a lion's mane and the ribcage of a baboon.

Finally he stopped playing the music and opened his eyes. He looked up at the giant naked man who towered over him almost ten feet. The small black man put his wooden flute in his lap, and motioned for the giant to sit, pointing to a pile

of straw and broad dried banana leaves. The giant just stood there and watched the little man and waited for him to start playing the beautiful music again. Motioning again, the small, flute player, spoke to the giant, "Come in here out of the snow. Sit with me awhile. I have been waiting for you. My father waited for you his entire life and my grandfather waited too. For many, many generations we have studied the signs and researched your coming. I truly thought you would not come until another generation and I have taught my eldest son all about you. Someday my son would have taken my place here to wait for your arrival."

The giant listened to the words and couldn't understand the language but he could feel the little black man's thoughts and intentions in his head. The giant thought about drinking the fermented liquid again. He thought that maybe the little black man had some of the drink. The little man stood up and went farther into the cave and returned quickly carrying a very large gourd. The giant smelled the familiar fermented brew and he smiled baring his teeth. The giant's smile and grimace looked the same on his taut long face. The flute player again motioned for the giant man to sit down on the straw and banana leaves. The giant understood and sat down, looking at the gourd, smelling the scent of the brew. The little flute player produced two cups from beneath his giraffe skins and poured the brew into each cup. Extending one cup of brew to the giant he continued speaking to him out loud and also to his thoughts, "You are an infant and an adult, my large friend. The hard sac that you were born in was brought to our people when the earth was very young. We were told to plant the sac under the earth and fertilize the soil above the burial. We were nomads in those ancient times. We killed wooly mammoth, giant deer, plains okapi, and buffalo. We survived the ice age

when many of our food animals did not. Many tribes of people died out and their races vanished forever but we remained and we always made pilgrimages each year to the location of your sac buried deep in the ground."

He paused and produced a pipe from his giraffe skins and snapped two pieces of flint together. He created a spark that flickered into a tiny flame and he puffed and sucked air as he got the pipe to light. The giant had never seen anything like a pipe before. The flute player was aware of the giant's virgin mind. He extended the smoking pipe to the giant and showed him how to suck in and breathe out. The giant man took the pipe in his large hands and tried to smoke it like the little man had explained in his thoughts. He sucked in smoke and held his breath for only a few seconds and then he started choking and coughing. Smoke belched from his mouth and his nostrils but the little black man laughed and chuckled, retrieving his pipe from the giant's hands. He laughed and said, "No more pipe smoking for you."

The giant stopped coughing and the little flute player kept talking, "My name is Poho Abshuli. The natives around this mountain range call me a hermit, a witch, sometimes even a demon. My family visits me on occasion. I have my duties so I stay up high in the mountains while my family lives in the village of our people. I offer you anything you need to continue on to your destiny. I will be your guide northward. I need to sleep tonight but tomorrow we will be on our way. I realize you do not sleep but you are hungry."

He got up and walked back into the depths of the cavern and came back carrying a leg of fully dried antelope meat. He handed the leg to the giant and said, "I will sleep now and you should eat. When I awaken we will go north."

The giant ate the entire antelope leg and gnawed away at

the bone trying to get at the marrow inside. When he finished eating he picked up the brew container and swilled it. He sat back against the wall of the cavern and watched the little black man sleeping in a hollowed-out corner of the cavern. The giant sat there reflecting upon the events of the past few days, the fighting with many animals, the young woman who pleasured him and the small boy-child who entertained him. The giant man had learned so much in such a short time and he was eager to learn more. He liked the flute player and finally he could communicate with someone, even if it was awkward and not vocalized speech.

The wind, which had blown noisily all night long, had slowed to an almost imperceptible breeze. Poho Abshuli woke up and produced more meat and drinks for the giant and then played his flute while the giant ate and drank. Poho played vibrant songs full of color and radiance. The giant loved to listen to the flute. Poho finished playing a fast chirping song and then got up, hopping to his feet like a Jerboa, an African kangaroo rat. The giant stood also, following his lead. Poho gathered up his belongings and packed everything in a sack that he attached to his back. He walked out of the cavern and waved to the giant to follow him.

They followed a rough mountain trail and encountered more Klipspringer antelope, and they bounced away like jackrabbits. They walked half a day when Poho decided to stop and rest. He opened his sack and gave the giant two bananas and he ate one himself. They both shared drinks of water from his water bag. While they stopped Poho pointed to a massive mountain range north of them, saying, "there she is. That is Kilimanjaro, Africa's highest mountain rising up like some angry fire god looming above the continent. Kilimanjaro is where we go. She calls our names. Well, she calls my name,

Poho Abshuli; she only calls you from within. You do not have a name. You, I had been told by my father and his father before him, are above any name. All names would fall short of your being. You are the embodiment of the prophecy of what will come to pass. You are a new species, an infant still, but growing to fit your chosen destiny. Come, let us get moving."

Poho led the way and the giant had to walk slowly in order to not overtake him and pass him, leaving the little old black man behind. He saw many new animals on the journey and each time Poho would tell him what the animal was called and how it functioned in the environment. They saw a pair of greater hornbills flying overhead and flocks of flamingos, egrets, and ibis. Poho described the ibis of ancient Egypt as they walked. Poho was well educated and had actually studied at an American university. He related the Egyptian details to the giant, "The ibis-headed god was called Thoth by the Egyptians. He was centered in Hermopolis and sometimes he was shown with the head of a baboon. Thoth was considered to be the scribe of the gods and they say he invented the hieroglyphic script. Thoth was only one of many Egyptian gods but I think, personally that he was the most intelligent of their gods."

Poho stayed a step ahead of the giant and they both paused when they heard a loud noise ahead. The giant almost stepped on Poho's foot. Poho crouched down, holding a finger to his cracked and dry lips, motioning for the giant to get low and out of sight. They both crept quietly into tall elephant grass growing profusely along the trail in front of large boulders. They saw a band of men come around a boulder cluster. They were dressed in khaki clothes that were dirty and stained. They carried machine guns and machetes. Poho counted the men on his fingers. There were five black men and

one white man. Four of the black men carried a large heavy crate between them. They were complaining that they would never make it down out of the mountain range carrying the heavy load. They were tired and on edge. The white man and the lead black man with a military shirt on talked quietly to each other as the four other men put the crate down and rested. The giant did not like hiding, he wanted to learn more about the men in the khaki garments and his curiosity propelled him towards the crate. Poho stayed where he was, hiding in the tall grass and before he could stop him the giant had got up and walked towards the crate. The resting men saw him coming and started shouting at him, "Stop! Go away!"

They grabbed their rifles and tried to point them at the giant but his sheer size and appearance frightened them so badly that they turned and ran. The four men disappeared around the boulder cluster and were still running down out of the mountains when the white man turned around and saw the giant trying to open the crate. The black leader pointed his gun at the giant but before he even had time to aim a tiny dart stuck in his neck. Poho reloaded his blow dart pipe as he watched the black leader fall. The white man did not raise his gun. He was frozen in bewilderment at first, not comprehending what he was seeing. His mind raced as he thought, "That giant must be over ten feet high...he has no hair on his body...he is naked..."

He saw the black leader fall with the tiny, feathered dart in his neck and he panicked. The white man started to run but the giant turned his attention to him. The white man stared into the giant's cold blue eyes and his gun slipped from his hands to clatter on the rocky trail. A wet stain appeared in the front of his khaki trousers as he urinated on himself. The giant bared his teeth at the man. He began to growl as

he struggled with the locked crate. The white man started to open his mouth to speak just as he was hit in the jugular with a feathered-dart from Poho's blow dart pipe.

The giant, in frustration and anger, grabbed the padlock with both hands and jerked with all his strength. The lock snapped open like it was made of plastic. The force of strength coming from the giant also jarred the lid off the crate. Poho stood up and walked slowly over to the two downed men. He said, "They are asleep. They won't like the headache they have when they wake up either."

Looking down into the crate, the giant man stared at the contents. He was joined by Poho, who walked up, saying, "this isn't good. This isn't good at all."

The crate was filled with precious stones of all shapes, sizes and colors. It also contained sculptures made of gold and silver. Poho shook his head and exclaimed, "My, oh my, this is some of the treasure of the Olobe' Pumba. They will want it back. We should return it at once to the Olobe' Pumba. I do not know how to get to their world beneath the mountains but I know a place where they might come out at night in search of the missing treasure. We must go north anyways. The place is in our path towards Mt. Kilimanjaro."

Poho suggested the giant carry the crate and the big man put it on one muscled shoulder as if it only weighed as much as a pet Persian cat. The two strange characters, Poho Abshuli and the giant hairless man, began their trek once again to the north following a worn path down out of the mountains and into the tropical rainforest. Halfway down the slopes many trees were growing profusely and Poho enjoyed the shade they provided. They saw many rock hyraxes, rabbit-sized hoofed mammals related to elephants and horses, which hopped about looking like ground hogs and acting like small goats on the

rocks. They once saw a honey badger ferociously attacking an underground beehive and he was so intent on his mission of stealing honey that he never noticed them walking by. The air was pleasant and the sun not as intense as in previous days. The scenery they walked through was mostly tropical rainforest but they managed to skirt the edges and not venture into too much of the thick deep jungle. Poho pointed out the many kinds of monkeys leaping and chattering in the upper canopy of the jungle. He exclaimed in delight when he shouted, "Black and white Guerezas monkeys! They are beautiful. They look like a big monkey skunk with the black body and the big white markings. Over there are a few spot-nosed monkeys. See how they tear fruit off and throw it down after they chew the sweet pulp."

A little farther along the jungle trail Poho spotted another troop of monkeys in the trees and he shouted again at the giant, "Crested mangabeys! Those monkeys have such great personalities!"

They finally reached the grasslands after a short trip through the rainforest and the first sight they beheld when they left the thick foliage was of a herd of nine reticulated giraffes. The giant man was amazed at the height of these brightly spotted animals. He noticed the garb Poho wore was from the same skin pattern as the tall creatures striding through the grass. He thought these creatures, because of their size would be very dangerous in battle but Poho grasp his thick arm and said, "They are docile animals. The feed on the leaves from the tallest trees and would rather run than fight."

When the two men came out farther into the grasslands, Poho was proven correct because the giraffe herd galloped away a safe distance, kicking up a cloud of dust. They walked through the tall brown grass of the African savannah and the

giant carried the treasure easily but Poho grew weary. He motioned for them to stop and rest. The giant put the crate down and sat on top of it. Poho sat on a round rock and got out some dried meat and opened a water bag. The giant was still hungry after such a meager meal but he endured. They resumed their journey much this same way for the next day and a half when they reached the base of Mt. Kilimanjaro.

Poho exclaimed, "This is where we wait for nightfall. This is where the She-ghosts, the Olobe' Pumba, will pass by in search of their stolen treasure. I have seen their tracks along the many trails we have been on. I have never before known them to be so bold to come out of the hidden caves so frequently. They must be enraged at their treasure being stolen. Poho found a solid wall of rock with carvings all over it to lean on and he slid down to sit with his back to the rock. The giant put down the treasure crate and once again sat upon it. Poho Abshuli pulled out his pipe and lit it again the way he had before. He sighed as he smoked. The giant stood up after about five minutes of Poho smoking and sighing. His big nostrils flared, as he smelled the air. A heavy odor wafted towards him on the wind. He looked at Poho, who was still smoking his pipe but his eyes were almost closed as he began to drift off to sleep. The giant walked a few steps in the direction of the smell. The sun was setting low and the mountain cut off most of the sunlight. It would get dark sooner on this side of the mountain. The giant could already see his friend, the moon, low in the pale blue sky. The smell grew stronger and he sneezed. His sneeze jerked Poho awake and he yelped, "Don't scare me like that!"

The ground shook. Poho felt the thunder vibrating in the ground and thought that maybe it was a small earthquake. Poho was about to say something about earthquakes when the thunder in the ground increased and the smell had gotten

more powerful. They both looked to the south and out of a small stand of scrub trees strutted an enraged white rhinoceros, followed by a young rhino only about a year old.

They also saw that something very white moved through the trees in the oasis of jungle. Poho immediately began to run up the trail into the mountain. The giant stood his ground and awaited the rhino's charge. The big beast snorted, sounding like a leviathan pig, and thumped his massive feet on the ground, stirring up clods of dirt. The giant saw that many white forms were in the small stand of jungle trees and that they constantly were moving. Poho looked back and shouted, "She-ghosts!"

The angry rhinoceros charged the giant, snorting loudly, and the giant answered with a challenge of his own. The giant roared and bellowed like the rogue lion and clenched his teeth. When the rhinoceros lowered its massive head, thrusting upwards with the long horn that had been growing from thousands of matted hairs since the animal was born, the giant leapt high into the air and jumped completely over the rhinoceros. The animal skidded to a halt and looked around for the giant man. The animal's rage had cooled when he realized there had been no impact. Now the beast was confused and disoriented. The rhinoceros shook its huge head and grunted, trotting away from the mountain. The young rhinoceros bellowed and ran after the fleeing rhinoceros.

The forms in the trees all stopped their motion and now from this distance the giant could barely make out between ten or fifteen white skinned women with white, long hair, glowing in the moonlight. Poho sat down on the rocks and shook his weary head, muttering, "The She-ghosts, the She-ghosts."

The white haired women were adorned only in loincloth bottoms around their hips. They strode confidently away from the concealment of the foliage. Their leader, a beautiful

woman with tight hard biceps and rippling thighs, approached the giant and put her hand on his large chest, pushing him backwards away from the crate containing the treasure. The white women did not speak. The leader snapped her fingers and four of the women ran up and picked up the crate, carrying it away into the dark jungle. The rest of the women followed them until only the leader woman remained. She did not speak but merely looked at the giant and the old black man sitting on the ground behind him. The black man nodded and she turned as swiftly as a flash of lightning and was gone. The giant blinked his eyes, wondering if he had ever seen anything as lovely as that white haired goddess. Poho spoke up when they were all gone, "That was Queen Aedea of the Olobe' Pumba. We are lucky they let us live. They are gone now and many more lifetimes could pass before another mortal man would ever see them again."

The giant and Poho resumed their climb up into the mountain. Kilimanjaro pulled the giant along as if a powerful magnet throbbed in the heart of the mountain, attracted to his intense opposite pull. They climbed until Poho was exhausted, so they stopped and ate and drank very little. The giant was anxious to be moving on because of the irresistible pull that dominated his will now that he was in close proximity to his destiny. His body quivered and he trembled while he stood waiting on Poho to regain his strength to resume the climb. Finally the giant could not stand the irresistible pull any longer and when Poho was asleep, the giant man started climbing up the mountain trail alone.

He climbed hard and climbed on into the next day. The heights were dizzying and the altitude sapped even his massive lungs but the magnetic pull could not be denied. His skin began to crack and dry, especially at the bottoms of his feet

and around his face. The giant naked man climbed upward into the snow and ice and breathed out clouds of vapor with each effort. His fingers were frozen and the ice had turned his fingers numb. He saw a flat cliff-stone extending out, jutting like a shark's fin from the side of Kilimanjaro. The giant felt the pull from within the mountain concentrated here. He crawled out on the frozen ledge and looked down over the valley below him. He stood on the shark's fin ledge and roared a challenge to the world. He felt like a king with the magnetic pull buzzing in his ears and his body quivering in pleasure and in pain. He was a new species and his mission had become complete. He knew now what he had come to do. The information flooded throughout his mind as he fell down on the flat ledge. Even as life left his strong body his mind was filled with infinite knowledge of what purpose he had served. The giant died and his skeleton was buried beneath layers of rock and glacial ice. He died with the knowledge that he had completed his destiny.

Six months later, in the village of the African tribe of the WaHila, a woman named, LuTi Ko Lo, bride of Boei, went into hard labor. The midwives of the tribal council closed off the birthing hut to all except high priests of the fire mountain god, Boei. The women pulled an oval elongated shell-like sac from her body. The women and priests were worried and did not know what to do with this strange birth. She had had a six-month pregnancy that had produced an oval hard shell-like sac. They comforted LuTi KoLo and would not let her see what she had delivered. She was still the bride of Boei and she was blessed. This shell-sac must be a great gift from the fire mountain god, Boei. Suddenly the grass woven door of the hut opened and an ancient, small black man dressed in giraffe skins stepped inside the hut. He smiled as he told the WaHila

people what they must do with the shell-sac. Their tribe is truly blessed he told them. Poho took the shell-sac along with many of the priests and midwives and carried it into the jungle. They covered the shell-sac with dirt and planted a Limlolly tree over it.

LuTi Ko Lo visited the tree everyday for the rest of her life, nurturing it and watering it.

After giving birth LuTi Ko Lo never spoke again, but all of the people could hear her thoughts in their minds and she knew what they said to her. She lived to be two hundred and two years old. LuTi Ko Lo daughters and her grand daughters prayed daily at the base of the Limlolly tree. They passed the blessings of Boei down, generation after generation. The WaHila people were given a gift on the day of LuTi Ko Lo's delivery, a secret gift that they carry inside their minds. Only the WaHila people can speak and hear without voices.

The WaHila people have never cut down another tree, and even to this day they will not live in houses made from trees.

HawkerCrow

Saurus ran towards the river. He was thin and lithe and quick like a deer. The two lions chased him. He called for help, hoping that Cabe and Kristall had the raft ready to launch. He trusted both Cabe and Kristall with his life. Cabe was very strong and had shoulders like a brick wall. Kristall was tall and regal with long hair that danced in the wind. Saurus felt deeply for her. Their teenage years were still filled with such danger that neither of them thought they had too much of a chance reaching twenty years old. Saurus was too young to get very tired and his strong legs propelled him at a high speed but the lions were very hungry and desperate. The boy sprinted like he had the sandals of Mercury, his tunic flapped as he ran. His small crested helmet fell off, bouncing on the sandy scrub brush-filled ground. One of the lions roared. Both lions were young males and filled with frenzied violence. Saurus saw the river's beach ahead and searched for signs of the raft. His antelope skin sandals slapped hard against the pebbles of the beach as he caught sight of Cabe sitting on the beached raft only about fifty yards away. He yelled, "Cabe! Help! Get the raft in the water! Now!"

Cabe jumped up and saw Saurus running towards him and waved. He then noticed the large roaring lions chasing behind him. Cabe grabbed the edge of the raft and began to shove it out into the river. The river's current gripped it and pulled it out, with Cabe leaping on trying to keep it near

shore so that Saurus could jump on too. Saurus neared the raft but the lions were only a few yards behind him. A shadow crossed over the lions from the sky and moved towards Saurus. Something grabbed Saurus under his arms and lifted him into the air just as the first lion leapt, claws extended and teeth salivating. Cabe paddled and struggled in the current of the river while Saurus hung from the hands of Kristall, soaring on her giant kite wings above the water. Saurus's weight pulled Kristall lower and lower and she yelled to him, "Saurus! I have to let you go or we'll crash land in the river. I'll try to let you down on the raft, if I can make it that far."

Cabe paddled against the current trying to reach the gliding girl holding the young boy. Saurus yelled back, "Hang on, Kristall, I can't swim good!" His feet were touching the water as they glided closer to the raft. To be only sixteen years old, Kristall was daring and fearless as she held onto the fifteen year old Saurus. Saurus and Kristall were sweet on each other in that puppy love way. Cabe was only a few years older than the two teenagers but his maturity and intellect was more like a twelve year old. Cabe was slow upstairs but strong as an ox and as honest and loyal as a young man could be. Cabe paddled valiantly against the current as Kristall lowered Saurus closer to the raft. The front end of the raft struck a large rock in the river and Kristall dipped at the same time, causing Saurus to be thrown onto the raft. Kristall followed him and crashed on top of Saurus. Her canvas kite wings fell on top of Cabe and Saurus. The raft was tossed violently in the surging waters of the Romodo River. Cabe untangled himself and then helped Saurus and Kristall up. Kristall folded her kite wings and strapped them tightly to her back. They all three took up paddling, navigating the turns of the rushing rapids of the Romodo River.

Half an hour later, the river slowed and the raft drifted with very little guidance. The walls of the canyon rose on their left but the right side was a sandy beach bordering the edge of a lush jungle. They had left their homeland, Diago, three months ago, vowing to never return. They were considered criminals in Diago where expressing love or emotion was strictly forbidden, punishable by banishment or death. Diago was the only civilization the three had ever known. Only in tall tales, stories told to children, did they ever dream that other civilizations existed in the world. Diago's population was a few hundred thousand and there have been quite a few banishments over the years. The people who were sent out into the wilderness never returned. Banishment from Diago was known to be certain death. Outside the towering stonewalls of Diago there were monsters and devils and all manner of evil creatures that would kill and eat human flesh. Cabe was the one who had convinced them otherwise. Cabe had never grown up and still believed the stories that told of other people living somewhere in beautiful places filled with love and kindness. Cabe had kept a book of the stories of Atlissa, Therimonical, and the book of Yo, which had a fabled fantasy map of a place called Ramma Ting.

Cabe told Kristall and Saurus the stories of Ramma Ting everyday when they were growing up. Cabe still carried the page with the map of the flat world and the location of Diago and the southern place known as Ramma Ting. After three months of traveling and narrowly escaping many dangers, Saurus and Kristall doubted that Ramma Ting existed but Cabe would never give up his dream. They had nowhere else to go, Diago would never accept them back unless they went back to be executed by the axe. The raft slowly drifted on the now peaceful Romodo River. The Romodo River ran near Diago

and they knew it would be easy to follow it back home. They all three looked back the way they had came and watched the north sky. The clouds heaped up like a bunch of fur mice and Saurus said, "We can never go back. This world is beautiful, even if we never see another human face again."

Kristall smiled at him and touched his face, saying, "Yes, it is beautiful out here, dangerous but beautiful. I am happier with you two here, my best friends, even if we live on the edge of danger."

Cabe grinned, "We are bestest friends, Kristall and Saurus! We can live better than in Daigo! I like floating on the water."

Saurus clapped the strong broad back of Cabe and laughed, "Yes my big friend, this is great floating on the river!"

Cabe giggled like a small child and exclaimed loudly, his voice echoing off the canyon wall, "We will soon find Ramma Ting!"

Saurus squeezed Kristall's hand and said, "Yes we will, but for now let's steer in to the beach and get us a fire started. We should stay here for the night, it seems safe enough."

An hour later they had the raft secured to a root protruding from the ground and a small fire crackling. Kristall had formed a small shelter with the use of her kite wings to keep them dry at night in case of rain. They all sat around the small fire and warmed themselves. The days were hot but at night the temperature cooled off. They unrolled the furs brought from Daigo and spread them out under Kristall's kite wings. Saurus cooked a fat fur mouse well done for their supper. The fur mouse had been kept and carried in Cabe's backpack since yesterday when he had killed it with his slingshot. Most of their meals had consisted of black chickens, fur mice, or rock hyrax. They liked the taste of hyrax best but

these small creatures were shy and hard to find. Fur mice were very common and could easily be shot when they emerged from their underground burrows. They each ate in silence until Cabe spread out his map of the flat world. Cabe studied this map everyday. He seemed to think they would eventually find Ramma Ting. Saurus asked him, "Cabe, are we getting closer to Ramma Ting?"

The thick fingers of Cabe scratched his head and touched the map, "We are here, in the canyon of Romodo. We have many days journey ahead of us. Soon we will leave the raft and the river behind. Ramma Ting is past the Epic Mountains. There it is cold. I do not like cold. We need big clothes to keep us warm."

Kristall looked at Cabe with serious eyes and asked, "My friend, Cabe, is the place of Ramma Ting like the books? Will we find love and happiness? Are the people there so different than Diago?"

Cabe smiled a big smile, looking like the jaguar baboons of the Romodo moatlands. "Yes! Yes! Yes! Kristall! Yes! Saurus! We will find Ramma Ting and we will find love!"

Suddenly they heard something large crashing through the jungle towards the beach. The sound was moving towards their small fire. They all were silent and watched the edge of the jungle part. Saurus leapt to his feet, followed by Kristall and Cabe. There was nowhere to run. Cabe loaded his slingshot with a round stone and readied to fire. Saurus pulled out his stone knife and Kristall crouched with a throwing stone in her hand. The jungle parted and out strode a huge strange being. Two steps beyond the jungle and it stopped and spoke to them in the language of Diago, "Do not fear. I mean no harm. I am HawkerCrow. I am a Devoit of the Riddle and the Serpent. I have listened to your talk and know your needs and wants. I

can help you find Ramma Ting if you desire. I have never been there but I can show the way. If you wish I can show you the Temple of the Riddle and the Serpent. I only ask one favor in return."

Saurus, still clenching his knife, replied, "One favor?"

The three people observed this creature called HawkerCrow. He was taller than they were by at least two feet. HawkerCrow had smooth skin like the oil massagers in the emporium of Diago but his skin was very light blue. His large eyes were white with the tiniest black dot for a pupil. They noticed that his face was very doglike, with a short snout and muzzle but the rest of his form seemed almost human. Then they saw that HawkerCrow had only three fingers and three toes protruding from leather sandals. HawkerCrow's fingers and toes did not have nails but blunt square ends of blue flesh. He was an imposing figure much larger in frame and muscular than Cabe or anyone from Diago. His chest and loins were covered in a scaly plate-like garment. HawkerCrow seemed to not carry any weapons.

HawkerCrow held up one stubby blue finger, "Just one favor, that is all I wish."

Kristall lowered the rock in her hand and said, "One favor? Just what would that favor consist of?"

He walked closer on his three toed blue feet and sat down by the fire, saying, "You would have to trust me on that one. I will show you the way to Ramma Ting and you grant me the favor. I promise the favor would not mean any harm to you. I am not treacherous or dishonest. You have my word as set out in the Hollim, the Holy Word of the Riddle and the Serpent."

Cabe tucked away his slingshot, satisfied that this creature did not mean any danger to them and sat on the opposite side of the fire. Kristall and Saurus sat also on either side of the

large creature human thing called HawkerCrow. "I have seen your kind before."

HawkerCrow said and continued, "I once tried to help one of your kind but he died from the bite of the Delphne plant. If you had ventured any farther into this jungle you would have also encountered Delphne plants. They resemble large flowers of yellow and white and they smell like honey. Creatures of the jungle are lured close to the flowers by the alluring scent of honey and when they get too close, snap! The flower closes quickly exposing three narrow fangs that pierce the creature's skin. The poison is injected instantly and depending on the size of the victim, fur mice die instantly, primary food for the Delphne plants, large creatures sometimes last ten minutes. Delphne Plants are beneficial too. They are the reason the jungle prospers. Delphne plants disperse seeds of other plants picked up by their long twisted flowing roots systems that wind all over the jungle floor. Before the other such as you died he told me one thing. He said, "I miss love. I miss my people. I saw the map of the flat world and in my mind I know I will find Ramma Ting." He died in my arms. I put his body up high in the branches of a tree so that his spirit may see the sky. He is the reason I knew that you three were noble creatures. Any creature capable of love is capable of nobility."

Saurus looked across the flickering fire as night had somehow fallen while they talked. Saurus looked at Kristall's face and he saw how beautiful she was in the firelight. He felt the powerful emotion of love, the forbidden Daigo law, coursing throughout his body. Kristall looked back at him, meetings his eyes, mirroring his feelings. Kristall truly did love Saurus and she loved Cabe, but in a different way. HawkerCrow observed the sharing of looks from the human creatures and smiled, "I can see you have found love and yet

change in scenery. They could see the sun setting beneath the low hanging clouds. They only had a short time before it was night again. Cabe had killed two gish with his slingshot and carried them in his pack for tonight's supper. HawkerCrow led them to a stand of moosh trees, which were shaped like umbrellas and announced, "Here is a great place for our sleep time. We have shelter from the big moosh trees and the big predators of the prairie will stay away from our fire."

Saurus, curious, asked, "What big predators of the prairie?"

Cabe got busy building a fairly large fire while Kristall un-strapped her kite wings. They all listened to HawkerCrow as he explained, "Ah, the dreaded prairie predators, huh? I guess you've never heard of the Gruju? The jungle had the deadly Delphne plants and other big creatures that would kill you if you blundered into their territory but the Gruju are different. The Gruju kill because they enjoy killing. They don't kill to eat. They eat only prairie snails and lion grass. They do not eat meat. The Gruju kill anything that moves. They hunt constantly because of their need to murder and destroy life forms. There are not many Gruju in the prairie because they only breed once and bear one infant. They are very territorial and will kill each other as soon as kill anything else. The only time they do not kill one another is the short breeding season, when they tolerate each other long enough to breed."

Kristall shivered, "What do they look like?"

HawkerCrow smiled, looking so much more like a friendly dog, with his wrinkled snout, and continued, "Gruju look like killers! If we encounter one you will recognize it even though you have never seen one. With your inadequate weapons a Gruju would make a quick kill of you without me along. I know how to defend against a Gruju attack."

Seated around the campfire, eating fire-roasted gish, the four traveling companions got to know each other better through a steady serving of constant conversation. Kristall asked, "HawkerCrow where do you come from? I mean where do you actually live? Do you have a home or a family? Do you come from some type of civilization? I don't mean to pry or anything but I am curious."

HawkerCrow smiled, baring his dog-teeth, and replied with a chuckle, "Ha! A lot of questions, female! I never knew my parents but I was nurtured and taken care of by a wandering tribe of my own kind, the Fielsh. The remaining Fielsh today live hundreds of miles to the north in the caves of the ancients. My surrogate family lives there now. My last visit to the caves of the ancients to visit my family of the Fielsh was over two years ago. I enjoy the freedom of the flat world. I am a Devoit of the Riddle and the Serpent. A Devoit is a religious title bestowed upon a high-ranking Fielsh in the service of the Riddle and the Serpent. My servitude to the Fielsh religion and the Holy Book, the Hollim, is my life. I have never regretted my choosing and I continue to strive to find the purity of the Riddle and the Serpent."

Saurus looked bewildered and asked, "What is the Riddle and the Serpent?"

HawkerCrow, his blue skin reflecting the flames of the campfire, replied, "Why my boy, if I knew the Riddle then it wouldn't be a riddle, would it? Do you three even know how I come to speak the language of the Diago?"

Cabe stuck another piece of wood into the fire and Kristall, her eyes big with astonishment, said, "Oh! I didn't even think that you might speak something other than what we speak. There are other languages? What do they sound like?"

Cabe spoke up, "Everything talks different, it says so in

the books. In Ramma Ting there are many different ways to talk."

HawkerCrow clapped Cabe on his broad shoulder and replied to Kristall, "Cabe is right! Each living form has a language of its own. Even these gish we eat communicate with each other. The Devoit are schooled in the manuscripts of dialect. We are taught early in our devotion many difficult languages of the life forms of the flat world. We are even taught dead languages, the dialects of life forms that do not even exist any more. When I heard you speaking to one another I recognized the language as one I was taught and once a language is learned it is never forgotten. The Fielsh have long memories and long lives."

HawkerCrow now asked a question of his own, "Why have you three young things left Diago? Anyone ever to leave Diago usually dies very quickly."

Saurus tried to explain about the laws regarding love and emotion. HawkerCrow was not shocked but very disturbed by the information. When Saurus finished explaining HawkerCrow asked, "How could a people such as you not love? The Diago society is corrupt and misguided. I am sure many Diago people must love and show emotion. The civilization must have much shame and lies to hide emotion and love. The Diago rulers use this as a way of control I am sure."

Cabe shrugged his shoulders, saying, "That's why we are here and not there. Emotion is easy and feels right. To cover up your feelings seems wrong to me. Now you can see why we search for Ramma Ting, a place where we can be free to love and display our friendship."

HawkerCrow smiled wryly and said, "You are free to show love and emotion now, here in this remote prairie. You have more freedom than you ever could have in Diago. Cherish each

day in your journey. Remember I have never been to Ramma Ting. I will get you as close to there as I can."

He finished with a sigh and climbed up into the branches of the moosh tree. HawkerCrow was sleeping in less than a minute. They all settled down and soon slept under the dark sky of the prairie.

Cabe was shaking Saurus awake in the middle of the night. He had already awakened Kristall and now he said, "Saurus get up! Look!"

Kristall said, "Look Saurus! Look across the prairie!"

Saurus rubbed his eyes and stood up following their excited pointing fingers out across the dark landscape, dotted with moosh trees and lion grass. A vast glowing light shone far out over the prairie. The light was tinted blue like a clear stream. The glowing light seemed to surge brighter at times and it seemed to be getting closer. Saurus exclaimed, "It is beautiful! I have never seen anything like it. I think it is getting closer. What do you think makes such a blue light?"

Kristall could not take her eyes from the large glowing light that seemed to be getting closer by the minute and she replied with awe in her voice, "I would think that maybe the moon has fallen to earth if it wasn't still in the sky. We should awaken HawkerCrow and ask him what it is."

Cabe trotted to the tree and peered up into the branches at the heavily sleeping giant, HawkerCrow. He cupped his strong hands to his mouth and raised his voice, "Wake up, HawkerCrow! Wake up and come see the big light!"

The large sleeping giant awakened quickly and sat up on the branch, asking, "What?"

He blinked his eyes and started to look in the direction of the approaching light, saying, "It is Larcada. We had better find cover. The Larcada aren't really dangerous to us but very annoying."

HawkerCrow leapt out of the tree and gathered his few possessions as they also got their gear together. Kristall reattached her wings, spreading them out, and took off running. When she reached about fifty yards from their camp she became airborne. HawkerCrow watched the girl getting airborne and exclaimed, "The girl is flying…a flying girl…"

Kristall turned on an updraft and banked back towards Saurus and Cabe. They were trotting behind HawkerCrow, heading for a shelter of large boulders. Kristall flew past them and veered towards the approaching light. She wanted to see what phenomenon was causing such a beautiful glow. HawkerCrow, followed by Cabe and Saurus scrambled down behind the boulders and Saurus asked, "What are the Larcada?"

HawkerCrow laughed and smiled a dog smile, as he replied, "Larcada are phosphoric insects. The light is caused by an immense swarm of inner glowing insects all massed together feeding on the lion grass. The Larcada do not bite living animals but to be caught in such a swarm is unpleasant and I don't think we want to be covered with glowing sticky crawling bugs."

Kristall soared over the glowing mass of light and saw that millions of little things were moving in the light. She banked right and then curved left to fly directly over the light. She flew lower to get a better view. Kristall was amazed at the beautiful blue glowing light, moving across the lion grass. She could see that it was many insects with glowing bodies producing the light. Kristall flew past the glow and was about to bank and turn back towards the boulders where her friends had fled when she caught sight of something beyond the moving glow of light. She heard an eerie clicking sound and whirled higher on an updraft. She strained to see beyond

the glow in the darkness behind it. Kristall saw something very big moving fast, following the glowing light of the insects. The loud clicking was coming from this dark huge mass crashing through the lion grass. She thought about the stories that HawkerCrow had told her about the Gruju and she shivered, turning back in the wind and propelled her body at great speed towards the boulders where Saurus, Cabe and HawkerCrow awaited.

She landed with a soft plop on top of a boulder. Saurus looked up and shouted, "Well, where did you go?"

Kristall ignored his question and said, excitedly, "I saw the light but behind it is something big and dark. It could be the Gruju."

HawkerCrow stood up from behind the boulder and looked at the Larcada moving towards them. If a Gruju followed the Larcada it would discover them as soon as the Larcada's light illuminated the boulders. HawkerCrow sprang into action as Kristall folded her wings onto her back, "Everyone follow me quickly, run!"

They sprinted through the boulders following HawkerCrow. Cabe brought up the rear, and he made sure Kristall kept up. The Larcada turned at the boulders moving off southward into the lion grass. They could see the light moving away from them but HawkerCrow shouted, "If there was a Gruju behind the Larcada it will have scented us and leave the Larcada to hunt us down. Hurry!"

They ran on and Saurus and Kristall were getting tired. HawkerCrow and Cabe tried to rush them along but they were weary and not as strong. HawkerCrow stopped under a huge moosh tree near an assortment of large fifteen-foot high boulders. He looked back the way they had come and he knew there was no escape for them now. The Larcada light

was moving away from them but in the darkness a huge form moved fast towards them. HawkerCrow shouted, "The Gruju! All of you get behind me!"

HawkerCrow pulled out a long slender rod from his backpack and ripped off the end. The rod tip glowed brightly in the darkness. The light from the glowing rod lit up the boulders and the moosh tree. Cabe, Kristall and Saurus stood behind HawkerCrow, breathing heavily with their eyes wide. The big monstrous shape approached the circle of light. They could hear its loud grunting breaths. HawkerCrow produced a steel glove from his pouch and fitted it to his right hand. The glove had an axe blade and long pointed spikes protruding from the knuckles. The giant crouched with Cabe on his right and Saurus on his left. Kristall spread her wings, ready for flight. Suddenly a loud roar filled the air. The Gruju stomped its heavy claws in the dirt and stepped within the circle of light. Kristall almost fell backwards from the hideous appearance of the Gruju. Saurus steadied her and felt his own breathing quicken. Cabe took a step back as HawkerCrow thrust the light rod forward. The Gruju was as large as an elephant with a head filled with porcupine quills. Beneath each quill gleamed tiny black eyes, hundreds of eyes hiding beneath the hundreds of quills. The Gruju had only one nostril on the top of its quilled head, like a whale's blowhole. Its mouth was a massive opening that could swallow cattle whole filled with gnashing thick brown teeth. Gobs of syrupy saliva gushed from the wide mouth and a long flicking fat tongue slithered forth dripping more goo. HawkerCrow screamed at the Gruju, "Tempa Ush! Tempa Weddo!"

He yelled at the approached monstrosity, "By the gods of the Serpent and the Riddle, be gone creature! Tempa Ush! Tempa Weddo!"

The Gruju bent its prickly head down to the ground and scratched huge piles of dirt up with its fore-claws. The Gruju jumped high in the air without warning and HawkerCrow ran towards it. The blue skin of HawkerCrow shined in the light of the rod that he handed to Cabe before he attacked. The giant rolled beneath the leap of the Gruju and slashed upwards with the steel weapon-glove. The Gruju landed awkwardly as the axe and spikes bit into its crusty belly. It rolled and crashed into the boulders. Saurus could see its thickly scaled body covered with black stripes. The Gruju righted itself and shook its pincushion head, slinging slime in all directions. HawkerCrow stood and crouched, awaiting the Gruju's next charge.

Suddenly the area was filled with bright light. They all looked upwards thinking that the Larcada had returned. HawkerCrow kept his eyes on the dangerous Gruju as many torches lit the area from the boulders in a large circle. The Gruju snarled and scratched the ground. The torch- bearers were armed with long thin spears held in leather slings. Silhouetted human shapes were holding the torches and Cabe thought that maybe the Ramma Tingians had come to their rescue. The Gruju bunched its muscular legs and readied to leap at HawkerCrow. Before it could launch itself the torchbearers whipped their leather slings up and let fly the slender spears.

The Gruju was struck simultaneously with over thirty spear tips. Its scream filled the night air like a dying woman. One more scream and the Gruju fell forward. The massive beast sprawled in a spreading puddle of its own thick blood. The torchbearers moved forward, surrounding the dead Gruju. Saurus, Cabe, and Kristall could see that the human shapes were not human at all. HawkerCrow strode forward and the torchbearers opened a path for him to enter into their

circle of light. The torch-bearers all fell to their knees before HawkerCrow, as he said, slowly, "The gods of the Serpent and the Riddle are pleased. The Fielsh glow proudly with the death of the terrible Gruju! In the sacred words of the Hollim, "That which seeks to kill for food is just, that which kills to kill is sacrilege." I honor the tribe of the Suyulori for this great service to the Fielsh!"

The Suyulori were short and thin with two arms and two legs and one head; there wasn't anything else resembling a human about the Suyulori. Their skin was beaded with scale-like flesh, black to deep purple in color. The Suyulori's faces were mouth-less, with only one nostril and a thin slit where the eyes would have been. On each side of their rough heads were three oval orifices suggesting hearing holes. The Suyulori's hands and feet had no toes or fingers but ended in flat prehensile appendages. The Suyulori did not wear any form of clothing or costume. They all looked alike, seemingly the same in height and weight. The only difference was their beaded variation in slight coloring. HawkerCrow stood in the center of the kneeling Suyulori and said, "Praise to the Suyulori!"

A loud humming began. The vibration hurt Saurus, Kristall and Cabe's ears. They put their hands over their ears to try and lessen the pain of the humming vibration. The sound was coming from the chests of the kneeling Suyulori. Their beaded skins shook with the effort of producing the loud humming noise. Clouds of dust began to rise from around the vibrating Suyulori. The humming increased in volume and Saurus pulled Cabe and Kristall away from the noise behind the boulders. A large whirling dust cloud was formed with HawkerCrow in the center. Saurus put his fingers in his ears and looked around the boulders at the growing tornado of dust and sand. He could not see HawkerCrow anymore, only the

spinning whirling twister of dust. The twister pulled more sand up into its spinning winds and rose fifty feet high into the night air. The torches burned brighter in the hands of kneeling Suyulori. The winds did not touch the flames. Suddenly the dust tornado was gone.

HawkerCrow was also gone. The Suyulori had disappeared and had left only one brightly burning torch propped up in the sand. The humming and vibration had stopped instantly. Saurus stepped out from behind the boulder and walked slowly towards the single burning torch. Kristall and Cabe followed behind him. The torch symbolized their journey, they were alone again and Cabe motioned for them to look where the giant Gruju had fallen. The Gruju was gone too.

The next morning after an exhausting sleep, they tried to make sense of Cabe's map, searching for a way to find a clue to the location of Ramma Ting. They proceeded once again in the direction that HawkerCrow had been leading them. A half days walk through the plains they reached a sparse forest with a slow dribbling creek. The water was cold and clear and they drank their fill. As Saurus bent down to sip the cold water again, Cabe shouted to him, "The tree! Look at the tree!"

Saurus followed Cabe's gaze and saw a twisted gnarled tree with a monstrous root system. The roots looked like tentacles of a giant squid. Cabe shouted, "The tree is the same as the one on the map!"

Cabe held up the map and pointed to a picture of a big old tree near a creek. He shouted, "We are on the right track! Look at the map! We are very close to Ramma Ting!"

Saurus grabbed Kristall's hand and danced in a circle around the tree, singing, "Ramma Ting must exist! Ramma Ting is real! Ramma Ting is real!"

Cabe clapped his large hands as they danced and laughed

around the tree. They danced and then fell down laughing on the moss-covered ground. Kristall rolled on her wings and Saurus held onto her in a tight embrace. Cabe jumped to the ground and rolled around with them. They were all so very relieved and happy to finally see a shred of evidence that Ramma Ting really existed. They finally stopped laughing and sat in a circle checking the map more thoroughly.

The wind picked up and the temperature dropped slightly as they sat beneath the huge old tree. Saurus looked up beyond the branches and saw that the sky was filled with thunderclouds. Kristall commented, "We should seek shelter, a storm is coming."

Saurus looked back at the map and said, "Ramma Ting should lie beyond this forest and the mountain of Ruhn. This forest is called Polleegollee Wood. The map of the Polleegollee Wood shows it to be vast and dangerous. I wonder if HawkerCrow will ever return from the Suyulori? We could use his knowledge and guidance to get through this forest."

Cabe grunted, "He had better business than us I guess."

Kristall stood first and they followed her lead, walking along the creek into the Polleegollee Wood. The temperature was pleasant and there were no biting insects but some of the plants tried to nip at their ankles and their arms as they passed. They traveled for two days in the Polleegollee Wood without seeing much of anything except animated plants, varieties of small birds and squirrels. They finally came upon a tall javelin sticking up from the ground with a strange skull impaled on the tip. The javelin at first seemed wooden but when Saurus touched it he discovered that it was petrified wood. The skull resembled a large ram with four horns, two from its head and two on its snout. The ground around the javelin was worn down as if by many feet from heavy creatures. They soon

left the javelin behind and continued on through Polleegollee Wood. About a hundred yards away from the javelin and the skull they came to the base of a massive tree. The tree was at least as wide as a castle wall and they could not see the top of it thrusting up into the gray clouds. The tree's bark was rough like large scales and a sticky sap oozed from the edge of each plate-like scale of bark. Saurus asked Cabe, "Is this tree on the map?"

Cabe unfolded the map and studied it for a minute, "No, there is nothing on here about a giant tree. There is a symbol shaped like a "v" in the middle of the Polleegollee Wood, though!"

Kristall whispered, "I wonder what is shaped like a "v?"

Suddenly they heard thunder and realized that the storm had caught up to them. The rain started slowly at first and then began to pour in sheets of cold droplets. The only shelter was underneath the monstrous branches of the giant tree. They all crouched down and watched the water run off the big twisted branch above them. Kristall heard something above the sound of the rain and said, "Do you hear that sound?"

Saurus replied, "I hear the rain. What sound?"

Cade said, "I hear it too. The chirping. It sounds like crickets."

The sound grew louder and multiplied. It was coming from the tree. The three friends all stared at the rough scaled bark of the giant tree. They saw that each large scale of bark slowly bent back and opened a small cavity behind it. Thousands of scales of bark opened slowly revealing the dark cavities concealed in the tree. As the bark opened they could see something moving out of the hidden cavity behind each scale of bark. Kristall withheld her scream and stopped breathing as Saurus and Cabe grabbed her arms and started

to run away from the tree. The small creatures emerged from the bark spaces and flapped their four black wings. There were thousands of them emerging and sitting on the edges of the bark. The tree had become alive with movement, almost as if it were a huge termite hill.

The small creatures had faces like catfish with big gulping mouths and bristled sets of long whiskers. They had four wings like some kind of freakish bat and were multi-legged with small claws on each tiny foot. The cricket noise came from their wings rubbing together. Saurus and Cabe dragged Kristall through the forest, running as far away from the big tree as they could get. They looked back and watched as they ran. The flapping small creatures were taking flight like lunatic pilots steering 'out-of-control' helicopters. The black flapping shapes, each smaller that Cabe's hand, began to fly crazily in circles. In seconds there were thousands upon thousands of the black flyers in the air all around the tree. Some of the black flyers had reached them and zipped by their heads. They ran faster and almost ran directly into a big leather basket in front of them. Saurus grabbed Kristall and pulled her into the basket. Cabe jumped in last and they ducked down while rain pelted their skin and the black flyers whirled and zipped in the air all around them. The inside of the basket, which could have held four more people, was covered with soft fur and had containers of water and other objects. Thick straps extended from each corner of the basket up into the forest. Saurus looked up and followed the straps and nudged Cabe to look up also. Towering above them was a blue and white orb that resembled the moon. It wasn't the moon but it was a giant balloon painted like a moon with a "v" shape on the side. They were in a balloon basket. They had never before seen such a thing but there was a picture of it in the fantasy books of Ramma Ting. Saurus

found the attached line and untied it. The balloon lifted from the ground slowly. They left the Polleegollee Wood behind as they slowly rose above the trees. The black flyers still zipped around them like chaotic catfish with wings. The balloon cleared the treetops and out into the open sky. Rain continued to pour on them and the gray sky rumbled as loud crashes of thunder accompanied bright flashes of lightning.

Saurus and Kristall sat down while Cabe stood up holding on to the basket while looking down on the forest. Saurus told Kristall, "Now what do we do? How do we even control where we go? How do we get down out of the sky? It seems we are desperately lost. Cabe, do you see anything down there?"

The rain started to let up, turning to a slight drizzle. Cabe replied, "Looks like the forest has thinned out and we are over a prairie again. Wait, I see mountains up ahead. Maybe those mountains have the one called Mount Ruhn?"

Kristall's eyes brightened, as she said, "Mount Ruhn? That is the mountain near Ramma Ting? We are close?"

Cabe watched their flight towards the mountains helpless to control their speed or direction. Night came and they all slept in the bottom of the balloon's basket. Saurus was awake with the first glimpse of the sun on the horizon. He shook Cabe and Kristall awake, saying, "Look, we are over the mountains." Cabe unfolded the map and studied it. He exclaimed, "There it is. That tall peak over there is Mount Ruhn. Once we go past it we should see the giant walled city of Ramma Ting."

They watched the mountain as they neared its peak. Saurus and Kristall drank from their water containers and ate as Cabe ate the last of his dried meat. They seemed to be getting lower in the sky. The mountain loomed larger as they neared and the balloon dropped altitude as the wind shifted and blew cold air at them. Saurus shouted, "Look, there! On the mountain side is a tower!"

The balloon was headed directly at the tower and they had no way of controlling their descent. Saurus shouted, "Hang on!"

The balloon rocked as they clung to the sides and Kristall jumped out into the cold air, unfolding her gliding wings at the last instant. The balloon collided with the tower and tangled on its outside staircase. Cabe fell out and landed on an iron balcony but he was only bruised. Saurus hung by one hand onto the lip of the dangling, upended basket. The ropes of the balloon were tangled in the iron railings of the outside staircase. Saurus tried to pull himself up but he could not get a good hold. He finally grabbed a swinging rope and lowered himself down to another balcony of the tower. He was a flight of stairs down from the balcony on which Cabe stood.

They looked up and saw Kristall soaring in circles above the tower, which stood fifty stories high. It was white brick with many round windows and a staircase winding around it from the floor of the mountain to its observation point. Saurus yelled at Kristall, "Land on the balcony below me and we will join you."

Kristall circled in tighter and slower until she softly dropped on the balcony directly below Saurus. Cabe and Saurus quickly descended and joined her on the lower balcony as she folded her wings back onto her back. There was a wooden door in the tower across from the balcony. Saurus tried the handle and found it open. They entered into a dark place with steps leading both up and down. Cabe, in a soft voice, said, "I think we should go down. I have had enough of heights."

Saurus shook his head and agreed, "Yes, let's find our way our of here and on solid ground."

The place seemed vacant. The stairway was fairly well lit because of all the round windows in the tower. The tower

wound down until it finally reached a ground floor that ended in a huge round room. The floor was made of stone and covered in ornate rugs. The walls were hung with beautiful tapestries depicting wild animals of many varieties. The double-door opening that lead outside was wide open and they could see a vast lawn filled with brightly colored wildflowers. Cabe, speaking in a low voice as if in reverence of this place, said, "Nobody home I guess. Look at the beautiful flowers. I haven't seen such gardens since back home in Diago."

He walked out of the tower and Saurus and Kristall followed him. When they stepped out of the doorway expecting to enter the sunshine of the gardens they were stunned to realize the gardens were gone. The doorway did not lead outside at all. They left the inner tower and stepped into another room. They were still in the tower. They could see the door behind them and the beautiful gardens were back out of that doorway. Cabe tried to walk back out the doorway and into the gardens only to find that the open doorway had an invisible barrier in place like cold glass. The room they now stood in was darker than the last tower room and filled with tables upon which stood bottles of liquid and ornamental bowls and cups. The walls were covered in murals depicting the Suyulori battling many beasts, including murals of fights with Gruju. On the far wall was a fountain pouring water from a monster head into an oval pool. Above the fountain was a massive painting of HawkerCrow or one of the Fielsh that resembled him holding a curved weapon in one hand and the book of Hollim in the other hand.

Kristall exclaimed, "Is that HawkerCrow in the painting?"

The three of them studied the large painting in the golden ornate frame not noticing movement behind them, until they heard a voice, "Hello again! My wanderers from Diago!"

HawkerCrow stood behind them with his massive arms crossed on his chest. His blue skin looked black in the low light. He grinned at them with his dog snout wrinkling up showing his teeth. Cabe smiled broadly and Saurus exclaimed excitedly, "HawkerCrow! We are glad to see you! We have been lost and now you are here. What happened to you and the Suyulori?"

Kristall laughed and said, "We are glad you aren't hurt. The fight with the Gruju and then the Suyulori and you disappeared in that tornado cloud!"

HawkerCrow laughed, "I am sorry I had to leave so abruptly but the Suyulori needed a Fielsh of the Riddle and the Snake urgently. My healing was needed for a young Suyulori that had been bitten by a Joker Spider. Joker Spider's are tiny but their venom is very strong. Without the healing of the Fielsh the Suyulori would have died in a couple of days. I returned to find you but you had already gone on with your journey. To tell the truth I did not expect to find you alive. You were very lucky to travel the Polleegollee Wood and not encounter tragic danger."

Cabe shifted the conversation, "Where are we? Is that you in the painting? Is Ramma Ting nearby?"

HawkerCrow held up his hands to slow the youngster down, "We are in the tower of the Riddle, the farthest outpost of the Fielsh. This is my first time here. Rev A Mandu is the host Feilsh of the tower of the Riddle. I have heard Ramma Ting is not too long a journey from here if it exists. Remember I have never been this far before. My Fielsh duties have always been to the southern regions. Rev A Mandu is in the observation room at the tower's summit engaged in the havoc prayer. The havoc prayer lasts two days. My time of the havoc prayer is a month away. I will need to be in my sanctuary during that time. Oh

yes, the painting, no, that is not me. That is my ancestor Gli Chist, once the Champion of the Serpent."

Kristall sincerely commented, "HawkerCrow, the Fielsh are so deep in mystery and history, it is so fascinating. It would seem like it would take me many lifetimes to understand it all."

"We will eat and sleep here tonight. I will lead you to the other side of the Ruhn Mountain tomorrow, and yes Kristall, the Fielsh are an ancient race and we have much history and tradition," said, HawkerCrow.

They slept in bedrooms of the tower of the Riddle and ate a heavy breakfast in the dining room of Rev A Mandu, who was not present, still engaged in the havoc prayer. HawkerCrow led them to the stables and they mounted the Fielsh riding animals, Sallies, which resembled the Diago horses. The only noticeable differences in Sallies and Diago horses were that Sallies were very tall and lean with no mane on their necks and they were tail-less. HawkerCrow did not ride but Saurus, Cabe, and Kristall rode high on leather saddles with long tall pommels. They rode the mountain trails all day and finally crossed over into the valley on the other side of Mount Ruhn.

HawkerCrow stopped them on a ridge in the valley and said, sadly, "Here I must depart. This is as far as I can guide you. My duties call me to my sanctuary. I have no more time to devote here. I am sorry. You have been great friends and I will pray for your safety and success. Take care of the Sallies. If you can return them to the Fielsh someday I would be grateful. Rev A Mandu has been notified that you are welcome."

Saurus shook HakwerCrow's giant hand, as did Cabe, and Kristall hugged him from the saddle of her Sallie. Saurus said, "Thank you so much HawkerCrow. We will miss you!"

Kristall waved and shouted, "Goodbye!" as HawkerCrow

trotted back into the mountains at a pace they could not believe.

The watched as the large blue-skinned giant ran out of their view and then they turned their eyes to the valley stretched out before them. Cabe pulled out the map to Ramma Ting and looked at it one last time before he folded it back up and nudged his Sallie to follow Kristall and Saurus down the narrow trail into the valley. That night they camped under an open sky in a meadow near a fast moving river. The Sallies were tied to a slender tree surrounded by rich grass. Saurus sat next to Kristall and they held hands as Cabe cooked a small meal from their provisions. They ate in silence and each thought about what had brought them to this point in their lives. Diago seemed a long time ago and very far away. They had survived the dangers of life outside of Diago and their love and friendship had endured and thrived in opposition to what the Diagons believed. Sleep came swiftly and the Sallies slept standing up.

Later in the night the Sallies began making noise and moving around. Saurus woke up quickly and looked around. He saw a light in the distance and nudged Kristall, whispering, "Wake up!"

Cabe was on his feet and Kristall attached her gliding wings quickly. Saurus said, "No, Kristall. Stay here."

She pulled away from him and said, "No Saurus, I'll find out what is coming!"

Kristall ran into the dark meadow and launched herself into the sky. Saurus and Cabe put out the fire and readied the Sallies for flight. The light was nearing, about a hundred yards away now. After a few more minutes Kristall landed near them and shouted, "Do not worry it is only the Larcada. I didn't see any Gruju following these Larcada. Remember, they are harmless. We just need to stay out of their way."

They all mounted the Sallies and trotted out of the path of the phosphoric insect swarm. The Larcada was a beautiful blue glow across the meadow and they all watched in admiration as the Larcada moved slowly north. When the Larcada was almost out of sight Cabe said, "Look, over there!"

Saurus and Kristall swiveled in their saddles and followed Cabe's eyes to a dim glow on the horizon. Saurus said, "More Larcada?"

Cabe shook his head and replied, "Not this time. That light is more like civilization. Maybe we have found Ramma Ting?"

They could not run the Sallies because of the darkness of night. The ground could be treacherous for them, so they only walked them at a leisurely pace letting the animals find their own way in the darkness. The dim light on the horizon grew brighter as they slowly neared. The light left them for a time when they passed through a small wood filled with thick leaved trees but when they left the shadows of the trees the light was closer and they could tell it was a city. They could see towers filled with many windows and lights glowed on the tall walls. The distant city had many towers all topped with circular peaks filled with light. They finally reached an outpost tower about a mile from the walled city. The tower had light coming from the windows a hundred feet off the ground. A figure stood on the balcony of the tower and shouted down to them, "Who comes this way?"

Saurus shouted in return, "We are weary travelers from a far away city called Diago. We have traveled many miles following an old map from the book of Yo. We are searching for the place called Ramma Ting? Is this Ramma Ting?"

The figure looked down in silence. He finally spoke slowly, "Ramma Ting is no more."

Saurus was still looking upwards at the figure but Kristall and Cabe lowered their eyes to the ground. All three of them were stunned, disappointed, and they felt their hopes crushed with those few words, "Ramma Ting is no more."

"You have reached Ramma Gennos, the city of light."

The figure continued, "You cannot enter Ramma Gennos without an invite. The next tower up this road to the city is occupied by the Lucius. He is the one to talk to about entering Ramma Gennos."

After the figure finished he turned and went inside the lighted tower. They walked their Sallies on the sandy road leading away from the lighted tower and towards Ramma Gennos. After a short ride they neared another tall, lighted tower with a gate beyond it made of blocks of granite. They saw many figures on the balcony and one shouted down to them, "Stop! Do not proceed. This is the gateway to Ramma Gennos. No one may pass with the invite from Lucius."

There were many small buildings along the road near the bottom of the tower and suddenly many men with fifteen foot spears ran out and surrounded them sitting upon their Sallies. The guardsmen grabbed the reins of the Sallies and shouted, "Where did you come by these Sallies? They are the animals of the Fielsh!"

Kristall shouted back at him, "We are protected by the Fielsh! These Sallies were given to us by HawkerCrow of the temple of the Riddle and the Serpent!"

The guardsmen stepped back away from them and even the men on the balconies backed away. One man turned from the balcony and ran inside the tower. A large fat man emerged and stood upon a platform that was slowly lowered to the ground. He wore a white robe like a huge beach towel around his fat body. He was bald and hairless. He was as fat as

a Wusht hog in a mud pit but his fat was not loose or wiggly, he was hard and tight. He left the platform and strode towards them with short chopped steps. He stopped, facing them, and held one hand high in the air, saying, "Praise you children of the Fielsh! I welcome you to Ramma Gennos."

The tower guard shouted, "Open the gate!"

They heard a loud cranking noise like rusty pulleys against metal and the large gate swung open to reveal a winding street that led to the brilliantly lit city of towers. The guards let go of the Sallie's reins and marched through the gate. Saurus, Kristall, and Cabe followed. The heavy gate swung shut behind them as they neared the first of the many towers. Only Cabe looked back and watched the gate close with a grating sound. He saw guards running to the walls and climbing up long ropes back out of the walled city. He looked back and the four guards who had led them inside had run off and climbed a removable stair-ladder out of the city. Lucius was back on the tower balcony and he waved at them from the distance. They saw only a brilliantly lit city of towers before them, no people, no movement, and no sound.

They stopped the Sallies in front of the doorway to the tall tower twenty yards in front of them. The city was so well lit up it seemed like daylight to them. Cabe actually shaded his eyes to look up at the tall tower filled with windows. The heavy doorway swung open and a giant man-form walked out. The light came from behind him so his features were hidden in shadow but his silhouette was massive. He spoke in a loud booming voice, "Welcome to Ramma Gennos, boys and girl!"

As soon as he spoke they recognized him. The giant continued, "Remember me?"

Saurus was shocked, and he whispered, "HawkerCrow?"

Kristall exclaimed, "HawkerCrow? HawkerCrow! It is you!"

HawkerCrow spread his huge arms out and shouted, "Silence! You think you are here to share peace and love? The mission of the Fielsh is two-fold: to honor the Hollim, the Holiest of Holy, the Book of our Faith and to search for the pure of heart to replenish Ramma Ting. Ramma Ting is not a city like in the book of Yo. Ramma Ting is the heart of Ramma Gennos. This city is pure light. There are no inhabitants of flesh and blood. Only the Fielsh can enter here and live for longer than a day in such power. The light source is the Larcada. Each tower is filled with living swarms of Larcada hives. This is where the Larcada thrive and breed and replicate. Within these towers is a nest filled with the nectar of the Larcada. Ramma Gennos is the source of the nectar that gives the Fielsh their strength and power. The Larcada are swarms of phosphoric insects but they originate in the belly of the Serpent. Beneath Ramma Gennos lies a vast cavern, an immense place where lies the Gennos, the monster Serpent. The Larcada begin as parasites that live within the Serpent's belly. The Fielsh learned long ago of the power of the Larcada nectar. The Riddle and the Serpent, a complex society governed by the Hollim and ruled over by the Priests of the Fielsh. Ramma Ting calls. Come with me young pure-hearts."

Kristall spread her wings and sprinted towards the wall. HawkerCrow shouted, "Come back!"

It was too late. Kristall was airborne. The guards on the wall watched helplessly as she glided high above the city. Saurus and Cabe kicked the Sallies in the ribs and the animals leaped up and ran. HawkerCrow shouted at them too, "Stop, you fools! There is no escape!"

HawkerCrow signaled to the guards. The Sallies trotted away from the wall but a guard pushed a latch and the ground opened up. A trap in the ground opened and the Sallies fell

down into a pit. Saurus and Cabe landed on top of their steeds. The Sallies were both killed with the tremendous impact of the fall. Cabe bounced on the animal and then cracked his elbow against a rock on the floor of the pit. Saurus jumped as he fell and landed on both Sallies. He was unhurt lying on the dead Sallies in the bottom of the twenty-foot pit. They heard a voice above them and looked up to see HawkerCrow standing at the edge of the pit. He boomed down to them, "I told you to stop! I hated to see the Sallies die uselessly, they were good animals. I guess you are ready to meet the Serpent, Ramma Ting."

In the pit the mud walls started to ooze and slide. The bottom of the pit became unstable and rumbled, shaking loose oozing mud. The bottom started to tilt and lean. The mud walls slid apart to reveal a huge muddy tunnel opening into darkness. The Sallies slid into the tunnel disappearing in the darkness. Saurus and Cabe slid behind the dead animals into the tunnel. The last thing they heard was HawkerCrow saying, "Goodbye pure-hearts!"

Kristall glided on a brisk air current and circled back to the place where she had seen Saurus and Cabe fall into the ground. She saw HawkerCrow standing at the edge of the pit. Kristall saw the opportunity and dived like a pelican after a surfacing fish. HawkerCrow was unaware of the gliding girl closing in on him as he shouted goodbye to Saurus and Cabe.

Kristall zoomed in like a hawk and impacted the blue-skinned giant with her feet striking in the middle of his back. The collision was so powerful her gliding wings snapped and broke on contact. HawkerCrow was thrown, by the force of the crash with Kristall, into the pit. Kristall's momentum carried her into the pit too, where she landed hard on HawkerCrow's back. Her broken wings smacked into the mud sides of the pit and one wing stuck sideways in the wall. Kristall heard Cabe

and Saurus screaming from within the tunnel into the earth. HawkerCrow was unconscious. She stood up, her feet on his back, and saw Cabe trying to climb out of the tunnel. She saw Saurus coming up behind him fast. They were screaming but suddenly their screams were drowned out by a tremendous hissing sound, like a massive steam engine throwing on brakes.

Cabe grabbed HawkerCrow's foot and pulled himself into the pit and out of the tunnel. Saurus jumped like a kangaroo frog over Cabe and landed on the other side of the pit just as a black slimy shape thrust its hideous head out of the tunnel. The Serpent, Ramma Ting, opened its wide mouth and they were suddenly bathed in the glowing light of the Larcada. The light came from inside the serpent. The Serpent's hiss filled the pit like a torrential rain of noise.

The slithering Serpent's head almost filled the pit, like a humpback whale's massive snout. The Serpent could eat them all at once with its huge mouth. HawkerCrow shook himself awake. Saurus, Cabe, and Kristall crouched on the far wall and HawkerCrow got up and stood between them and the Serpent known as Ramma Ting. He whispered to the creature, "Ramma Ting, oh god of the Riddle, I have brought you pure-hearts. Take them in and relish what a Priest of the Fielsh has brought to you."

The Serpent opened its ugly mouth again and light erupted in the pit. HawkerCrow stepped back with fear in his eyes. He realized that Ramma Ting might not understand his words. HawkerCrow now felt fear as he realized that the great Serpent might view him a food too. The blue giant stepped back and chanted as the Serpent squeezed more of its gigantic bulk out of the oozing muddy tunnel. HawkerCrow stood in the center of the whirling cloud of dust particles once again

like when he had left with the Suyulori. The blue-skinned giant was invoking his chants and creating the whirling cloud again. The tornado around HawkerCrow was building in intensity as the huge Serpent hissed and snapped its jaws. Kristall screamed, "No way! Not this time HawkerCrow! You will not get away this time!"

She jumped into the dust tornado and grabbed HawkerCrow by the wrists. Energy coursed from HawkerCrow into Kristall. She was locked to his skin by some magical electricity. Her body shook and vibrated as they both stood in the midst of swirling winds. A full minute the winds swirled and Kristall with HawkerCrow shuddered with the magic invisible fire that poured throughout their bodies. Saurus and Cabe heard a loud pop and Kristall was thrown back into them. They caught her shaking body and stopped her from hitting the muddy floor. HawkerCrow stopped shaking and the winds disappeared. He looked around, his eyes wild with bewilderment, and then he saw the large hissing Serpent open its mouth again. It was the last thing HawkerCrow saw. The Serpent engulfed the blue-skinned giant and only his feet were sticking out of its slippery mouth. The Serpent, Ramma Ting, tilted its head back and gulped once more as HawkerCrow's feet slid down into the belly of the monster snake.

The Serpent swallowed the body of HawkerCrow and then put its slanted eyes on Saurus, Cabe and Kristall. The Serpent flicked a long forked tongue in their direction before it thrust its sleek black head into the oozing mud of the pit and burrowed a new tunnel into the bowels of the earth beneath Ramma Gennos. They watched the unbelievably large Serpent slither away into the mud. It was many minutes before the entire long body of Ramma Ting was gone and the mud oozed back in place, closing off the tunnel it had just made.

Kristall shook her head and Cabe and Saurus supported her by the arms. She whispered, "It's gone. HawkerCrow is gone. We are once again on our own."

She stepped away from Saurus and Cabe and said, " I love you two, let's go find our own place. We don't need a map!"

Kristall chanted like a Suyulori and entwined her delicate fingers together. A swirling cloud of chaotic winds circled around the three of them. Saurus and Cabe stepped closer to Kristall and the tornado whirled around them with greater force. Kristall's eyes were closed but they could see her skin turning blue. The pit was gone and all they could see was the churning circling winds around them and the smooth blue skin of Kristall.

Camouflage Man

Everybody knows about all those super heroes in the comics and the movies. There are the popular ones like Batman, Superman, Spiderman, Wonder Woman, and the X-Men and the not so popular ones like Dare Devil, Iron Man, The Silver Surfer, and the Sub-Mariner. I liked reading comics and watching the movies with the heroes always winning no matter the odds. I almost used to think they could be real but I grew up and found out that evil wins more than good in the real world. We don't really have any super heroes in the real world. We do have heroes they just aren't super powered. Some firemen are heroes and policemen and even mailman, but what about a guy in a tight suit dashing into danger to save the day? I wanted to believe that a super hero could fly in and save us from disaster but those jets hit the twin towers and there wasn't any Superman around, not even a Spiderman with a big web to catch those out of control jets.

A few months ago, when I had given up on super heroes, I discovered that one exists in Houston, Texas. He is secretive and almost unseen. He delivers swift justice and disappears into the shadows. I have studied this strange character for almost a year now, following him and observing. I have found out that he lives in a trailer park on the south side of downtown Houston with his mother. He works during the day as a part-time letter carrier for the Postal Service. His name is Danny Gerber and he is in his early thirties. I found out from a few people in the trailer park that he went to high school in

Oklahoma and his mother retired here a few years ago. They said that he had trouble in school and was always an outcast. Danny doesn't have any close friends and doesn't particularly care for any of his co-workers at the Post Office. He goes to work six days a week sometimes ten hours a day delivering mail to crack houses and neighborhoods infested with pit bulls and other dogs used to guard drug houses. The Post Office managers don't like Danny either and assign him to the dirty work of delivering to the worst areas of town. Danny doesn't care; in fact he lives in such a fantasy world he barely notices.

He delivers the mail with purpose but at night Danny comes to life. It is a night when he becomes, in his own twisted mind, a super hero. I have watched him sneak out the back door of the trailer, dressed in a tight long sleeve shirt, stretch pants, Air One lacer-less basketball shoes, and a hunter's head covering camouflage mask. It seems that he spray-painted his tight clothes in a camouflage pattern. He is like a deer hunter gone crazy. Even his gloves are camouflage. He carries a small camouflage backpack as he sneaks out. On Danny's shirt, in the middle of his chest is painted crudely a big red circle or maybe it is an "O."

On some nights he gets in his car, a 1988 Toyota Celica, and on other nights he sneaks into the shadows leaving his trailer on foot. He never ventures into the light but always travels in the shadows. There are some nights when I have lost him and had to go home without discovering what he did. I have watched his rescue of a kitten from the railroad tracks, help a wino walk across a dark road to an alley, and even catch a loose pot-bellied pig and return it to the pen in a backyard. Danny is a secret super hero and he has something wrong with him. He thinks that he is invincible. I keep following him because he is interesting and he is an enigma. Someday

I think he will die doing what he does. He has no fear and does not consider injury or death. Danny, the camouflage man, or whatever he thinks of himself cannot keep up his nightly forays into danger without serious consequences.

Helping kittens is one thing he does but Danny also is a hero in true criminal situations involving dangerous men. I have seen him shot at, hit in the face, beat with a pipe, and even thrown off a roof. Nothing has ever stopped him from being a super hero in his own way. I know he is twisted, mentally bizarre, but he handles being a mailman and he lives his life with good morals and values. Men kill but men who kill for good are heroes and men who kill otherwise are evil. Danny has not killed that I know of and I don't think he could kill. I don't think it is his nature. He has the true values of a super hero. I keep wondering what that big red circle, the red "O" on his chest stands for.

There is one person Danny that Danny cares about besides his mother. Her name is Sidney Hoya. Sidney works at the Dollar General store. Sidney is twenty-seven years old and only has one eye. She has a cheap glass eye in her left socket. She realizes that everyone stares at the glass eye. She doesn't seem to mind. I have seen Danny and Sidney in the park across from his trailer, talking. Sidney is a peculiar and surreal. She is short and thin and frail with very pale skin and long stringy blonde hair. On her right arm she has a continuous spiral scar that circles around her arm beginning at her wrist and disappears under her shirt. She has told people that she wants a continuous scar from one hand that never stops until it runs from one side of her body to the other. She cuts this scar trail one inch a week with a razor blade. Danny is one of the few people she claims to have shown the scars full progress.

Tonight I sit in my car and watch as Danny, in his

camouflage super hero suit, emerges from the trailer and sneaks off into the shadows. I got out of my car and stayed back, following him stealthily. He traveled, always in the shadows, and I followed as best as I could. Finally he stood in the darkness next to the museum. I saw a slender woman walking briskly down the sidewalk. It had begun to drizzle. A few seconds later, I felt bigger drops. The rain had gotten heavier and I was getting soaked. I never did have an umbrella with me when I needed one. Danny stepped out of the shadows in front of the woman. I realized the woman was Sidney. She was startled and turned to run but he grabbed her and lifted his mask. Danny let Sidney see his secret identity. This meant something. This meant something in Danny's life, in his mind and I knew Danny cared too much for this strange self-mutilating girl. Sidney stood there looking into Danny's face and then they both went into the shadows behind the museum.

They were kissing in those shadows. The rain was pouring now and soaking them as they kissed, oblivious to the rain and the thunder. The one eyed self mutilating girl and the twister super hero kissing behind the museum. I stood there hidden behind a low brick sculpture and watched the two new lovers take a sweet moment out of their lives. Danny and Sidney, drenched and different, kissing in the rain. I was touched and thought that maybe I had seen enough of this super hero. I saw him find love. I was there and with my empty normal life felt like his super power was to fall in love with a one-eyed girl. Maybe she would stop using the razor blade on her skin now that Danny could save her. I thought about love and marriage and companionship. I thought that maybe some people get to find them and live with them in their back pocket. I thought maybe I wasn't one of those people and that I could only live

those things in dreams and other people's lives. I was a watcher and a loner. I wasn't a super hero and I could never save anyone. I knew I couldn't even save my own life.

That's when I felt someone coming up behind me. I turned but it was too late. They had me. The three men in long jackets and rain hoods grabbed me and put a gun muzzle to my neck. I couldn't see their faces in the darkness and the rain. They were like shadow riders with their faces hidden by the rain hoods. I grunted as they dragged me farther into the shadows. I tried to fight but I heard a warning, as the one with the cold wet gun against my neck said, "Stop it right now or your head is gone!"

They shoved me up against the brick wall of the museum and a hand replaced the gun at my throat. The gun was placed on my temple. I could feel my pulse pounding next to the gun's barrel on my temple. I wondered where Danny and Sidney were. The three men probably didn't know that they were back in those dark shadows kissing. The leader, with his gloved hands at my throat said, "Reach into your pockets and hand over your wallet and your car keys, now!"

The man waited while I slowly pulled out my wallet and then his hand let go of my throat. He fell slowly down to the cement. The other two looked around and then looked down at their fallen collaborator. I was stunned. The gun had fallen out of his hand and I quickly kicked it away. The dark hooded man on my left screamed at me, "Don't! Get back up against that wall!"

The other dark man grabbed the gun and pointed it at me. Suddenly something flew out of the shadows and struck the unarmed hooded man. The would be robber hit the ground and tried to get up but the attacker from the shadows kicked him in the face. I ducked instinctively as the other hooded

man fired the gun at me. That's when I saw the camouflage man, Danny, leap at the shooter and strike him in the stomach with a kick. I saw Sidney watching with her one eye as Danny hit the hooded man four times. I saw the leader lying on the cement next to me with a tiny dart stuck in his neck. The other man Danny had first knocked down got up and saw Sidney watching. He ran to her and grabbed her by the hair, dragging her to the ground. He produced a slender knife and put it to her white throat, screaming at the super hero, camouflage man, "You! Stop your silly ass crap right now or the girl bleeds like a pig!"

Danny had already knocked his man unconscious and it was only I, the man with the knife holding Sidney and himself standing in the rain. The other two hooded men lie facedown on the cement as the heavy rain pattered on their long coats. I was leaning against the brick wall and the man with the knife held Sidney by her hair. I couldn't see his eyes under the dark rain hood but I thought the must have fear and crazy lust in them. Danny stood up and dropped his hands to his sides, as if in defeat. He pointed to the man and then pointed to his chest at the big "O" and said, "Know that you are scum! You did not have to choose this life of immoral crime. Your choice is wrong and has led you to justice."

Pointing still to the circle on his chest he said, "This is the answer. Zero. I am Zero Tolerance! I spend my life cleaning up people like you who dirty their hands with the evils of the world! Let the girl go and I will spare you much pain and misery."

The man with the knife to Sidney's throat laughed, and replied, "Get a real life stupid hero! Zero boy, whatever. You look like an idiot deer hunter in those camouflages and I ain't no fool deer! Now back off and I'll let the girl live!"

Danny, Zero Tolerance, said calmly, "I thought that would be your reply."

With a quick flick of his wrist a dart appeared in the hooded man's chest. The knife slowly dropped from Sidney's throat as the darted man slid down in a crumpled pile of wet clothes to the cement. Sidney stepped away from the unconscious man and I stood up. Danny stood there in the rain like a god from some Himalayan cult. He folded his arms across his chest and stood there with three men lying on the wet cement all around him. He was Zero Tolerance and he had risen to super hero status in my eyes. I knew he was a twisted mental part-time mailman that lived in a trailer with his mother and loved a one-eyed girl but in this moment he was legendary.

Sidney ran to him and hugged him tightly. I walked out of the shadows and into the deserted street. The rain was letting up, back to a slow drizzle now. My shoes were heavy with the soaking of the rain. Danny and Sidney strolled out of the shadows behind me. I looked back into the darkness behind the museum and looked back in the street. I saw Sidney walking towards me. Danny was gone. She came up to me and asked, "Are you okay?"

I tried not to look into her glass eye and replied, "Yes, I am fine. Where did he go?"

Sidney searched my face and said, "Where did who go?"

Fiancée

Fremy said, "The dang Russians bombed Chernobyl and killed about a hundred million people!"

Richie grimaced, replying, "I don't trust no Russians and I don't trust no Chinamen either, not to mention them Moohamid Iraquians!"

Fremy was much taller than Richie, six foot three to Richie's five foot eight, and he looked down at the smaller man saying, "Heck, we don't even have a need or room on the planet for Iraquians or Iranians or any of them other Irian tribes!"

Kirt started laughing at the two men and said, "Look you two, enough politics. The world has enough political govern mentalists without you two yahoos getting on your soapboxes!"

Kirt had assisted Fremy Marzelles and Richie Dillon ever since he had counseled them after their release from mental correctional institutions. Kirt always tried to stay neutral in these cases but he had come to really enjoy being around Fremy and Richie. He didn't consider them as equals or even friends but he did enjoy their company. Their bizarre ideas filled his day with entertaining conversation. Kirt took the two men to lunch once a week at the off the main street diner, Zebello's Café. Fremy usually wore jeans, a t-shirt and a railroad cap and Richie always wore overalls. Both men were mid-forties, balding, single with no prospects, and eager for drinking a beer and watching a football game, preferably the Denver Broncos.

It was cold this time of year in Denver and today all three men wore heavy coats to Zebello's Café.

Richie had never been married but Fremy had once married a college cheerleader who flunked out of the university. Fremy was once a brilliant man but after the accident his life had changed and the cheerleader wife left him. Richie couldn't attribute his mental instability to an accident. It was something he acquired through plain good old genetics or bad luck or not enough brain cells. The two men had become friends in the Institute and both men had been under the counseling of Dr. Kirt Russen.

Fremy coughed and replied, pushing his railroad cap back on his balding head, "Now, now Dr. Kirt, you know Richie is going to run for the Senate! His platform is to run all the Chinamen and Rooskies and Moohamids out of the country. I agree with him too! I'm getting tired of the commies burning the American flag and washing their cars with it and not saluting or saying the American pledge to the flag. It's a wonder we even have a pledge to the flag any more with all these crybaby commies running around using the American flag for a beach towel!"

Richie grabbed a glass of water and lifted it, "Yes! Let's make a toast to the American flag!"

The waitress, Gina, a young version of Barbara Streisand with a smaller nose, came over to their table and asked, "You boys ready to order?"

Suddenly they all heard the loud explosion of glass breaking and looked towards the front door. A medium sized man with a medium sized brown dog stood in the doorway holding a huge automatic rifle. The man wore all black and covered his face completely with a replica Spiderman mask. The dog's face was covered too with a red ski mask with

eyeholes, nose hole and mouth holes. The Spiderman masked man said, "Don't fuckin' move!"

Kirt leaned back in his chair and froze. Fremy looked at the man like he was crazy. Richie coughed and the Spiderman masked man looked in their direction. The masked dog barked and the man shouted, "I thought I said, nobody move! That includes coughing and speaking! Now everyone stand up and keep all your hands up in the air where I can see them."

There were only eight people in the café, eleven including the two waitresses and the cashier. The cooks didn't count because nobody could see back in the kitchen and the masked man had no idea about how many cooks worked at a café. He growled, "If you move and I don't shoot you I'm gonna let my dog loose on you and I tell you now that he is hungry!"

Fremy continued to stare openly at the masked Spiderman. The man noticed his direct stare and said, "Hey! You! Keep your eyes on the floor!"

Fremy didn't respond and continued to stare at the man with the big gun. The man got angry and started to walk towards their table. Fremy cleared his throat and said, "You got the wrong suit on mister. Spiderman don't use no gun and he don't have no Spiderdog. What the heck are you anyway, one of them Moosehameds? You must not be an American because you sure would know better than you do!"

The masked man grew even more agitated. He screamed at Fremy, "Holy crap! Are you insane or just have a death wish! I'm gonna' shoot you right in the face!"

Richie stepped forward and said, "No. You am not going to shoot my friend!"

The Spiderman masked man let his masked dog loose at that moment. The dog growled and charged the men. Kirt fell backwards as Richie charged to meet the attacking masked

dog. Fremy hollered at the masked man, "You is a Moosehamid and a stupid one! Richie likes to kill doggies!"

Richie had grabbed a butter knife from a table as he and the dog collided. The masked dog jumped for Richie's throat but Richie blocked its teeth with his left hand. He plunged the butter knife deep into the vicious dog's chest. The growling dog let out a last yelp and fell thrashing in pain on the floor. The Spiderman masked man went berserk and yelled, "You killed my dog! Oh, you bastard! You crazy dead bastard! You killed my dog! Oh son of a bitch, you are dead! You killed my dog!"

Fremy was walking defiantly towards the enraged masked man as he moaned and screamed over his dead dog. Suddenly the masked man aimed the gun at Richie and began firing rapidly. Fremy didn't even flinch as bullets zinged by his head. He reached the firing gunman and grabbed his wrist and twisted upwards. The masked man dropped the gun to the floor where it clattered under a table. Kirt got up from the floor and clambered after the gun. He reached under the table and grabbed it. Fremy had the masked man's wrist and kept twisting. The masked man winced in pain, grunting out, "Let me go! You bastard, you big dumb bastard! Ow! Let go my arm!"

Kirt pointed the gun at the complaining man and Richie walked away from the dead Spiderdog. Kirt breathed heavily from the excitement. He told the waitress to call the police and then said to the Spiderman masked man, "You are going to jail."

Fremy saw that Kirt had the gun and slowly released his grip on the masked man's wrist. The masked man stumbled away from Fremy and shouted, "You ain't gonna' shoot me! I'm walking out of here and you can't stop me!"

Kirt pointed the gun and shouted back, "Don't move!"

Fremy didn't say anything but charged the retreating masked man. Richie also ran forward as the waitress yelled, "The cops are on their way!"

Suddenly the Spiderman masked man stopped and faced Fremy and Richie. He crouched like the real Spiderman as he said, "Get back you two retards! I got two poison darts in my wrist-guns. Stay back or you die!"

Fremy smiled like a big yellow happy face and laughed, saying, "No Mr. Spidermoosehamid, you don't have any poison darts. I will tell you what you are going to get though, a good American whopping!"

Fremy leapt forward before the masked man could react. Fremy bear-hugged the Spiderman masked man and the force of his rush carried them through the big plate glass window. The two men crashed struggling out into the street. Richie jumped through the window after them, yelling, "Get him Fremy! Choke the Commie Mohamen Islaman out of him! Show him how American's whop ass!"

Kirt came out of the café's door followed by the patrons and the waitress. Fremy wrestled the masked man and held him down. A police car screamed up to the curb. Kirt put his hands up quickly so the cop wouldn't shoot him. The officer had his gun out and screamed at Kirt to drop the gun!

The Spiderman masked man aimed his right wrist at the cop, and with just a small sound of air, a poison dart flew from his wrist gun. The dart hit the cop in the right thigh. Kirt had dropped the gun and it fell as if it were a feather in honey, slowly dropping towards the cement sidewalk. Fremy crouched on top of the masked man and Richie just stared at the cop. The cop slowly looked down and stared in disbelief at the tiny red dart sticking in his thigh. He pulled it out and looked at

as his eyes fluttered. The cop dropped to his knees and then fell over on his face on the sidewalk. The masked man laughed and thrust his knee up into Fremy, knocking him to the side. The masked man rolled away and got to his feet screaming at everyone, "You killed my dog! I will get you all for this! I will return and kill you all! Fremy charged at him but the Spiderman masked man turned and ran out into the street.

Fremy stopped as he watched a metropolitan bus crash into the running masked man. The bus driver slammed on his brakes as the masked man bounced off the front of the bus and rolled underneath it. Kirt, Fremy and Richie all watched as his body tumbled beneath the stopping bus. The tires screeched on the street and they could smell the rubber burning. The Spiderman masked man's body rolled to a stop behind the bus. The crowd approached the body. The Spiderman mask was gone. Kirt examined the body and said, "He's dead."

Fremy saw the Spiderman mask hanging in tatters on the muffler of the bus. Richie said, "Roadkill. He's as dead as his dog."

Fremy retrieved the torn mask as held it up, saying, "He ain't the real Spiderman."

Fremy tucked the mask into his pocket. They all heard sirens approaching and the crowd was slowly growing larger. Gina, the waitress, came forward and handed the poison dart to Kirt. The cop was still face down on the sidewalk. Gina walked over to the dead man behind the bus and took off a ring on her left hand, throwing it down at the body. She stepped over the dead man and walked across the street, disappearing into the approaching crowds.

Gyllfae and Bogmai

The river flowed underground for hundreds of miles before it finally surfaced in a spray of mist, spurting droplets from a warm spring deep in the forest. The pressure from the underground river spewed water over fifteen feet in the air in a continuous stream above the rocks of the pool. Gyllfae reclined upon a boulder that overlooked the water-spray in the center of the pool. She liked to look down into the clear water and watch lemon fish swimming in the depths and occasionally coming to the surface in search of fallen insects. Gyllfae had been visiting this place of magical beauty for countless ages. She didn't even know how old she was. Her beauty never faded and she always reflected an enchanted radiance of prepubescent beauty. Her hair was a tangle of long white ringlets and her eyes a myriad of blue and gray flecks. Gyllfae's skin was as white as a lily and smooth like satin. She was the last of her kind.

Brendan had been digging in the forest for hours searching for fossils. He needed more evidence of the habitat of the Staurikosaurids, bipedal predatory dinosaurs inhabiting this part of South America during the Mid to Late Triassic. The Staurikosaurids included some of the most primitive of all dinosaurs. Brendan had uncovered many of their bones in new areas of the rainforest, proving that their range was far greater than before imagined. His excursion party consisted of Brazilian guides and extra bearers. He liked to work and

travel light. Brendan stood up from the excavation and wiped perspiration from his glasses. He was too young to be credited for his work and had to rely on his mentor for proper respect in the paleontology world. A twenty-five year old paleontologist didn't command much respect with the graybeards of the academia circle. Removing his cap Brendan wiped his sweaty face with a small rag and put down his tools. He slipped a few more fossil bones from a Protoceratops and a striking claw from a Noasaurid, an eight-foot long raptor-like dinosaur found mostly farther south on the South American continent in Argentina.

Brendan removed his canteen and took a long swallow of the cool water. The rainforest's humidity was stifling and the heat sweltering. Brendan capped the canteen and then looked deep into the jungle as he heard a long low moaning. It sounded much like one of those deep moans made by howler monkeys. He hadn't seen or heard any howlers in this part of the jungle but maybe he could get a glimpse of a troop of Amazonian howler monkeys. Brendan started off into the jungle following the moaning sound.

Gyllfae heard the moaning sound near her precious spring pool and scanned the jungle foliage for its source. She knew what made the sound and it was a sound Gyllfae knew well. She stood up and darted into the safety of the trees. She climbed a long curving branch as thick as an elephant's thigh until she was high into the jungle canopy. She had a good view of the spring pool and the surrounding jungle. Gyllfae waited for the approaching moaning sound as it neared the spring pool.

Brendan walked briskly through undergrowth and clearings of palm and fern. He was getting closer to the sound. The closer he got the more he decided it wasn't howler

monkeys. He thought that it sounded bigger than monkeys. He knew black howler monkeys could be loud enough to be heard for miles in the jungle but this sound wasn't just loud, it was deep, as if it came from something very large. His curiosity pushed aside his fear of the unknown and he cautiously strode forward towards the increasing loud moaning sound.

From her perch high in the tree Gyllfae saw Brendan approaching the spring pool from the south but from the north she could see the Bogmai, smashing plants and moaning louder than ever. She knew the man's scent had attracted the Bogmai. The Indians of the region knew better than to venture in this region without covering themselves in musk scent of tapir to protect them from the Bogmai. This man was not an Indian and did not have scent protection. He was unaware of his dangerous plight. Gyllfae felt nervous fear for the innocent stranger in the jungle. She had never seen a man close up and no man had ever seen her. The Bogmai knew Gyllfae and disliked her but respected her. It would destroy her if given the chance.

Brendan stopped when the moaning stopped. He had reached the spring pool. He admired the beauty of the water's spray into the air. The jungle was quiet around him and that silence made him afraid. The birds and other creatures had hushed. The only sound was his breathing and the splashing of the water's spray. Brendan looked around the spring pool and searched the boulders and foliage for a sign of life. He heard a low whistle from the trees and saw a turkey-sized great curassow fly quickly through the trees like a big black vulture fleeing death. He felt as if he were being watched and scanned the spring pool's edge again. This time he saw it. He was being watched. The thing was across the pool from him between two boulders, almost looking like a boulder itself. Brendan, at

first didn't know what the thing was but he continued to stare at it as it regarded him with yellow eyes. The thing coughed like a volcano spitting up lava but otherwise it didn't move. Brendan was still, afraid to even breathe. Gyllfae watched in silence from her perch high in the canopy of the jungle above the spring pool. A spider monkey climbed up next to her and also stared down at the scene of a man staring across the pool into the eyes of the Bogmai.

The local Indians told the stories of the Bogmai for as many generations as they could remember. The Bogmai was not their enemy but more like a respectful presence that they had learned to live with and avoid. Only a foolish person would venture into the Bogmai's territory. The Bogmai was a god, a bad god, a ravenous god, a powerful god, yet still a god to be reckoned with and to know to stay away from his anger. The elders of the tribe told the Bogmai's story each festival year, and Roa, the youngest hunter, remembered the story well. Roa had sat in the darkness just beyond the crowd with his brother and listened as the old man chanted and cackled the story of the Bogmai. The old man's words reverberated in young Roa's dreams still. The old man sang slowly and chanted, "The jungle was born with the mountains for a mother and the sky for a father. The father sky god mated with the mother mountain god and she rumbled and her womb erupted with fire. The mountains belched forth the liquid fire and covered the barren dirt. The sky god cooled the mountain god's child and named the offspring the jungle. The jungle grew and flourished and the mountains became calm as the mother mountain god watched her child mature. The jungle grew and smaller gods were born in the depths of its belly. Jaguar gods,

Tapir gods, Monkey gods, and many more began to appear in the jungle. The water god brought lakes and rivers to cool the jungle and then finally the mountain mother god wanted more. She rumbled and shook the ground and the sky father god answered with thunder and terrible lightning. The sky god rained down water that mixed with the mud of the mother mountain god. The two gods again created another creature to contend with the jaguars and monkeys. Shaped from the muddy clay from both mountain and sky the father and mother god of the jungle formed a man and a woman. The man and the woman were beautiful but when the clay hardened in the sun they became brittle and dry and when they moved pieces broke apart. The parent gods were saddened because they thought the man and woman were their most beautiful creations. They decided to try and create a better man and woman and this time they would not use the muddy clay. The clay man and woman were then abandoned, in many broken pieces, by the river. The sky father god and the mountain mother god then used all four elements earth, fire, water, and air and created the men and women of our tribe to live in the belly of their first son, the jungle."

The old man had paused here and smoked from a wooden pipe. He continued after a pause and a long drink from the gourd, "The abandoned clay man and woman were found by the god of the night, the dark god liked the clay man and woman so he decided to create his own version from what remained. The dark god used the thick tar from beneath the ground and mixed it with the clay. He produced a mass of wet and sticky clay and tar. The dark god shaped this mass into his own creation. He called his new creation his son, Bogmai. He gave the Bogmai some of his powers, night vision, powerful strength, and his own evil temper. He didn't want the sky god

or the mountain god to be jealous of his son and try to destroy him so he told the Bogmai to hide during the day and only roam at night. The dark god also gave the Bogmai a territory to call his own and warned him that if he ventured from it he could be destroyed. The Bogmai stayed within his territory but eventually he became confident and ignored the warning of hiding during the day. The Bogmai learned to live with the people of our tribe and never killed them, unless they ventured forth into his territory. The Gyllfae lives in the Bogmai's territory but she is another tale."

Roa remembered the tale and shivered at the scary story of the evil dark god and his son, the Bogmai. Roa had not forgotten the boundaries of the Bogmai's territory but he was on a dream quest. The drink had given him the vision to follow and he must complete his dream quest to take his place in the mating ceremony. In the dream state he was invincible anyway, not even the terrible wrath of the Bogmai could touch him. Roa neared the pool and heard the sounds of crashing fronds and broken branches. He stepped to the edge of the pool and saw the Bogmai and his eyes also took in the strange man that was unlike any of his tribe or even any of the other tribes of the jungle. Roa was proud because his dream quest was so powerful and produced such incredible visions. He would tell the greatest story of his dream quest when he returned. Many of the women of the tribe would wish to mate with him, again and again. Roa stepped closer to the pool's edge and shouted as loud as he could across the water. Gyllfae looked down and saw the young tribesmen as he shouted. The monkey beside her on the branch jumped up four feet higher in the tree when the young Indian shouted. Brendan's head turned, as he jumped, startled by the shout. The Bogmai snorted like an enormous pig and lowered its head, angered by the loud noise. Brendan

looked back at the huge Bogmai and then to the young Indian. The boy had red and white designs painted on his face and his chest. His only garment was a piece of deerskin around his waist. A short bow was slung across his back with a quiver of arrows. After seeing the Bogmai, Brendan wished he had carried a gun.

There was a long moment when the jungle was very quiet. The usually noisy birds and monkeys stopped chattering and not even the breeze made any sound. The shout from the young Indian echoed and then died in the foliage. The Bogmai, head down, eyes squinting at the Indian, seemed frozen in anger, and Brendan held his breath. Gyllfae readied herself to interact if necessary. She waited for the quiet tense moment to end and chaos to begin.

Suddenly the Bogmai, which resembled a giant hog as large as a rhinoceros with four foot long tusks protruding from its pig nose, snorted and screamed, charging directly into the water. The massive Bogmai splashed and swam towards the young Indian boy across the pool on the opposite bank. The Indian boy unslung his bow and fitted an arrow instantly. Brendan watched as the Indian boy shot one arrow and had three others in his hand ready to fire again and again. The first arrow struck the Bogmai in the right shoulder but the huge pig creature barely noticed the tiny, feathered shaft sticking out of its muscular body. Gyllfae leapt from her perch and landed on the boulder near Brendan. Her movement caught Brendan's eye and he glanced away from the scene of the Bogmai and the Indian boy, discovering the surreal innocence and unique beauty of Gylffae. Two more arrows from the Indian's bow scored direct hits in the back and shoulder of the gargantuan hog. The Bogmai snorted and sprayed water in all directions as it neared the Indian boy. The monstrous

pig thrust its bulk from the water to attack the boy but the Indian was too quick and jumped up, grabbing a long branch hanging over the water. He scampered up into the tree like a squirrel monkey. The Bogmai tossed its powerful head back and forth bellowing rage for all the jungle to hear. The Indian boy laughed from the safety of the tree. The raging Bogmai swiveled around searching to vent its rage elsewhere and found Brendan staring wide-eyed across the pool. The large tusked pig shook its massive snout and screamed like a woman in pain. Brendan's breath stopped momentarily as he realized the creature meant to attack him. The Bogmai plunged back into the pool charging and swimming towards him. Brendan started climbing the boulder upon which Gylffae stood.

Roa watched as the Bogmai charged across the water towards the strange man. He fitted another arrow into his bow and patiently took aim for the Bogmai's head. Brendan couldn't climb fast enough and when the Bogmai came lumbering out of the pool he was only halfway up the large rock, well within easy reach of the Bogmai's tusks. Gylffae had to intervene in this silly three-way confrontation. She knew she could not let this situation continue to escalate. Roa aimed and let loose his arrow just as the Bogmai slashed with his tusks at Brendan's unprotected back.

Gylffae acted with speed unlike any creature on earth. Brendan and Roa witnessed her acts but only really saw a blur of white as she leapt at the arrow and the Bogmai. Gylffae intercepted the shaft in mid-flight, grabbing it with her left hand and at the same time she flipped and landed with both feet on the head of the Bogmai. Her force smashed the massive head of the Bogmai into the ground. From her place of impact Gylffae stood on the Bogmai's head and then jumped away towards the boulder Brendan was clinging to. As she jumped

over Brendan she reached down and grabbed his shirt, hauling him upwards on top of the boulder with a Herculean strength that he couldn't believe such a lithe female could possess. The Bogmai recovered and shook its head. The pig eyes glared at Gyllfae and the Bogmai snorted in disgust as it trotted off into the jungle. Roa had watched in amazement as Gyllfae had performed her unbelievable heroics. The young Indian boy saw her break his arrow into two pieces and toss them into the foliage. Gyllfae stared at the boy and pointed to the jungle. Roa understood her completely and dashed off into the jungle not looking back or stopping for over a mile.

Brendan was sitting on the top of the boulder and Gyllfae stood next to him as they both watch the Bogmai and the Indian disappear into the thick green jungle. The birds and monkeys had started chattering again and the jungle was no longer a scary quiet place. Gyllfae looked down at the strange man. Brendan felt relieved that she had saved him but now as he looked up at her he was filled with a disquieting trepidation. This unusual woman was like nothing he had ever encountered. Her physical appearance was unlike anyone he had ever seen. He even wondered if she was human. She was beautiful but in another worldly way. Her nose was so small it almost didn't exist. Her eyes were overly large and shiny and her ears were so tiny they seemed to look like they were the ears of an infant. Her petite body was incredibly athletic but youthful in a childlike way. She was covered in a sheen of white blonde hairs all over her pale skin and her mass of lion-like mane of white curls cascaded over her shoulders and down her back. He was amazed and entranced by her but afraid of her at the same time. A tiger is beautiful but kills.

Gyllfae reached down and touched his face with her small but strong hands. Brendan relaxed as she caressed his cheek

and traced his jaw line with her finger. He started to speak to her but she silenced him by putting her finger on his lips. Gyllfae took his hand and led him down the boulder and into the jungle. The monkeys chattered in the trees following them high in the canopy. They didn't walk far and she led him to a rocky overhang with a clearing of smashed yellow grass beneath it. Gyllfae pushed him towards the back wall of the rock and knelt down in front of him. Brendan seemed to have no control of what was happening to him. His mind flashed back to the Indian boy firing arrows at the huge pig with four tusks splashing through the water. He was alone in a labyrinth of vine and frond, alone except for this strange beautiful female creature. She knelt in front of Brendan and quickly unbuckled his pants, yanking them down to his ankles. Brendan gasped at the sight of this white-haired nude female as she grabbed his underwear and thrust them down into a wad in his pants. Brendan was naked from the waist down and before he could even react Gyllfae had taken his manrod into her mouth, vigorously pleasuring him. The warmth filled him and took Brendan to a place of heat and pleasure. This experience was unlike any he had ever had. His mind traveled in this exotic landscape, as he seemed to be in a dreaming place. Brendan thought he would awaken at any second. He threw his head back and gasped as he could no longer control the fiery pleasure and he exploded into a kaleidoscope of ecstasy as the tiny female drank of him. Gyllfae smiled up at Brendan as his knees buckled and he sat down heavily beside her. Dinosaurian fossils were long forgotten in his state of bliss. Gyllfae stared deep into his eyes and Brendan gazed back in dreamlike stupor. Gyllfae pulled off his shirt and kissed his chest and neck. Brendan felt each touch of her lips like a feathery brush of warm heat. He reclined upon his back as she tenderly kissed

his skin. Gyllfae, so childlike in appearance, beautiful as a young goddess, administered pleasure upon him and he was soon surging with desire again. Gyllfae leapt upon him and impaled herself upon his manrod with luscious energy. She had determination in her bright eyes as she rode him in the jungle as the monkeys cheered overhead. Brendan was overwhelmed and could not even move to respond to her wild urgent lust. Gyllfae rocked and bucked and then clamped tighter upon him as she felt his release. Gyllfae shuddered and opened her wet lips, uttering a shriek that shook the jungle and quieted the monkeys and the birds. She fell forward onto Brendan's chest, breathing heavily.

Brendan had passed out and slept in a black deep sleep with Gyllfae on top of him. When he awoke Gyllfae was gone. He sat up and put his clothes back on while monkeys stared down at him from the treetops. He glanced upwards as they chattered and said to them, "Did you enjoy the show?"

He turned and headed back towards the pool in search of the beautiful white girl. He walked and walked and soon discovered he didn't even know in which direction he had come from. He had probably been walking in circles. The ever-present monkey troop was still overhead. The boisterous monkeys had been following him the whole time. He looked up into the canopy and asked the monkeys, "Hey, at least you guys could show me the way back to the pool!"

The monkeys didn't answer. Brendan shouted into the jungle, "Hello! Where are you?"

He shouted again, feeling foolish, thinking that maybe she could hear him. Brendan suddenly realized that the monkeys had become silent. He looked up at them and they all seemed to be unmoving and quiet. They were not looking down at him anymore but into the distance. Brendan heard something coming through the jungle. He shouted, "Hey!"

Thinking it was the girl but then he realized shouting might have been a bad idea when he heard branches breaking and plants snapping. Something was coming but it wasn't the girl. Something was coming and it was big. Brendan started climbing the nearest tree just as the Bogmai, with three of Roa's arrows still sticking out of it's thick hide, came into his view. The giant hog shook its four tusks back and forth and let out a rumbling grunt as it saw him trying to climb the tree. Brendan had gotten a slow start and was only five or six feet up into the tree and having a hard time finding a way to get any higher when the Bogmai charged.

The Bogmai collided with the tree trunk and shook Brendan but he held on and climbed higher. The Bogmai backed up and snarled, looking up at Brendan. That is when Brendan's guides and bearers entered the clearing shouting. The Brazilians saw Brendan up in the tree and the massive pig creature shaking its head on the ground. They shouted at the Bogmai, trying to distract it from Brendan. The beast whirled around like a fast armored tank and belched forth a loud grunt of anger. The Brazilians had achieved their aim in diverting the creature's attention but now the Bogmai charged them. The ground shook with the heavy feet of the Bogmai pounding in a full sprint towards the scattering Brazilians. Brendan saw his men running in all directions into the jungle. He watched the Bogmai crash through a patch of huge ferns and disappear into green foliage. He could hear men screaming and the crash of broken vegetation. He listened for a time until the sounds grew faint and finally stopped. A monkey sat a few feet above him in the tree. Brendan looked up and said, "Hello, monkey. Do you think it would be safe to get out of this tree now?"

The little spider monkey just tilted its head and chattered incomprehensible monkey talk. Brendan started a slow climb

back to the forest floor. He jumped down and landed in one of the Bogmai's enormous footprints and fell over. When he started to get up from the ground he noticed a pair of tiny feet near him. Looking up he saw that the girl had returned. She squatted down next to him and produced a skin filled with water. He drank greedily and she smiled. After he had wiped his mouth Gyllfae pushed him down on his back and sat on his chest. She reached back and began unbuckling his belt. Brendan grabbed her and shook his head, saying, "No. Not this time little girl. You have some explaining to do. Stop it! What is it with you? Are you some kind of jungle nympho?"

His aggressive behavior stopped Gyllfae and she stared at him, her big beautiful eyes almost filling with tears. He held onto both her arms to keep her from anymore sexual advances. That's when the Bogmai returned. Gyllfae sat on Brendan's chest and turned when the Bogmai crashed into view. The giant four-tusked pig was only twenty feet away, snorting like a slow train. Brendan released Gyllfae's arms and she jumped up. Brendan got up quickly too. They stood side by side facing the monster hog. The Bogmai pawed the ground and its tiny eyes almost glowed with yellow light. Gyllfae stepped between the Bogmai and Brendan and held up one hand. The Bogmai stopped pawing and raised its head, staring at the pale tiny female. Gyllfae crouched down, bending her knees and continued to hold her hand towards the Bogmai. Brendan watched in disbelief as Gyllfae crouched, moaning and her body started to quiver. Brendan could tell she was under a great deal of pain and stress but he had no idea why. The jungle was silent again and then Gyllfae screamed. The scream was long and piercing. She fell to her knees on the ground and Brendan saw blood splatter between her feet. Gyllfae looked back at him and then she reached between her legs and produced a bloody

white egg the size of a softball. The Bogmai stepped back and then with a sound retreated into the jungle.

Gyllfae held out the egg to Brendan. She stood back up and carried the egg gently to him, as he stood transfixed with awe. Gyllfae put the bloody egg in his hands and then kissed it. She touched his face with her small hand and then kissed his lips. She wrapped both of his hands around the egg. They stared at each other a long time. Brendan held the egg and stared at the beautiful mysterious girl. Gyllfae kissed the egg again and then turned and ran off, leaping into the nearest tree like a gliding phantom. She was gone instantly. Brendan searched the trees for her white form but only saw the many monkeys that had gathered overhead. Brendan stood in the jungle holding a large white egg with drying blood on it. He sat down, leaning against the tree he had previously climbed. The egg was warm in his hands and Brendan cradled it gently. The monkeys chattered and cavorted above him in the tangle of branches and vines. Brendan rested his head and leaned back, falling into a deep slumber. The egg began to wobble. The monkeys heard the tiny clicking noises from the egg and stopped their ruckus to watch. A crack appeared in the eggshell. One tiny white tusk poked out.

JUDY'S ARMADILLOS

The armadillo tried to hide in the shrubbery in front of Judy's house but Josh and Gil were not fooled. The full moon lit up the night like a far away lantern. They stopped about twenty feet away from the hiding armadillo and Josh whispered, "Hey, I still see him in there. We got him now. This time tomorrow night Betty and Linda Marie will be grilling up some 'dillo steaks."

Josh grinned, with a mouth full of stained teeth, at Gil, a freckled grossly overweight man with overalls and boots that looked like they were made during World War I. Josh was bald and had lean muscles popping out of his wiry frame. Josh pushed his thick black glasses back on his long nose and spat on the ground, whispering again, "Gil get your fat self over there and cut off the 'dillo's escape route. Hurry up! What do you think this is Christmas Day?"

Josh was married to Betty, a black haired trailer queen, and Gil's wife, Linda Marie, was almost as big as he was and could actually eat more. The two men had been friends for quite a few years and they frequently took their wives out to Ryan's Buffet Restaurant on "All You Can Eat Night." Josh never had any money except when his unemployment check came in the mail and he ended up hunting down small animals for supper rather than buy groceries. Southern Texas had been home to both Josh and Gil for many years but they both had come from other states, Josh from Alabama and Gil

from New Mexico. The oil industry had drawn them both here in the hopes of hiring on at the chemical plants. Their dreams had been dashed when Gil failed the physical and Josh couldn't pass the drug test.

Josh held a crab net in his bony hand and advanced upon the shrubbery in front of Judy's house. Gil walked as quietly as he possibly could, which was not quiet at all and the armadillo poised itself to dash from the shrubs and scamper across the lawn to the safety of the bushes near the water of the canal. The armadillo's tiny eyes twinkled in the darkness and Josh motioned for Gil to run into the shrubbery. Just as Josh and Gil ran forward with crab nets in their hands, Judy's front porch light came on.

When the light came on the armadillo jumped straight up, almost clearing the ground a foot in the air. Josh and Gil ran full into each other. The armadillo ran out of the shrubbery and darted across the porch into a thick grouping of hedge and ferns. Josh fell down hard and landed on a cactus. Gil didn't fall on the ground but Josh's crab net handle smacked him in the face. Gil started crying and wailing, holding his red face with both hands, his crab net on the ground. Josh howled and scrambled up out of the cactus. His back and rear end was filled with cactus quills. The noise filled the rural neighborhood and other porch lights began to come on. Judy opened her door and saw the two men, Josh howling and grabbing at his backside and Gil slobbering and crying, holding his face. She heard the neighbor's dogs barking and she screamed at the two men, "Hey now! What are you two doing out here? After my armadillos again? See what happens when you try to catch them? How many times I done told you to leave them critters alone? I should call the police. If I didn't know your wives I would. Now you two cry babies get on home and stay away from my armadillos!"

Judy was a nice looking young woman with a passion for stray cats and any other creature that needed some assistance. She had many cages out behind her house full of odd animals that she had taken in and nurtured back to health. She had raccoons, nutria rats, a one-winged cormorant, a blind barn owl, rabbits, mice, and many other animals. Her hands had nicks and cuts on them almost all the time from getting bit and scratched by her "pets." She knew Josh and Gil liked to eat anything they could catch. She hated it when they tried to eat animals that liked the safety of her yard. Playing Bingo on Thursday nights with Betty and Linda Marie was fun but she warned her girlfriends that they needed to control their husbands. She told them that one of these days somebody was going to call the police on them.

Josh and Gil picked up their crab nets, Gil still crying, and walked slowly out of Judy's yard. The armadillo slowly came out from the concealment of the hedge and hopped up on Judy's porch. She bent down and scratched it behind the ears. When the two men got across the street Josh slapped Gil and said, "Shut up crying already! You didn't even get hit that hard. Heck my mommy used to beat me harder than that with a switch! I'm the one that got it bad. I got cactus stickers in my butt! Dang! Just look back there at that armadillo on her porch. He is laughing at us, I swear!"

Gil wiped his face with his dirty hand and replied, "Josh maybe we should stay away from Judy's yard. Linda Marie already warned me to stay away from there. She said the police are going to arrest us and throw away the key. I don't want to be in no jail. All you get to eat in there is breadcrumbs and water. Josh, I can't just eat breadcrumbs and water. I got to have real food. I got..."

Josh slapped Gil upside his head! "Stop it Gil! You are

getting on my last nerve boy! Now hush and listen. Remember the words of my favorite song? "Dirty deeds done dirt cheap" by AC/DC? Well catching armadillos is a dirty deed but somebody's got to do it. That somebody is us, Gil!"

Gil pleaded, "But Josh, we better not because..."

Josh slapped Gil again and said, "You are really getting my blood to boiling now Gil! I swear I'm going to have to punch you right square in the nose if you don't shut up the whiney boy crap! Now here's what we are going to do. When the lights go out in a little while we are going back over there in Judy's yard and we are going to grab that little smart aleck armadillo. That's right stop shaking your head. We are going to get the armadillo and tomorrow Betty and Linda Marie are going to be happy as they cook us some 'dillo steaks! Am I right? I say Gil, am I right?"

Gil zipped his lip because he didn't want to get slapped again and just nodded up and down. Josh attempted to put his skinny arm around Gil but Gil was too wide and so he just patted Gil on his broad back.

A few hours later, deeper into the south Texas night, Josh and Gil crept as quietly as they could back across the road into Judy's front yard. The house was dark and the dogs weren't barking. Josh motioned Gil to circle the shrubbery and they would flush the little armadillo out in the open if it were still in there. As they approached Josh peered into the dark shadows of the porch and saw, to his amazement, the armadillo sitting on the top step. Josh motioned Gil to join him approaching the porch. The two men walked slowly, coming from both sides of the porch, towards the armadillo. As they approached, the armadillo stood on its hind legs and flicked its ears. Josh said, "Now!"

Both men rushed forward and swung their crab nets

towards the little animal. Suddenly Josh and Gil stepped into the trap. Both men were jerked off their feet when they stepped into wire nooses. The wire pulled their legs up and they hung upside down from Judy's porch, swinging helplessly like a deer hunters trophy. The armadillo had never even moved and Judy opened the door as she turned the porch light on again. She smiled at the men hanging upside down from her porch, their heads a few feet from the ground. She opened a can of dog food and poured it into a bowl. Nine armadillos came hopping out of the shrubbery onto the porch and began eating. Judy picked up the men's crab nets that they had dropped and went back inside, turning off the light behind her.

The armadillos ate noisily, smacking their leathery lips, and Gil started crying again. Josh had never seen a man as fat as Gil hanging upside down and started laughing. The armadillos finished the dog food and scampered off the porch.

MONTANA MIST
(Winter of the White Wolf)

E verybody has a different story about love. Old timers tell about loves lost and true love found. Some people will even tell you how much they love their damn dog or even cat. This story isn't really like those but it does have a common theme. This story has love filled to the brim of the glass of life but that's where any resemblance ends. I heard tell once that love has over a hundred different meanings and you know what I think? That is an understatement. This is a story about living and how life keeps going, giving and taking, until you look around and see the road behind is a twisted thing like a multi-jointed snake. The road behind determines how you look to discover which fork ahead is the best route. Sassy Lilytrotter had stumbled down a curving, looping, backtracking, circling road all her young life. She was twenty-eight yesterday, wearing jeans, hiking boots and a white cotton shirt, she stood looking at a new road to a new place.

Sassy wasn't considered beautiful and maybe by some, not even pretty, but she was out of the ordinary. Pale blonde, green eyed with olive skin, she seemed foreign and her nose had a slight bump in the middle. She was skinny and bow-legged with pretty hands and feet. Sassy had beautiful white teeth and when she smiled it was like clean T-shirts hanging on

the clothesline in the backyard. She had held many different occupations since she left Tucson, Arizona, nine years ago. Sassy had worked in El Paso, Texas as a waitress in a small café, a toll-booth cashier in Houston, Texas, posed nude for magazine photos in Reno, Nevada and even was a ski instructor in Granby, Colorado for a few years. Sassy was always looking. She was looking for something that she couldn't find. Sassy wanted to go where the road led. She walked past other people's dreams and security and followed the twisting snake through deserts and mountains, big cities and cow towns. Sassy was on a quest and she didn't even know it. She would take her small earnings and saddle-up, following fate or hope or desire into new horizons with new promises. A skinny green-eyed girl carrying a backpack full of her life, down the roads of America.

Hanlon Starky had been here for eleven years, studying wolves. With shoulders resembling big rocks hidden beneath his shirt, Hanlon was a large man. He liked the mountains and he liked the cold and the snow of winter. He was a loner, almost a hermit. The people in town liked him but he never said much. Hanlon mostly just kept to himself and his wolves. He lived in the cabin his grandfather left him up in the mountains. He was thirty five years old but sometimes he seemed older with his thick full beard covered in ice and snow and his old cowboy hat pulled down low over his striking blue eyes. Most of the townsfolk didn't know anything of Hanlon's past. Everyone knew he was a wolf expert and that he had a few big degrees from some fancy college in Michigan but that's about all they knew of his past. Before he found his way to his grandfather's cabin Hanlon was an odd mystery to the

people of this place and his presence since wasn't much more illuminating. They called it a town but mostly it was just a bunch of families and loners that city life cast out. The few people that lived here wanted to be here and they accepted each other. There wasn't much of a town, up here in the mountains, only about fifty people, maybe eight families lived in log cabins spread out surrounding a few businesses. There was an eatery called the Ice Bowl Café and a bar next to it called Shade's. Hazel Trade was the name of the town store. Hazel Jouresske owned it, an aging woman with fire in her pale eyes and a witch's temper to match her foul tongue, but within she had the heart of an angel. The town had a name created by Osburg Snektz, the first man to build here. It was called Rime, a word from the Germanic *hrimaz*, meaning hoarfrost. Rime was the frost, a granular coating of ice that covered all the trees and the rocks in the area when Osburg found his way over the mountains and into the region. He liked the level area before the mountains rose again and decided to stay with his wife, building the first cabin. Osburg Snektz's cabin still stands but is used as a storage house now.

The summer in Rime is short and it the only time people can reach the town. The mountain road is treacherous and barely passable, even in the summer. In the winter Rime is isolated from the world. Sassy left behind Browning, Montana under an August sun and hitched a ride in a truck through Columbia Falls, Whitefish, and got out in Eureka. She left the main highway and found a gravel road filled with holes and bumps that led upward north into the mountains. Rebel Shuckers pulled up beside Sassy in his faded red jeep and asked, "You headed up to Rime, I guess, need a ride?"

She squinted at him in the bright sunlight and said, "Is that where this road goes? I couldn't find it on my map. Sounds like a place I might be headed. If your ride is free I'm taking it, if not my legs feel good and could use some stretching."

Rebel was over fifty but resembled a wild musk ox that had seen better days. Sassy figured he was more like seventy. His confederate cap wasn't even gray anymore, more like black and dirt colored. He laughed at her smartness and clapped his own head, "I usually charge but today I got a 'free special' going. Hop in, missy! It's a mighty long walk up to Rime."

Rebel chattered away like he had kept his mouth closed for the last ten days. Sassy listened and asked questions when he paused long enough to let her speak. Rebel growled away, saying, "Rime doesn't get many visitors. You got family there?"

"No. I don't have a family anymore, just me. I think maybe Rime is where I'm supposed to go. I've been just about everywhere else."

Rebel smiled at her and winked, "Well, Rime sure can use some new blood. They ain't many people living up there and anybody wants to come join the bunch is more than welcome. Heck I can even find you something to do to help you make some cash, even though most folks don't really need paper money up in Rime. We mostly trade one another for goods and services. Missy, uh, what is your name anyway? Mine's Rebel, Rebel Shuckers."

She smiled big showing her ice white teeth and said, shaking his right hand as he drove, Nice to meet you, Rebel. I'm Sassy Lilytrotter."

Hanlon walked slowly through his cabin and watered his ivy. He conversed with the plant each day as if it was his roommate from college. The plant knew more about Hanlon than all of the residents of Rime. Hanlon's cabin was sparsely decorated with old wooden furniture set in a circle around the fireplace. Inside the circle of chairs, on the floor, was a huge grizzly bear rug. On the walls hung Crow Indian spears and arrows along with a few mounted big trout gathering dust. Hanging horizontally over the fireplace was an old taped up hockey stick and two worn hockey gloves. There was also a gun rack in the corner filled with four rifles and one handgun in a holster was draped on a peg. Each day in the summer Hanlon picked flowers and put them in a vase on the iron table in the kitchen. The vase stood empty during the rest of the year as a reminder that snow covered all the flowers. Hanlon gave the hockey stick a long look and then headed out the door towards the fenced enclosure behind the cabin.

Hanlon studied the wild wolves but he also took in orphaned wolf pups and raised them until they could be released safely back into the wilderness. In eleven years Hanlon had reared and released sixteen wolves back into the mountains. There were many times during the years when he would recognize one of his wolves returning to the scene of their old home. Hanlon always kept journals of the wolves and their journeys. He wrote down everything he thought was important. Walking behind the cabin he whistled loudly, and then called out, "Thor! Sif! Come here!"

The two wolf pups, about half grown, came loping from the perimeter of the enclosure. Hanlon smiled and opened the gate, going in and crouching down as the two young wolves leapt upon him, licking and play biting. He grunted to the young wolves, "You missed me? Yeah, you two missed me."

Hanlon had named the two wolf pups, after the Norse god Thor, the god of thunder and his wife, Sif, the Norse goddess of fertility and the magic of women. The two wolves jumped up and licked his face and neck as he tumbled to the ground and wrestled with them in the grass. Hanlon had been a surrogate parent to Thor and Sif since they were brought to him when they were only about six weeks old. The townspeople thought it odd that he kept wolves. He even looked like some kind of wolfman with his heavy beard, long blonde-streaked brown hair hanging in unruly strands, and big fur coat walking around in the woods in the cold of winter. People referred to him as 'Wolfy' but never to his face. Most of the people knew to mind their own business in a place like Rime. Nobody wanted to know too much about anybody else and especially about Wolfy, the big man in the cowboy hat that ran in the woods with wolves.

<p style="text-align:center">***</p>

There was one person in Rime that knew Hanlon better than the rest. Her name was Cynthia Horn. She was a tall pretty woman with straight strawberry blonde hair and skin the color of cream. Hazel sometimes called her Cinnamon because she had a light dusting of freckles across her nose. Cynthia lived in one of the rooms above Hazel Trade. The four rooms above Hazel Trade were the closest thing to a hotel that the town of Rime could offer. Hazel Jouresske provided breakfast and supper, clean towels and sheets, to her guests who paid for the rooms by the week. Cynthia kept her room immaculate and ran her own business from her room. Prostitution might be illegal elsewhere but in Rime there wasn't a lawman or a judge or even a jail. Crime wasn't tolerated and the people here knew it. The last time there had a been a theft or a robbery had been

before Hanlon had even moved to Rime. There had been only one murder in the entire history of the town and both men had shot each other at the same time. Rebel had been standing in the road and watched the two fools pull pistols on each other. They shot almost simultaneously and the bullets hit each man in the chest. They both fell in the snow, instantly dead, with their blood turning the snow around them pink like a strawberry snow cone. Rebel walked over and declared each man guilty of murder and sentenced him to death. The two men were placed in the storage building where their bodies were kept frozen through the winter. In the spring Rebel brought the sheriff from Eureka up to Rime and told the story of how they murdered each other.

Cynthia knew Hanlon better than anyone but not because he was one of her clients. She had tried every known trick to try to get Hanlon in her bed but he just wasn't interested. Cynthia wanted Hanlon and had grown to respect his secretive nature. She knew he visited the Shy girl's house on the south end of town. Cynthia didn't understand why Hanlon would be interested in the Shy girl but for some quaint reason he went there once a week, bringing a few groceries and gifts. The townspeople called her the Shy girl but her real name was Elizabeth Minking. Elizabeth lived alone and rarely went anywhere outside of her house. She was even more reclusive than Hanlon and that's why they called her, Shy girl. Elizabeth was shy but she also had a reason to keep to her own place, she was blind. Once a week, usually on Saturday, Hanlon would get a sack of groceries and a small gift that he had made or found or traded for and walk through town, headed for Shy girl's house. Elizabeth would be waiting but she never talked to Hanlon, only listened to him talk to her. He usually only stayed for an hour or so and then would give up on hearing her

talk back to him. Hanlon would bring her groceries and gifts and had done so all these many years. Hanlon also owned the house she lived in but the people of Rime didn't know this. He looked after the Shy girl almost like she was another of his wolves. Cynthia kept trying to talk to Hanlon and find out what went on in his secret visits to the Shy girl's place but he would keep his mouth closed tightly and mutter some excuse to leave. He never went up to Cynthia's room but would talk to her when they ran into each other in Shade's bar. Hanlon didn't really talk to anyone else in Shade's and the other men knew to keep their distance. Hanlon had almost beaten a man to death years ago when he talked about Shy girl. No one said anything about Shy girl around Hanlon again.

Hanlon frequented Shade's bar at least twice a week, and sometimes on Sunday night. The only women ever seen in Shade's were Cynthia, Hazel, the Despardio twins, Lucy and Lucy Anne, and occasionally Sara Kinch, the clerk at Hazel Trade. Hanlon would say only a few words to any of them except Cynthia. He found Cynthia interesting and intelligent and never could understand why she was a prostitute. He asked her once and she had explained, "Well, Hanlon, I never did like to work any other way. I didn't like doing dishes or washing clothes. I hated schoolwork and sports. I don't even like to watch television. I always just loved to have sex. I guess I just wanted to get paid for being naked. I am naked when I work and I am dressed when I'm not on the clock. I think I got the best job I could have asked for. I have my regular clients here in Rime and in the summer time I get my other clientele from Eureka and even a man from Whitefish."

Cynthia was in her early thirties. The only woman as

pretty as Cynthia in Rime was Elizabeth, the blind Shy girl, except she had a long red scar across her forehead. Shy girl had long silky dark hair, almost black like a summer mink. Sara Kinch, the Hazel Trade clerk only showed up in Shade's when Hazel felt like dragging her along for company. Sara was twenty-something with red hair and black rimmed thick glasses. If there had been a library in Rime she would have worked there. She was widowed. An elk had killed Sara's husband up in the mountains. The story was that Dave Kinch had shot a big bull elk and tracked it to where it had fallen. He bent down to begin to cut it and clean it when he realized to late the big animal wasn't dead yet. The massive elk hooked him with that giant rack of sharp antlers. The points went right through his coat and shirts and out his back. The elk stood up with Dave Kinch impaled upon its massive rack of antlers and stumbled off down the slope. Trackers found Dave's frozen body still impaled upon the dead elk antlers two days later, the elk and Dave had both been chewed upon by wolves and foxes.

Hanlon fed his wolf pups, Thor and Sif, and headed into town. He had a thirst and knew right where to go. Hanlon had a thirst for a certain drink each time he felt low. It wasn't as often as it used to be but on some days when Hanlon thought about his past too much he would feel this drought in his gut. It was like his insides were a desert in some far off place and his mouth would dry out and his eyes would itch. He would sneeze more often than usual and then he would start shuffling papers in his cabin or go out and watch the wolves. Papers and wolves were only distractions and every once in a while he would almost pay a visit to Cynthia's room but he never did.

He would turn into Shade's bar before he ever got to Hazel Trade and Cynthia's room. The bar keeper knew what he was thirsty for and as soon as Hanlon stepped in, Jury Fello would make his special drink. Hanlon would only want this drink when he felt like this and Jury knew just how to make it, two shots of tequila, a half a glass dark beer, and half a glass of buttermilk. Hanlon just called it, GutMilk. Hanlon took his GutMilk and retired to the back corner away from the old jukebox. Jury Fello, the bar keeper and owner of Shade's had been making Hanlon's GutMilk for at least ten years now and Hanlon never complained, even though he had raised the price a few times, because buttermilk and alcohol prices kept rising. Jury was married and had three children, all boys, all the time. Jury was proud of his sons and taught them everything about running the bar. Sometimes when Jury took a few weeks off to go hunting or when he was out sick one of his boys would run the bar. Everall, the eldest, twelve, even tried to make Hanlon's GutMilk once but he never did get it right. Hanlon just drank it anyway and acted like it was as good as Jury's.

Besides running Shade's bar Jury had a curious hobby. He collected and raised butterflies. Behind the bar he had a hothouse where he had a jungle of plants. In this hothouse he kept thousands of butterflies. There were cocoons and chrysalis, caterpillars and flying kaleidoscopic winged insects everywhere among the plants and the vines and the fronds. Jury took Hanlon in there one time and in seconds Hanlon had butterflies landing all over his coat and his beard and his face. He could feel their tiny feet and antennae tickling his skin and he saw their long curled tongues flicking forth into the hairs of his beard, tasting the droplets of snow and getting drinks from his beard. Hanlon looked at Jury, who had a stupid smile on his face, with butterflies almost entirely covering his body

and watched the multi-colors of their wings flapping like fields of spring flowers in the breeze. Jury and Hanlon stood in the center of the hothouse surrounded by tropical plants in the dead smack center of a Montana winter with butterflies from all over the world covering their bodies like a living, flapping, paper layer of new skin. Jury was laughing as he put some drops of a liquid on his extended tongue. Hordes of the butterflies flew at his face all landing and flapping on his tongue, lapping up the sticky nectar. Hanlon was amazed by the show but he never went in the hothouse again. Jury was a good bar keeper but his hobby was too bizarre for Hanlon and from then on he kept his distance.

Sitting in the back corner of Shade's bar, Hanlon gulped his GutMilk and leaned forward on the table with his old cowboy hat pulled low over his eyes. He was thinking about the past. He was remembering playing hockey as a kid on the frozen ponds of Michigan. He loved that game. He hadn't seen a hockey game in eleven years, but he kept seeing hockey in his dreams. He also thought about his many wolves through the years up here in Rime, Montana. He liked traveling alone in the woods of the mountains tracking his wolves. Sometimes he would follow them for days. They knew he was there behind them and they respected him. The wolves knew him and allowed him his pursuit. Sometimes they would allow him to get as close as twenty yards and then they would howl and growl and run off into the forest. Last year he watched a pack of eight adult wolves stalking a deer with a broken leg. He recognized two of the wolves as Geronimo and Bluejay, two of his former pups that he had released into the woods. Geronimo was entirely black, like a slick demon of the night, and Bluejay was a blue-gray shade that seemed like a flash of blue and smoke as she ran through the snow. The wolves surrounded the

injured deer, a buck with only one antler, and closed in for the kill. Hanlon was only forty yards away and the wolves allowed him to watch. Geronimo, the big alpha male of the pack, tolerated his presence. The big male wolf also made the first rush at the one antlered deer. He charged in, attacking the deer face on, while two other wolves attacked the deer's unprotected hind legs. The deer went down fast as the two wolves bit yellow teeth into the deer's frail hindquarters. Swinging the one antler around to attack the wolves, the deer made another mistake. Geronimo saw his chance and leapt at the deer's unprotected throat. The big black wolf clamped down on the deer's jugular and pushed the animal over in the snow while the rest of the pack rushed in with snapping jaws and sharp teeth. The deer died quickly and the wolves growled and snapped their jaws at one another as they fought over their kill. Hanlon smiled proudly as the laws of nature were played out before him. He was thrilled that Geronimo and Bluejay had become successful and had a pack of their own. He watched the pack a few moments more, writing the days events in the wolf journal, and then returned back to his cabin, his safe haven away from the human enigmas that burdened his troubled heart. When Hanlon was out in the mountains and the forests trailing the wolves he felt alive, he felt calm and clean. The world of people, his world of origin, always pulled him but tortured his soul with the guilt and pain of his life. Hanlon became more like a wolf with each trip into the desolate winter mountains but with the spring he returned to the meadows like a tame hound to his master's door. Hanlon was living in two places, his heart and his past.

Lucy and Lucy Anne Despardio were born in Browning, Montana to Fred and Milly Despardio, in 1976. Fred was accidentally killed at a construction site by an unmanned bulldozer that had jumped out of gear, in 1989. Milly won a huge settlement from the insurance company and moved to Rime to live with her mother Ethel Lynn. The twins loved the woods in the summertime and sledded the hills in the winter. The Despardio twins were local favorites growing up as the only twin girls to ever live in Rime. Lucy and Lucy Anne were identical twins and the only way to tell them apart was to see them naked. Lucy Anne had a birthmark on her left breast and Lucy had a mole on her left butt cheek. Sometimes their mother, jokingly, would call them Mole and Mark. They both kept their dark brown hair short and straight and always wore matching earrings and clothes. The twins liked to keep people guessing which girl was Lucy and which was Lucy Anne. The best way to tell them apart was by observing the girls opposite personalities. Lucy was full of laughter and charm. She always had a joke to tell and waved to everyone she saw. Lucy Anne was pleasant but more guarded. She had a bad temper on occasion. Lucy Anne almost killed Rebel Shuckers when he accidentally splashed muddy water on her with his jeep. The twins were leaving Hazel Trade with groceries and walking down the main street when Rebel came around a corner and hit the biggest pothole in Rime with his right front tire. Lucy Anne had shielded her sister being closer to the street and Lucy only got a few speckles of mud on her clothes. The mud and water drenched Lucy Anne from waist down. Her shoes were soaked. Rebel didn't even notice what he had done and plowed down the muddy street, parking his jeep in front of Hazel Trade. He turned to get out of the jeep and Lucy Anne was already on top of him. She had given her bag of groceries to

her sister and ran after the jeep. She started to choke Rebel and whirled him around in the street. Caught off balance, he fell in the muddy road in front of Wellington Birch's Clydesdale horse-drawn wagon. The huge Clydesdale horse reared up and his big heavy hooves danced all around Rebel as he rolled in the mud trying to dodge the powerful steps of Wellington's horse. Rebel rolled out from under the nervous horse and stood up covered in mud and water. Wellington got his horse under control and shouted at Rebel, "Stay out of the road you drunken fool! You could've been killed!"

The Despardio twins weren't beauty queens but they were attractive enough to get attention from the local men, though not as much attention as Cynthia. Shy girl was a true beauty but none of the men ever went around the blind girl. They all thought that she was insane or mentally slow. Shy girl was avoided by most of the residents of Rime. She hardly ever left her house much less come into to town, and when she did everyone stared openly at her, knowing that she couldn't tell anyway. They noticed how her clothes never matched and sometimes they would see her with two different colors of sneakers on her feet. They didn't laugh at her, the people of Rime weren't cruel, they just observed and acknowledged her blindness and stayed away from what they knew nothing about. People lived in Rime because they were tolerant of the people around them and because this was their place, a place where each accepted the other and respected their mysteries and secrets.

Lucy and Lucy Anne Despardio had always held a deep crush on Hanlon Starky. Hanlon liked the twins but he never talked to them in public very much. He kept to himself like he always did. Both girls knew that Hanlon had a weakness and they each had taken advantage of it throughout the years.

Lucy Anne had realized her chance had come on a night when Hanlon had consumed more than just his GutMilk and had followed it with a pitcher of dark beer. Jury waved to him as he left the bar and he walked on wobbly legs out into the street late in the evening one spring. Lucy Anne had been delivering an armful of old shirts to Hazel and saw Hanlon walking in a weird halting way. She smiled and ran over to him, grabbing his arm and saying, "Poor Hanlon, it's hard to see out in here in the dark. I think you might need help to find your way home tonight."

Hanlon looked up at her and the light from the bar shone on her face. At first he didn't recognize her and said, "Cynthia, oh, thank you."

Lucy Anne wrinkled up her nose and said, "Nope. Try again. It's me, Lucy Anne. I'll help you get home tonight, Hanlon."

He was too drunk and too tired to resist and let her lead him down the road. That night he had smelled her hair as she helped him take off his boots and he put his arms around her small waist and kissed her hard. Lucy Anne and Hanlon crawled all over each other as if they were animals and the moon had called out, commanding their frenzy of sex. Lucy Anne left after Hanlon fell asleep. She tried to start a relationship with him but Hanlon only retreated further away, disappearing into the woods for days at a time. A few years later Hanlon had found himself in her twin sister Lucy's bed after a night of too much GutMilk and woke up the next morning to be ravaged by Lucy again. Lucy was much more aggressive than Lucy Anne and Hanlon had taken more of a liking to their bed play. He pulled away from her too after a short romance. The wolves and the woods always called him away, that and his past.

Rebel drove the jeep like he drove a nail, crooked and inconsistently. If the road had holes and bumps he could find every one of them and Sassy bounced around as if she were the first champion jeep rider to stay on longer than eight seconds. Rebel talked incessantly as he drove but most of what he said Sassy couldn't hear over the roar of the jeep and the jarring shock of each rut and bump. The ride into the mountains to Rime was a long one and by the time they crested the hill overlooking the small town Sassy's ribs were sore from the jostling ride. Rebel stopped the jeep and got out. He looked down on the town as Sassy got out too. Rebel said to her sighing, "Ah, Rime is always so beautiful in the spring. Look how the mountains stand tall behind the town, almost like they are protecting Rime from the sky."

He pointed down to Rime and continued, "Sassy, see that tall building? That's Hazel Trade. That's where you can get a room. The other building close by it is Shade's bar and then next to that is the Ice Bowl Café. I think I can get you a job working there. That white building farther away is the church and the hall. We used to have a minister but he had been mauled by a big grizzly bear while he was out trout fishing. He didn't die but when he saw his face and all the scars after he got out of the hospital he cursed God and became a carpet salesman over in Browning. He was a good preacher too. I guess if he could sell God your soul, carpet selling must've come easy enough for him."

Sassy replied, looking out over the town and noticing all the flowers growing along the mountainside, "That's awful, are there a lot of grizzly bears up here? Do they attack people all the time?"

Rebel pushed his Confederate cap back on his head and chuckled, "Heck, Sassy, of course there are a lot of grizzlies

up here. They eat about a kid a week and sometimes they eat somebody's dog too."

He kept laughing and then pushed her with a big hand, "Not really! There are plenty of bears but we haven't seen one around town in a long while."

Sassy reached down and picked a handful of yellow flowers and they both got back in the faded red jeep. Rebel drove down the winding road and into the heart of Rime, Montana.

Elizabeth had an organized and busy life, even though she lived alone and rarely ventured out. She didn't have any close friends anymore and no one in town, except Hanlon, ever came to her house. Shy girl stayed close to her everyday routine. She listened to talk radio in the mornings after breakfast. After listening to her favorite radio show she changed clothes and began her morning workout. Shy girl would stretch and do pushups and sit-ups and then climb on her stationary bicycle. She would ride and imagine she could feel the wind in her hair. Each day when her muscular legs pumped those pedals around and around, Elizabeth felt that she was riding across America. On some days she rode marathons, journeys, hours and hours of riding that stationary bike that traveled for the blind girl across valleys of peach trees, mountainous regions, long desolate highways through deserts of saguaro cactus, shadowy roads in the deep woods, and on down dirt roads always back to her small cabin in Montana. Elizabeth had not been born blind. An accident had left her without sight years ago. She thought it would have been easier if she had never experienced the world with vision, that way she wouldn't know what she was missing. The world was all laid out in her memories like an encyclopedia of images to fill her black world. When she

257

rode her bike, Elizabeth could imagine the scenery around her from memories and it made her smile. She liked to ride and travel deep into these inner visionary journeys. Sometimes she saw flowers in the fields alongside the roads she pedaled and other times she could see a herd of deer grazing in sparsely wooded pastures. She loved the feel of her thighs burning and the sweat on her skin as she passed through canyons and rolling hills. She could imagine chipmunks scampering across the silent road and mourning doves cooing and taking flight as she passed. Elizabeth rode on and on each day until her legs grew weary and fatigued or until the road faded and the blackness returned. She would stop pedaling and look around as if her house would be in front of her. She tried to visualize what the outside of her house looked like but she only saw a black space in Rime, Montana. Shy girl would then peel off her sweaty workout clothes and take a long bath, drifting into a languorous arena with the hot water soaking into her pores.

She was blind but far from helpless. Elizabeth knew where everything was in her house. She had organized each shelf and cabinet. She knew which cans were beans and which ones were soups. The towels were always stored in the same place and each drawer contained different shirts and pants. She followed routine and organization and this kept her life ordered and safe. Sometimes she thought about opening the wrong bottle and pouring soap powder in her tea instead of sugar but she knew it was only a panic because it couldn't happen with her order of the house. She cooked her own meals and did her laundry. Shy girl accomplished everything by feel. On some days Shy girl would sit out on her front porch in a rocking chair just to listen to the sounds of the world around her. She liked to hear the different birds calling and singing. She liked the whistling song of the tiny black-capped chickadees and sometimes she

could hear a far away loon yodeling near the lake. She heard the frequent caws of the big black crows and the pesky screeches of blue jays and the northern gray jays swooping through the air around her house. She liked to hear new sounds and on rare occasions she might hear a hairy woodpecker sticking its beak into the trees like a machine gun firing and then calling its loud sound like a lost kingfisher's rattle. On other days, closer to the evening she could hear the lonely hoots of the barred owl or the eerie quavering whistle of the screech owl. Elizabeth cleanly identified each bird by its sound and visualized it flying or perching within her imagination.

Her house wasn't close to any of her neighbors and the only time anyone came out of town that far was if they were on their way out. Her house was the first house that outsiders passed on their way into Rime. Elizabeth thought that her yard was probably the worst looking in the entire world because she couldn't work there and see what it looked like. She imagined gnarly trees and scraggly bushes growing without organization. She guessed that tall sprouting weeds curved skyward in un-strategic areas and that clumps of mule grass dotted the pocked marked yard. She hoped that wildflowers grew in large numbers in her yard in the spring and summer to at least give it some color and beauty. Shy girl couldn't see that her yard was not the ugly place she imagined it. Her yard wasn't a mess but it wasn't manicured either. Hanlon planted beds of flowers and pulled weeds on some days. She knew he mowed her grass but that is all she was sure of. She never talked to him but accepted his kindness and thoughtfulness. Elizabeth barely tolerated Hanlon and he knew it, but his heart never let him stop looking after her. Shy girl needed him and he needed her.

Rebel introduced Sassy Lilytrotter to Hazel Jouresske and they shook hands and felt like mother and daughter. Hazel took an immediate liking to this traveling girl and Sassy knew Hazel was a woman that let her honesty and her, "what you see is what you get," attitude speak for itself. Sassy was in luck because Hazel took her personally over to her friend Marci Venturi's Ice Bowl Café. Hazel, Rebel and Sassy sat by the window and ordered lunch. Marci waited on them and welcomed Sassy to town. Hazel mentioned Sassy needed a job and Marci scratched her white hair, saying, "You timed this trip into Rime just right, girly. I have been short for two weeks now and I'm about plum worn out! Tricia Baker helped me out but she was pregnant and finally the baby started protesting that it needed to come out and be born. So Tricia had to quit and take care of that infant. She named her Bonnie. Sassy, quite a good name, I like it. You been a waitress before? Not that it matters, when can you start?"

That's how Sassy got a job in Rime working as a waitress at Marci Venturi's Ice Bowl Café. The next week was the first time Hanlon came into the Ice Bowl for supper on a Friday night in over a month. Hanlon mostly stayed at home and cooked for himself. He liked cooking and eating his own deer meat that he kept from his hunts. Every couple of months he liked to get dressed up a little and go into town and have a meal at the Ice Bowl. He would get an urge to eat something different than the same old venison and potatoes. He would get spaghetti and meatballs or liver and onions or try a hamburger and fries. He just wanted to get out and eat something different. He would put on his one white shirt and tie and his fifteen-year old dinner jacket. He would hang his cowboy hat on the deer antlers on the wall by the door and comb his long blonde hair back. Wearing clean black boots and a dab

of Stetson cologne Hanlon would walk through town and find his way to the Ice Bowl Café. Each time he did this, the townspeople always would stare at him. They never got used to seeing Hanlon without his old cowboy hat and faded jeans. His thick heavy beard was dark brown streaked with blonde and his shiny blue eyes protruded from his handsome face like the eyes of a Siberian husky in the dark. Hanlon walked into the Ice Bowl and made his way to his favorite table with the red and white checkerboard tablecloth. The Ice Bowl had mounted heads of animals, deer, moose, elk, all over the walls, among other things, like kayak paddles, old rifles, ice fishing poles, old snow shoes, skis, and assorted rusty metal highway signs, like the bent one with the jumping deer on it that Rebel had knocked down with his jeep about ten years ago. Hanlon always sat at the table under the big mountain goat head. He thought it was good luck to be around white animals. He had raised a white wolf once and he had grown to love that animal. Her name was Mist and she was a pure white wolf, an albino, and he had returned her to the mountains seven years ago. He hadn't seen Mist in two years and wondered if she was still alive. He picked up the menu thinking before he even opened it that he might like the spaghetti and meatballs again. He glanced over the menu as the waitress began approaching his table and then he looked up and saw her. Sassy was about to say, "What can I get you to drink"... but stopped short. Hanlon stared at the new girl in town as Sassy stared back. She never did get the words out quite right and said, "What drink is a I get for you?"

Hanlon didn't catch the mistake and looked away from her fresh face. Sassy felt as if Hanlon's deep metallic blue eyes had drawn her into their depths and pulled the floor away from her feet. She sucked in a deep breath and repeated, getting it right this time, "What can I get you to drink?"

He smiled, embarrassed at being looked at so deeply and sat up straighter as he replied, "Water, please and a glass of iced tea with my meal."

Sassy showed those perfect white teeth, shining like an incandescent glacier, and said, "Sure, I'll get your water and be back to take your order."

She left his table and he sat there following her every step away from him with hungry, curious eyes. Sassy went to the kitchen and got a glass of water and found Rico, the cook, staring at her. He asked, "What happened to you? You look like you just saw a ghost."

Sassy looked back at Rico, an elderly Hispanic man, and wiped her dazed look from her face, saying, "Oh, nothing, just a new customer came in that I haven't seen before. I thought I had waited on everybody in town by now, but not this guy. Do you know him?"

Rico glanced out the kitchen window looking out on the dining room and saw Hanlon sitting at his favorite table. Rico smiled like an opossum eating persimmons and cackled back, "Hey, well yeah, I do. That's Hanlon Starky, Wolfy, but don't call him that he don't like it. He's the wolf guy lives up close to the mountains, the farthest house from town. Hanlon's been here for over ten years studying wolves. Oh and Sassy, if your curious, he's single."

Rico started chuckling and smiling exposing his missing front teeth. Color rose in her cheeks. It had been a long time since a man had gotten to her. Rico had seen what she had already felt. Sassy left the kitchen and returned to Hanlon's table with his drink. She smiled, shyly this time, and said, "Ready to order?"

Hanlon saw her big smile and inside he felt at a loss for words. He hadn't even looked at the menu since she went to

the kitchen but he said, "Oh, uh, yes mam. I would like the spaghetti and meatballs with mushrooms please. No salad today, thanks."

Sassy kept on smiling and didn't want to leave his table. She liked his face and those blue eyes pulled her into him like an embrace. She fidgeted with her hair and jotted down his order even though she didn't need to write it down at all. She turned and than stopped, turning back one more time, saying, "Okay, by the way if you need anything else, my name is Sassy. I'll turn your order in and it should be ready soon."

Before she could leave Hanlon reached out and touched her arm, saying, "Wait, uh, there is something else. I don't have any company for dinner would you care to join me?"

Sassy was taken aback but she felt like this wasn't reality. He was asking her to eat with him. She was his waitress, not his date. Her legs felt weak but her heart pounded from his close proximity. Her thoughts whirled and now she knew what hormonal and chemical reactions took place when they were charged with receptive pheromones. Sassy placed her hand on his arm, feeling the fabric of his clean white shirt and the strength of his arm beneath it. She looked him directly in those deep blue pools of mystery and exclaimed, "That's the best offer I have had in months. I'm working but I tell you what...I'll take a lunch break and make Rico take orders if anyone else comes in tonight."

She returned to the kitchen filling Rico in on what had just taken place and turned in two orders for spaghetti and meatballs. Sassy took off her apron and went into the bathroom to fix her hair better and wash her hands and face. She put on some mascara and a little bit of make-up; she never wore much to begin with, and returned to Hanlon carrying two glasses of iced tea. Hanlon stood, pulled out a chair for her and she

said, "Thank you. Rico will bring our food when it is ready. We have thirty minutes for my break or longer if no other customers come in tonight."

Hanlon was entranced by Sassy. Their conversation ranged all over the map. Hanlon talked more in one hour to Sassy Lilytrotter than he had in the last ten years, except maybe the one sided conversations he had with Shy girl. Sassy talked about all of her jobs in all the places she had been and Hanlon talked mostly about his work in the woods, the wolves and the mountains. He told her about Michigan State University and his love of biology and science. He even mentioned that his grandfather's cabin had been left to him in his will. He told her he had a grant from the state to study wolves but he was financially secure and had been because of investments his family made. He didn't care about monetary things, only about the nature of things. He told of his love of the mountains and the wildlife they contained. Sassy admired this man and drank up his emotional feelings that he shared about the land and the nature of the place. Hanlon was impressed with Sassy's strength and individualism. He appreciated Sassy's strong character to live through all the situations that she had encountered in her adventures around the country. She told him she didn't even know how or why she had ended up in Rime. Before Rebel Shuckers had picked her up in his jeep she hadn't even known Rime, Montana had even existed. She thought this winding road led eventually to Canada. They talked and laughed and smiled and barely ate their spaghetti and meatballs. Hanlon watched her go back into the kitchen with their plates and he said goodnight to her as she waved from the window.

Hanlon walked down the dark street towards his house and encountered Cynthia sitting on the porch of Hazel Trade. She waved at him and motioned him over. She sat in a lean

back chair under the porch light. Cynthia took one look at Hanlon's face and exclaimed, "Oh my God, Hanlon. Where did you find that face? I guess you must have met the new girl, Sassy, and were truly impressed."

He smiled without realizing it and replied, as he walked on past Cynthia, "You are the smartest woman I've ever known, Cynthia. Yes, I met her."

He walked slowly into the darkness and his boots barely made any sound at all on the dirt of the street.

Hanlon Starky started seeing Sassy Lilytrotter often and neglected his wolf studies. He never saw her on Saturday night because he continued to make his trips to see Shy girl, Elizabeth Minking. Sassy was falling for Hanlon and he seemed to be falling in love with her too but there was some hesitation to take their relationship to the next level. Sassy didn't understand about his trips on Saturday night and asked him about them. Hanlon wouldn't answer and avoided the subject. Sassy asked Hazel and Rebel, even Jury and Cynthia but no one really knew what went on at Shy girl's house on Saturday nights. They told her that it is something Hanlon had always done and something he would probably always do. All her friends reassured her, even Lucy Anne and Lucy Despardio told her that Hanlon cared more about her than anyone they had ever seen him with. Jury had told her that since he started seeing her that Hanlon hadn't been in for his GutMilk. Hazel told her, "Child, he isn't seeing Shy girl the way he sees you. Hanlon doesn't love her or want her. I know she is very beautiful but Hanlon was never in love with her. I think he truly loves you, Sassy."

Sassy continued to ask Hanlon about Elizabeth Minking

but he grew more agitated and angry when she did. Hanlon took Sassy into the woods for a few days at the end of the summer and they camped and followed a pack of Hanlon's wolves. He pointed out the big black alpha male, Geronimo and his female pack leader, Bluejay. He told her stories of how he raised them and the great times he had had with his wolf pups. Hanlon shared his journal entries with her as they followed the pack. They made love in their tent during the final few nights of summer as the air turned cooler. Sassy always stared into his blue eyes and fell down into a cavern of love so deep she knew she could never climb back out. Sassy was desperately in love with Hanlon. She loved the way he smelled, like the outdoor woods. She felt so much emotion when he looked at her and pulled her close to his strong chest. Hanlon hadn't told her that he loved her but she could feel it, his love growing inside his heart about to burst through his skin.

Hanlon felt happier with Sassy up in the mountains than he had in many, many years. When he held her close he felt like they were one. Her hair in his face and her skin under his hands was like a taste of what heaven must be like. He shared the secrets of his wolves with her and they grew together, closer than he had ever let another human being get to him. His mind was free of his past during these days and he breathed the fresh air of the mountain woods and the smell of Sassy in his soul. He was in love with her but still he held back. He struggled to never let go of Sassy and at the same time his fingers slipped through her hair as he felt himself falling away when his past pulled and tugged on his heart and his mind.

Their last day in the mountains Sassy followed Hanlon through a thick stand of conifers and he quickly knelt down motioning her to kneel behind him. He lay flat on his stomach and she followed as they peered over a ridge and into a small

valley. Hanlon put a finger to his lips motioning for Sassy to not say anything. They both saw the wolves in the valley, about seventy-five yards away. There were four timber wolves. The biggest wolf was black and gray and was one of the biggest Hanlon had ever seen. This wolf was new to him. It was one of the few he had never encountered in these woods. He recognized the female instantly. She was an all white wolf, Mist. She shone like a patch of snow in the green and brown woods. Hanlon felt a tear form in his eye as he stared at his beloved Mist; she had two young black pups following her. He glanced at Sassy and pointed, whispering, "That is my good luck wolf, Mist. I raised her from a little white pup."

Hanlon remembered those days when his little white she-wolf would lick his face and run through the fields with him. Sassy saw the tears in his eyes and put her arm around his shoulders as they lay there on the ground that was covered in pine needles and brown leaves. Hanlon was relieved to find Mist alive and happy with a mate and a family of her own. He felt good on the inside because he knew his work meant something and he had saved another generation of the timber wolf in Montana and Canada. He had been worried the last couple of years that Mist didn't survive her return to the woods. His research and work was validated with Mist's success and life. They watched the wolves trotting through the valley. The two black pups rolled and tumbled, play fighting. They had almost vanished into the dense trees when Mist stopped and turned, looking directly up onto the ridge where Hanlon and Sassy hid. The female white wolf threw back her head and let out a low mournful howl. The big black male stopped and looked back at her impatiently while the pups stopped and stared at their mother. Mist stopped her howling and stared up at the ridge. Hanlon felt that she knew he was there but he made no

move to expose himself. Mist whined once and then turned and followed the big black male into the dense thicket. Hanlon rolled over on his back and Sassy saw that he was crying. He told her, "That was my Mist. Wasn't she beautiful?"

Sassy smiled and patted his chest, "Yes, Hanlon. Yes she was beautiful."

He looked at Sassy and smiled, with tear streaks on his face, "So are you. I will call the big black male Shadow. Shadow and Mist, Hanlon and Sassy."

He kissed her lying on the ground up in his precious wolf mountains.

The day they returned to Rime, Sassy went back to work at the Ice Bowl Café. It was Saturday and autumn was in the air. Hanlon walked Sassy to work and then went to Hazel Trade and bought the groceries for Shy girl. He walked down the street towards Elizabeth's house with his arms full of groceries bags as Sassy watched from the window of the café. She frowned and looked away returning to the table she was wiping with a scary sadness in her heart. Rico saw her and came out of the kitchen to put his arm around her. He said, "Sassy, he loves you. Hanlon is a different sort of man and so is that Shy girl. Whatever is between them cannot hold up against what you two have. I know love and I trust my gut in this."

She let the tears fall then and cursed herself for being weak. Rico hugged her and gave her a white napkin to dry her face. Rebel Shuckers came through the door and shouted, "I'm hungry, Sassy! What's the special today?"

She had to laugh. Rebel always cheered her up. He brought her here and she felt she owed him that much.

Without Rebel and his old jeep she might never have found Rime and Hanlon.

Hanlon told Shy girl all about seeing Mist again. He talked about her black pups and of how he named the new big male, Shadow. He explained that he had feared Mist was gone and how it had filled him with hope for the future. He told her about raising Thor and Sif and about how he hoped they would do well in the woods soon. Thor and Sif were getting close to release age and he would be reluctant to let them go. He had a strong connection to them almost as strong as his tie was to Mist. He related to Elizabeth his fears of not having wolves at his house. He asked her if she was ever lonely and didn't like living by herself. Elizabeth turned her head his way and he saw her lips part but she refused to speak. He thought he had almost got her to talk to him. It was just another near miss on getting Elizabeth to speak to him. She was a beautiful girl and he felt his heart ache with seeing her living in such a self-isolated world. He would never give up trying to get her to be free of her exile. Hanlon left Shy girl's house later than usual that night. He was supposed to go to the Ice Bowl Café and meet Sassy when she got off work but he walked home and gathered his gear. Going out back he whistled for the wolves and Thor and Sif ran eagerly to him. Rebel Shuckers fed them through a door in the fence whenever he was gone and the wolves didn't take to Rebel much. Rebel was too nervous around the wolves. Hanlon headed back into the woods thinking about Shy girl and the way she almost talked to him. He climbed back up onto the ridge where he had seen Mist and Shadow. He sat with his back to a tree and thought about his life. He was in love with Sassy Lilytrotter and he fought to

cling to that. Elizabeth still needed him and he would not let her down. She had become his responsibility and he could not shirk his duty. Mist had made it, on her own terms, and that was proof that his life meant something. Finding Mist again had demonstrated that there is always hope and that dreams can be realized. He found strength in Mist's success and he got up and breathed deeply of the autumn mountain air. He could smell winter coming and he decided to try and track Mist and Shadow and see her again.

White animals brought good luck. He remembered his father telling him that when he was just a little boy. His dad had even given him a snowshoe hares foot for good luck on his sixth birthday. He told Hanlon that a rabbit's foot is a good luck charm but a white rabbit's foot is an even strong good luck omen. Hanlon still had that white rabbit's foot on his key chain. He had to replace the binding on the top a few times but he always repaired it and put it right back on his key chain. Growing up his mom had a white cat named snowball. That cat loved to curl up on you and go to sleep. Once he was in the truck with his mom and dad and snowball sat in his lap and saved his life. A bus had slid on the icy road and slammed into their truck. His dad broke a leg and an arm and his mom got a concussion but Hanlon didn't get a scratch. He was just sitting between his mom and dad holding snowball. His family never got another pet if it wasn't white.

Hanlon tracked the wolves higher into the mountains. The air turned colder the higher he climbed. He followed their spoor and tracks. He stopped as night approached and made camp. He sat by his small campfire and looked up at the stars. They called Montana, the "Big Sky" and he knew why that was true. There were more stars visible in the Montana sky than anywhere on earth. He liked to look at the stars and

find a few of the constellations but more often he liked to use his imagination and create new constellations. Hanlon would connect clusters of stars to form wolves. He found one and named it Thor and another was called Sif. He found a huge cluster and called it Mist. He reclined on his back on his sleeping bag and ate some dry venison jerky. The stars swirled above him like a vast sea of twinkling wolf eyes in a massive cave. Hanlon smiled and thought about Sassy's eyes and her smiling face.

The next morning Hanlon took after the wolves trail with a determination and purpose. He wanted to see Mist again. He thought that by seeing her it would give him more strength in his own life. He thought Mist was his new source of power. He climbed higher and the air had gotten colder. He wore his fur coat and put on gloves. He knew he could smell snow. The first flakes began to fall around him, drifting to the ground like lost white dove feathers falling from Heaven or Valhalla. The tiny drops of moisture melted on his face and dotted his thick beard. That's when he heard the growls. He quickened his pace and followed the sounds of growling. He stepped out of a stand of big hardwood trees and saw the wolves surrounding an elk carcass. A large grizzly bear stood on the other side of the dead elk. Hanlon pulled out his handgun from his pack and released the safety. He did not want to kill the bear, maybe shoot and scare it off, but only if it meant to hurt his wolves. He watched with dread and anticipation as the huge bear opened it's mouth, exposing large yellow teeth, and then stood on its hind feet towering over eight feet high. The bear swiped the air with six-inch long claws that looked like garden rakes and bellowed, roar after roar, threatening the smaller wolves to give up their kill. Mist growled back and Shadow's hair stood up on his massive shoulders as he stood between the bear and

the two pups. The young wolves imitated their parents and growled and hunched their backs trying to look bigger and more threatening. Hanlon was about sixty yards away and above the scene on a small hill with snowflakes falling heavier now, like a sheer curtain, an obscure haze blurring the forest. The bear attacked and charged Shadow. The big wolf dodged the paw swipe and whirled and bit the huge grizzly in the rear leg while Mist attacked and bit the bear in the other rear leg. The pups ran behind their mother as the bear tried to turn back and attack but he stumbled and fell down, rolling a short ways on the ground. The wolves now stood between him and the dead elk as fearless and determined as ever, growling and showing their curving, sharp teeth. The wolves had drawn first blood and both of the bear's hind legs dripped red onto the ground. He hurt less than he was angry and he charged with a sudden ferocity Shadow and Mist leapt aside with calculating agility but one of the pups wasn't quick enough and the bear's claws smashed into the young wolf driving it into the ground. The bear pounced on top of the hurt wolf pup and snapped its back with its powerful jaws. Shadow and Mist barked and charged the bear from behind. Turning quickly, with the dead wolf pup in his jaws, the bear stood up, slashing the air with his claws. The wolves attacked relentlessly, dodging and leaping in to bite the bear but they could not hope to kill such a monstrous creature. The Grizzly bear was too big and too powerful for Shadow and Mist. The wolves drove the bear into the woods with the dead wolf pup still in his jaws. Hanlon watched the wolves chasing the bear out of sight and he sat down on the hill. He saw a red fox creep slowly from the edge of the thicket and rush in to snatch a sliver of meat from the dead elk. Hanlon sat there waiting for the wolves to return.

Another fox started to approach the elk carcass but turned

and ran back into the concealment of the thicket when Shadow emerged from the north followed by Mist and the other wolf pup. Hanlon felt horrible for Mist and thought that maybe he should have shot the bear. He watched them return to the carcass. The wolves sat down around the dead elk and licked each other's slight wounds. Hanlon thought about what he might have done but decided nature was not his to alter in that profound of a way. The wolves survived generation after generation, the ice age, facing cave bears, sabre-tooth cats, hyenodons, grizzlies and even polar bears. Wolves were great survivors found in all climates from the icy cold to the tropical heat. He admired them and though he felt Mist's pain for loosing a pup he knew she would survive and bear other litters of young wolves to run these mountain trails. Hanlon put his gun away. He had been clutching it so tightly his fingers had grown numb. His beard was white with snow and the brim of his cowboy hat was filled with white flakes. He took one long last look at Mist and Shadow and headed back towards Rime. He had learned much from them this time.

The air got steadily colder each day as autumn walked out the southern door of Rime, Montana and winter opened the door on the north end of town. Snow became a daily visitor and white transformed the town into its namesake, a place of infinite hoarfrost. Every morning the street would be the purest white looking like mass quantities of sugar poured on the ground and then the horses and the vehicles and the boots of the townspeople would turn the road into a brown and gray and white mixture of slush.

Black ravens flying high over the town could see the curving brown road chopping the town into two halves. Sara

Kinch and Hazel Jouresske were having a busy time because today was the day before Rime Wolverine Week. Tomorrow would start the small festival. Everyone in Rime looked forward to the festival each year at the beginning of winter. Banners were hung from the buildings and tomorrow everyone would gather at the old church hall. Most of the people would bring a covered dish and Hazel Trade would provide the paper plates and cups while Shade's provided the drinks. The Ice Bowl Café and Marci Venturi provided the scrambled eggs and bacon for the annual Wolverine breakfast gathering to kick off Rime Wolverine Week.

The tradition began when the town was very young and a hunter named Richard Younger returned from hunting with the biggest rack of antlers on a bull elk ever killed before or since. Richard told the story of how a wolverine jumped out of the snow and attacked him while he tracked the elk through the mountains. The wolverine was biting his heavy coat and trying to tear into his flesh when a huge elk charged and rammed the wolverine with its sharp antlers. The impact of the elk stepping on Richard and smashing into the wolverine jarred his arm backwards, discharging his rifle straight up into the belly of the bull elk. He heard a terrible bellow as the elk collapsed on top of him in the snow. He could see the wolverine lying dead about ten feet away, a brown piece of limp fur embedded in a snow bank. Richard crawled out from under the giant bull elk and returned to Rime the next day pulling the dead elk and the dead wolverine with his big horse. That night the town's hunters drank hard to celebrate the luck of Richard Younger and the battle of the elk and the wolverine. Each year after the event they celebrated that day and eventually the celebration took on an official name, Rime Wolverine Week, and had official events for the entire week.

The biggest event was the hunting of a wolverine by a group of hunters and their dogs. After the Wolverine breakfast at the old church hall the hunters assembled and a proclamation was read containing the rules of the hunt and the deadline. The hunters hunted together as a group and had to find and kill a wolverine within a week, bringing it back to Rime before the last night of the festival week when the Rime Social Dance began. There was only one time in the past when the hunt failed to produce a successful conclusion. One year the hunt began in the middle of the most severe blizzard Rime had ever experienced since the time of the mammoth and the wooly rhinoceros, in fact it seemed to the old timers that maybe the second ice age was coming. Two of the town's buildings had collapsed from the severe cold and weight of the heavy ice and snow. Big trees actually fell over from the weight of the ice and snow like giant icicles falling off the eaves of the sky. People could walk from one side of the road to the other and see mice frozen on the ground, one tiny foot raised to take another step and their miniscule whiskers broken off and strewn on the ground like slivers of glass. Birds froze on the branches and swung upside down, their claws frozen clinging to their perch. It was a bizarre sight to see each tree filled with frozen upside down birds. After the blizzard cleared children went out with baskets and picked the upside down hanging frozen birds from the tree limbs like picking fruit, filling their baskets for suppertime. The hunters went out into that blizzard determined to bring a dead wolverine prize back to Rime within the week. The storm grew worse everyday and when the Rime Social Dance began the hunters still had not returned. The next day the sun appeared and the town was under many feet of heavy snow. Two of Wilson Macdoun's dogs turned up at his cabin half dead. Both dogs eventually died that night.

A search party was organized and the weather was bright and sunny when the set out into the mountains. Three days later they found the hunters by luck and by accident. They had found a cigarette package crumpled in a low branch of a snow covered tree and then saw a few spent gun shells on the surface of a frozen lake. The searching men noticed something sticking up from the ice of the lake. They approached the object and discovered it was the barrel of a rifle poking up out of the frozen water like a small naked tree. They looked down at the barrel of the frozen rifle only to take a step back in horror as they discovered the wolverine hunters under the ice, frozen solid, their faces all looking up at the surface of the ice covering the lake. The searchers realized the frozen lake must have been covered with a layer of snow and the hunters never realized that they stood on thin ice until it was too late. The weight of the entire group broke the ice and sent them down into the icy water that claimed them quickly. The hunters froze rapidly as they tried to get out of the water. Their dogs were frozen under the ice with them and the searchers stared in horrific fascination at the dogs and hunters under the ice with mouths and eyes open, looking like some freaky underwater wax museum exhibit. The searchers left them safely ensconced in the ice until they could return and recover their bodies. The ice had preserved the wolverine hunters all through the winter and the dead men and dogs waited for the first spring thaw to see the townspeople return to get their frozen bodies from beneath the lake.

Hanlon never participated in the Wolverine hunt but he did come into town and eat with everyone on the morning of the Wolverine breakfast. He usually brought a dish of baked

beans to contribute to the covered dishes. Cynthia brought a casserole each year and whispered word that she would give discounts for her services during the Rime Wolverine Week. Rebel always took advantage of Cynthia's Wolverine 'specials.' The only person with more financial gain during the Rime Wolverine Week than Cynthia was Jury Fello over at Shade's bar. The festival brought out more drinkers than during the rest of the year. Jury could sell more liquor in one week than in any other three months. Elizabeth Minking, Shy girl, never left her house during the festival. She stayed inside tending her fireplace to keep warm, listening to radio programs, sewing and knitting in her dark world. Shy girl had an unusual talent for making blankets with different types of knitting fibers. She created whole rooms full of blankets, towels, throw rugs, and other large pieces of fabric. Her patterns were strange and otherworldly without organization or order. Some of the pieces looked like Pollock drip paintings while others resembled abstract splashes of blended colors. Elizabeth couldn't see her creations but identified them by the feel of the unique fibers of the fabric, following her stitching with sensitive fingers. She could pick up any blanket or towel and tell you its name and how she had created it. Each creation had a name and she had them cataloged in her mind. She had quite a collection of the stitched pieces from all her years in Rime.

Sassy was excited about the Rime Wolverine Week and she even had a new dress, purchased from Hazel Trade to wear. Sassy didn't wear many dresses and this would be her first time to wear a dress since she had arrived in Rime. She had bought a dark blue dress with silky material and long sleeves and low-cut neckline. She thought the dress might go well with Hanlon's

mysterious blue eyes. Cynthia and Sassy talked about the dance and Hanlon often. Cynthia decided to wear white this year to stimulate the people to warm to her idea that maybe she could be the annual 'Snow Queen' of the festival. Cynthia had never won Snow Queen, the townspeople voted on the Snow Queen and most of the women refused to vote for her and the married women would get upset if their husbands voted for her. Lucy and Lucy Anne had both won numerous times. Shy girl even got nominated last year as a joke and almost won, even though Elizabeth didn't even know about it until Hanlon told her later that week. Hanlon had shown up with groceries and sat in her living room, saying, "You know you almost won Snow Queen this year. I heard you lost by three votes. I voted for you, too. Maybe if you would come to the festival next year you might win it."

Elizabeth never even blinked but stared off into her dark world. When Hanlon left her house that day she cried for a long time and then started a new blanket, daydreaming what it would feel like to be in the center of town with a Snow Queen crown on her head and the people actually applauding instead of staring in silence. The crown would probably cover the angry red scar on her forehead. Tears melted on her cheeks by the heat from her fireplace.

Rebel Shuckers and his two Norwegian Elkhounds, Rebel Junior and Blackbird, waited alongside Jury Fello and his big brown and white dog, a Saint Bernard named Chuck in front of the old church hall. Rico carried an old double-barreled shotgun and held the leash on his two Akita dogs, Mix and Max. Rex Newberry, a white-haired man only a few years younger than

Rebel, a knife and ax-making specialist, had four Husky dogs and Jake Freshour, the town's part-time barber, held his leash tightly on his big Alaskan malamute, Rufus. Jake had to hold Rufus away from everyone and the other dogs because of his extremely aggressive behavior. If the dogs had to end up fighting with a wolverine only Rufus could possibly hold his own for any length of time. All of the northern breeds were tough and had incredible constitutions but compared to the fighting ability of a wolverine they were as likely to win as a field mouse defeating a bobcat in battle.

The wolverine, called by many people the glutton because of its nature to eat more than any other carnivore, is actually the largest animal in the weasel family. A full grown male can weigh as much as sixty pounds and grow to over four feet long. The wolverine is short-legged and powerfully built with a shaggy coat of dark brown fur and big paws filled with sharp long claws. The teeth and jaws are extremely strong and can snap large bones to powder. The wolverine has been known to attack and kill even the largest of animals. Elk, reindeer, and moose have been attacked and killed by the ferocious small creature. Wolverines even have been known to drive bears off a carcass with a display of vicious behavior by raising their thick hair on their backs, baring wicked teeth, growling, and swishing its large bushy tail. Rebel Shuckers had been on several wolverine hunts and witnessed the cunning and ferocity of these small dangerous creatures many times. Rebel tracked a deer through the snow on a hunt and came across a wolverine one year. He waited and watched from a safe distance as the wolverine gathered pieces of moss from the forest and climbed up into a tree over the deer trail. When the deer approached the tree the wolverine let the moss drop onto the trail. The deer stopped and tentatively sniffed at the moss and then began

to chew at it. Rebel watched in amazement as the wolverine dropped out of the tree directly onto the deer's shoulders like a brown demon with white claws and teeth. The wolverine grabbed the deer between its antlers with its powerful jaws and began to swipe at the deer's eyes with its wicked sharp claws. The wolverine was tearing out the deer's eyes as it bucked and tossed its head violently trying to dislodge its vicious attacker. Blood began to stain the snow in splatters and droplets under the tree. Rebel watched with horrid fascination as the wolverine held on and slashed with its terrible claws at the deer's eyes. Finally the deer, driven mad with pain and torment, gave up trying to swing the creature from its back and began charging and ramming the tree in an attempt to jar the wolverine from its shoulders. The deer impacted the tree, time and time again, until finally it banged itself to death, falling over in the snow with the white teeth of the wolverine grinning as it let go to walk around the deer, gloating over its kill. Rebel watched as the wolverine grabbed the big deer, three times the size of itself, by its neck and dragged the carcass across the snow faster than he would have imagined possible.

Rebel, Jury, Rico, Rex and Jake, along with seven other men in town, armed with their bear and deer rifles, stood at the table outside the old church hall while the rest of the town finished breakfast and came outside to officially begin the wolverine hunt. The entire town gathered in a semicircle around the hunters and their dogs. Hazel opened a leather case and assembled a single shot pistol. She turned and faced the people and the hunters and led a prayer and then the pledge of allegiance. She then raised her pistol high and said, "Good luck and may the devil-bear glutton die swiftly and valiantly

and our hunters return successful." Hazel squeezed the curved trigger of the pistol and a single loud bang echoed off the trees, shaking clumps of snow from the eaves of the church. A puff of black smoke curled up out of the barrel after the shot and the dogs began barking eagerly, running and straining at their leashes as the men trotted away from town past Hanlon's house.

After the hunters left the town and disappeared into the snow of the mountains the townspeople would begin their festivities. Each day different activities were planned. There were quilting socials, pie baking contests, wine tasting and beer brewing, knife throwing contests, log cutting and dog sledding, among others. Hazel was in charge of the festival each year and hand picked different judges for the different events each day. Sarah Kinch was always Hazel's second and she seemed to be everywhere at once organizing and making sure each event went off smoothly. Hanlon and Sassy attended the festival each day at some point, when she was free from work or he was free from his wolf studies. Sassy would hold onto Hanlon's arm and squeeze, trying to get inside of his soul. She liked his smell and his warmth. She was afraid of the depth to which she had fallen for him. Loving Hanlon Starky was like finding a rare and beautiful flower growing on a sheer cliff and then climbing out risking a dizzying fall to your death just to see the flower up close, to touch and smell its radiance. She feared his secret trips to Shy girl's house and worried what went on with the pretty Elizabeth Minking. Hanlon would not talk about it and Sassy grew increasingly agitated and anxious about their relationship.

Hanlon and Sassy had been judges, at Hazel's request, at the pie baking contest that day. Hanlon loved cherry pie and picked Mrs. Fello's cherry pie first and Sassy agreed. Mrs. Fello

was used to winning the pie baking contest each year and the last time she lost was so long ago she only remembered it was the year she made a pecan pie and her pecans had been raided by a pair of mischievous squirrels. She made the pie without enough pecans and lost that year to Mrs. Burr's apple pie. After the pie baking contest Sassy went back to work at the Ice Bowl Café and Hanlon returned to his house. That evening Hanlon fed Thor and Sif and played in the snow with them. They were getting huge, full-grown wolves ready to leave his enclosure. He knew it would be hard to part with them but the time was coming soon. This spring they would be ready to run free from fences and find other wolves in the wild. Thor and Sif would have their own pack someday or die trying to survive. Hanlon could not keep them forever.

Hanlon went inside and soaked in a hot bath, listening to his radio play country music, and thought about Sassy. He truly was happier than he had ever been. She would be coming to his house tonight after she got off work. Hanlon had gotten a bottle of wine from Butch Digger, a logger that had quite an impressive wine collection in his cabin. The bottle, an amber blush dated 1960, was elegant and smooth, and the wine was what Sassy liked. Hanlon had put out his few candles and dressed and cooked a simple meal of venison steak and potatoes, with his special baked beans and garlic bread. The candle flames flickered off the cabin's walls and the music filled the room with an ambiance seldom noticed by Hanlon. The fireplace crackled as the logs burned slowly and the subdued light glinted off the handle of the hockey stick over the mantle. Hanlon stared at the hockey stick and only glanced back into his memory momentarily and just touched base with his painful past. His thoughts returned quickly to Sassy and her cute nose and those pretty white teeth. He sat in a wooden

chair and stretched out his feet on the grizzly bear rug, waiting for Sassy to arrive.

The dogs would chase any scent they found if the men would have let them run free but Rebel and the hunters held them close, searching for evidence of wolverine. Miles up in the mountains the snow had picked up and the temperatures were dropping as the men continued to look for any sign of wolverine dropping or tracks. Jury veered off into a small ravine about twenty yards from the fanned out hunters and shouted when he discovered a half eaten deer beneath a stand of trees. The men quickly ran to Jury and his big dog, Chuck, who smelled at the dead animal and shook his tail with excitement. The other dogs caught the smells of death and the other scents of carnivores that had been eating on the deer. Jake found wolf tracks and fox, and a big lynx had frequently came in and left. Jake shouted when his malamute, Rufus, growled and strained at the leash, his nose buried in wolverine tracks in the snow. Rebel and the rest of the hunters ran over and all the dogs pushed their noses into the snow filling their nostrils with the strong musky scent of fresh wolverine. The wolverine had marked the carcass with musk and had dragged off a ribcage in the snow. The dogs barked and howled working themselves into an eager frenzy, anticipating the men to release them after the glutton.

Rebel and the men loaded and prepared their rifles. Rico popped two huge shells into the double-barreled shotgun and slapped the barrel closed with a loud click. Rebel yelled, "Let them go!"

The dogs barked as each one was released from the hunter's leash. The pack of dogs ran swiftly through the

thick snow, bounding and running, barking with their ears thrown back and their tongues lolling out of their pink and black mouths. Rufus led they way followed by the Akitas, Mix and Max, and the rest of the pack, while bringing up the rear was the huge Saint Bernard, Chuck. The men plodded on after them, adrenalin pumping and warming their blood as they trudged through the snow on worn snowshoes. They listened to hear for the sounds of the barks to turn to growls and whines to clue the hunters into the cornering or treeing of the wolverine. Rebel always hoped that the wolverine would climb a tree to escape the dogs. It was easy to shoot a wolverine out of a tree and the dogs wouldn't get hurt fighting with the vicious animal. The times when the dogs had cornered a wolverine and the animal had turned to fight had not been without considerable cost. The last two years the hunts had been favorable and a wolverine had been treed and shot easily. The last time before that a wolverine had turned and stopped running and faced the dogs. The fight had been brutal and two dogs were killed before the hunters could arrive to shoot the animal. Only once had a man been injured during a wolverine hunt and that had been over fifteen years ago when Billy Snype stepped in an old rusty bear trap and broke his ankle. He refused to go to see Dan Pirkle, a retired paramedic that lived in Rime and served as a town doctor during the winter months and his ankle got infected. He eventually had to have his foot cut off the next spring because the infection kept spreading. Billy refused to pay any of his money that he kept in glass jars hidden all over his house, behind paintings, under the sofa, bolted to the bottom of the kitchen table, on a prosthetic leg and walked on crutches like a big praying mantis. He said he wasn't walking anywhere farther than his house or Shade's bar anyway and crutches were all he needed. The men pushed

ahead through the winter snow and no one thought about one-legged Billy Snype. They breathed vapor from their mouths and noses as they pushed through the rugged terrain following the dogs towards the conclusion of the wolverine hunt. They hoped the wolverine would climb, for their dog's safety and a quick easy kill.

Sassy arrived and Hanlon met her at the door with a glass of wine and a kiss on her lips. She smiled and leaned into him. They embraced for a few minutes still standing in the doorway. Hanlon led her to the table and pulled out her chair, lighting the candles. He said, "You ready to eat my specialty? Tender venison steaks, cooked just like Thor and Sif like them and baked potatoes with a side of my sweet baked beans is on the menu. Sorry but those are the only choices tonight at Hanlon's café."

Sassy grinned and replied, "All I want to eat is your lips. You look so good tonight. Today was fun at the pie-baking contest. That's the first pie I have eaten in such a long time."

Hanlon grinned back and looked at her cute twinkling eyes in the candle flames and the flickering light from the fireplace and replied, "You know, yes it was fun, and I think for dessert I'm having an order of Sassy Lilytrotter."

They both laughed deeply and kissed again. Hanlon went to the kitchen while Sassy sipped the wine. She called out, "Hanlon, this wine is excellent. Where did you get it?"

He shouted back from the kitchen and she heard the clink of china, "Good huh? You bet you won't find wine like that at Shade's bar either. I got a connection. You know Butch Digger, one of the loggers that often shows up for lunch at the Ice Bowl Cafe? He is a sort-of wine collector and I made a deal with him and got this bottle special for us, tonight."

"Oh, Hanlon, that is so sweet and thoughtful."

Hanlon brought out the food as her last words were shouted and he popped out of the kitchen carrying bowls in each hand. They ate slowly, savoring the hot food and their close affection, filling the room with emotion and expectation of a beautiful night of love and passion. After dinner, they both washed the dishes together and returned to the fireplace sitting on the bearskin rug, Sassy leaned her back into Hanlon's chest and he wrapped his big arms around her in a comfortable hug. They sat like that for many quiet moments, listening to the fire crackle and the sound of icicles snapping off the eaves of the house. Sassy was incredibly happy and wanted the world to always stay like this, no Shy girl, and no wolves to follow in the mountains, just Hanlon and his arms around her. They made love with intense passion that night and curled up in the blankets of Hanlon's big bed. Sassy had tears of happiness in her eyes as she kissed Hanlon on the forehead as he slept. She loved this man and couldn't even remember who she was before she found her way into Rebel Shuckers old jeep driving into Rime, Montana.

When she awoke the next morning Hanlon was gone. She got up and got dressed and saw his scrawled note that he had left for her. She read, "Sassy, I won't be back before you have to go to work but stay as long as you like. I had to go to Hazel Trade for some things and then I will be gone for most of the day tending to business." He didn't explain really what he was doing and Sassy took it that he had to get away from her again. She reflected on their wonderful evening and smiled as a tear trickled down her cheek. She wondered if Hanlon could ever stay close to her and not seem to run away each time. She walked slowly around his bedroom curiosity tugging her along. She saw an old bookcase loaded down with

dozens of animal reference guides and field guides. Beneath the bookcase she saw a large cardboard box with the old lid half-taped shut. Sassy knelt down and tugged the lid off and saw that it contained a few old newspapers and a thick worn red scrapbook. She picked up the scrapbook and carried it to the bed and began turning the pages. The first few pages were old photos of Hanlon as a kid with a hockey stick in his hand skating on frozen ponds and ice rinks. It seemed like every picture of Hanlon he had some kind of hockey uniform and a stick in his hand. As she turned each page she saw how he progressed in age and filled out. She could see his face without the beard and she thought he was very handsome in his youth. There were photos of his high school team and photos of him receiving awards and trophies. The next section of pages contained many photos of his team and his awards playing college hockey at Michigan State University. She was amazed that hockey had been such a big part of his life and he had never mentioned it to her. When she turned the next page she realized that hockey was not just in his life but that hockey was his life. She saw many photos of Hanlon playing professional hockey and signing autographs. He was in the hockey uniform of the Dallas Stars and he looked exceptionally happy in the green and gold and white. She finished looking at all the pages and closed the red scrapbook. Sassy sat there on Hanlon's bed and was about to return the scrapbook to the box when she looked down at one of the old faded yellow newspapers. She saw Hanlon's name in bold print above a photo. The heading read: HANLON STARKY DALLAS STARS SCORING SENSATION RETIRES.

She looked at a photo of Hanlon in a Stars uniform and read the article and she learned that Hanlon had been on a record breaking scoring run for the year when tragedy had

struck in Dallas Reunion Arena. The game was in the third period and Hanlon had already scored a goal with the Dallas Stars leading the Colorado Avalanche 2-1. Hanlon dodged a hard check and took a long slap shot, striking the puck oddly and snapping his stick. The flying hockey puck violently shot into the glass near the goal. The glass barrier shattered into thousands of shards instantly. The puck traveling at an extremely high velocity had struck a young girl in the head. Blood ran into her eyes as the puck cut her forehead open. The game stopped and Hanlon skated off the ice. The girl was rendered unconscious and taken to the hospital. When the young woman recovered from the head wound, the doctors had discovered that she had lost her sight. Sassy took in a deep breath and almost passed out as she realized and read on that the girl's name was Elizabeth Minking. Sassy had turned the page and saw a small photograph of a younger Elizabeth Minking. Sassy recognized the photo and the name. Elizabeth Minking was blind because of Hanlon Starky's slap shot. Sassy sucked in air and spoke out loud, "Shy girl, Oh my God."

She knew that Hanlon was carrying the guilt for Elizabeth's blindness all these years. He felt responsible even though it had been an accident. Sassy could see everything now. Hanlon lived in a world where the past controlled his future. Shy girl depended upon the very person who had rendered her incapable of ever seeing again. Sassy let her tears fall as she realized what those two people endured each day. Her love for Hanlon increased as she realized how he must torture himself and how he dedicated his own life to take care of Shy girl. Sassy didn't know what she would do now and closed the box, fitting the tape back on its top. She returned the box to its place beneath the bookcase and left for her own room at Hazel Trade. Sassy Lilytrotter knew Hanlon's secret and she had to

think about what to do about the knowledge. She was very quiet at work and Rico let her be alone with her thoughts.

Today the town would all turn out for the knife throwing contest and the log-cutting contest. The townspeople would all cast their vote for the Snow Queen to be crowned Friday night at the dance after the hunters returned and cast their votes. Sassy waited on half the town as they came in and had lunch, taking a break from the contests at the Ice Bowl Café. She pocketed more tips than she usually did on three nights of work. Hanlon had returned to the forest in search of Shadow and Mist. He saw other wolves and caught a glimpse of Geronimo and Bluejay quickly breaking the icy edge and lapping up a drink at Crow Lake. He turned back later in the day and headed for home, hungry and disappointed. He thrust his hands into his pockets and touched the white rabbit's foot, thinking about his good luck in finding such a wonderful woman like Sassy Lilytrotter.

The wolverine backed up against a gigantic boulder of gray smooth stone. The dogs, with the hair raised upon their backs, barked and growled at the cornered wolverine. They were in a protected area surrounded on three sides by boulders and framed by tall trees covered heavily in snow. There was no way out for the trapped wolverine except through the dogs. The Akitas, Mix and Max, repeatedly rushed simultaneously from each side snapping at the animal and then hurrying out of reach of the wolverine's slashing claws. The chaos of barking dogs and growling wolverine stirred up the frenzied scenario. The big aggressive Alaskan malamute, Rufus, charged directly

in between the Akitas and grabbed the wolverine by its front paw. Rufus tried to pin the furry animal and shake it to death but the wolverine was too quick and cunning. The glutton leapt around, spinning in the air and landed upon the big dog's back. The big dog released the wolverine's paw as the other claws of the animal dug into the dog's back and chest. Rufus jumped and bucked like a wild horse trying to dislodge the demon bear latched onto his back inflicting horrendous damage with its long sharp claws. Rufus's blood bathed the other barking dogs in splatters as he jumped out of control in a circle. The wolverine's jaws found purchase on the big dog's neck and clamped down, twisting and exerting pressure. The powerful clenching muscles of the wolverine's jaws soon produced a loud cracking sound as Rufus fell; nose first, in the snow. The wolverine ignored the other barking dogs and stood over his fallen attacker, biting and shaking the dead dog. The Akitas got too close and the wolverine slashed Mix across the chest ripping open the dog's shoulder and blood poured into the snow, melting a hollow opening of red on the stark white. Mix yelped and hobbled away from the fight, barely standing and breathing hard, his long tongue licking his bleeding front. Max and Chuck stayed back, near the rest of the dog pack, barking in excitement and worry as the hunters finally came charging into the area.

The wolverine backed away from the dead dog and tried once to climb and jump out of the prison of boulders but its claws couldn't get a purchase on the tall smooth rock. The brown animal was filled with courage and raw ferocity, and backed up with its rump against the rock. Flaring all of its thick brown fur outward, the animal tried to project a larger intimidating size to its attackers. The wolverine growled loudly and bared its yellow teeth. Rebel's elkhounds barked

continuously and the Saint Bernard, Chuck, sounded like a baritone barbershop singer blasting burps into the cold air. Rico saw his Akitas and yelled when he saw Mix bleeding, "The damn thing got my dog!"

Rex's huskies stayed well away from the animal as it hissed and growled and Jake was the last to arrive, stumbling through the deep snow. He saw his big dog Rufus lying in a puddle of pink snow in front of the growling wolverine and shouted, "The bastard killed Rufus! The bastard devil got my dog! He is mine, Rebel, he is mine!"

Rebel stopped Jake from firing irresponsibly, out of anger, to keep him from missing and also endangering more of the lives of the dogs and the men as well. Rebel knew how dangerous a cornered wolverine could be. He kept one eye on the wolverine and spoke to the men, "Stay calm, we have him cornered and all we need is a clean shot. Jake takes first aim, while the rest of us cover the animal. We will all fire second to Jake's shot, agreed?"

Jake's face was red from anger and the cold wind. Rico tended to his hurt dog and then stood next to Mix and aimed his double-barreled shotgun at the wolverine. Jake and the rest of the hunters took aim at the growling animal clawing in the snow with its front paws. The wolverine must have sensed its own death and screamed like a banshee from hell's cave and then Jake fired his rifle. The bullet struck the wolverine just as it tried to rush the hunters. The beast took the bullet in the rear left leg and tripped in the snow. A brown furry ball of claws and teeth rolled in the snow and righted itself charging the hunters, dragging one wounded hind leg. Jake backed up as the animal charged and then Rico's shotgun blasted into the wolverine in its side as Rebel's bullet hit it behind the right ear. The other hunter's bullets penetrated the brown thick fur

and the wolverine rolled and twisted again, blood spewing like a broken park fountain in Spiro-graph patterns in the snow. The men rushed to hold their dogs back and leashed them up again, to keep them from attacking the dead wolverine. The snow was pink and red from so much blood. Rebel went to the dead wolverine and began cutting into its chest. He had removed his gloves to keep the hot blood from getting them sticky. Rebel found the animal's heart and cut it out, holding it in his outstretched hand, his twelve-inch hunting knife in the other, saying, "Each year we take the demon beast, the glutton, from these woods and we give back its blood. We celebrate its great courage and cunning, its power and intelligence, by partaking of its source, the wolverine's heart."

The men saw the small round lump of blood and muscle in Rebel's hand jerk once and quiver. Rebel held out the wolverine's heart to Jake, saying, "First blood, Jake, the heart is yours first."

Jake reached out and quickly bit hard into the hot bloody piece of the wolverine's internal pump. Blood ran from the corners of his mouth as he passed the heart around to the other hunters. A small piece was all that was left as Rebel took the last bite and swallowed the remaining piece of the wolverine's heart. The wolverine was skinned and cleaned efficiently by the hunters and the dogs were fed on its internal organs. The men cleansed themselves in the snow and packed up, readying to return home victorious after another successful Rime Wolverine Week conclusion.

Sassy decided to visit Shy girl. She wanted to end the pain of Elizabeth and Hanlon. She thought that maybe her intervention would help them both. She reached Shy girl's

house on the south end of town and stepped up on the porch past the old wooden chair. Sassy reached slowly out with her right fist, taking a deep breath, and began a light knocking on the door. She could hear movement in the house and then the door opened a crack. Sassy hugged herself, keeping warm outside in her fur jacket, and felt a warm surge of air from the inside of Shy girl's house. Elizabeth opened the door slightly and Sassy could see how pretty she really was. Shy girl's eyes stared past Sassy and she asked, "Who is there?"

Sassy stuttered nervously, saying, "Sassy Lilytrotter. You do not know me but I know you and I just wanted to talk to you for a second. I work in Rime, at the Ice Bowl Café; I need to talk to you. It is very important."

Elizabeth started to close the door and said, "No, I don't think so. I don't know you. I can't see you."

Sassy replied, "Please, Elizabeth. I wouldn't have come here if it weren't important to me and to you."

Elizabeth hesitated and Sassy repeated, "Please... Elizabeth."

The door opened more and Elizabeth said, "Come in out of the cold. You can sit in the chair by the fireplace."

Sassy looked around the room, which had few decorations and noticed how immaculate the house was. Shy girl's house was the cleanest and most ordered place she had ever been invited into. She knew the townspeople had no idea how nice this house was on the inside compared to such a bleak ordinary outer appearance. Shy girl was wearing a heavy denim long-sleeved dress and her long hair was loose falling around her shoulders. Sassy removed her coat and hung it on the back of the chair. Shy girl sat across from her in an old rocking chair covered with a colorful blanket. Sassy spoke first, "Thank you for hearing what I have to say. Elizabeth, please be patient and

listen before you speak. I know about your accident and what caused it. I don't know all the details about what brought you to Rime or why you stay here but I do know about the man who cares for you and visits you each Saturday. Would you tell me your side of the story or would you just like for me to continue?"

Elizabeth sighed and rocked in the rocking chair, which squeaked with each shifting of weight. Shy girl, almost in a whisper, said, "You are Sassy. I haven't spoken to anyone over a few words in a long time. Hazel would talk to me sometimes as I sat on my porch and a few other people but most just kept their distance. I liked my privacy. This place respects privacy. I know you are new to Rime because you are different than these people."

She held out her hand, reaching across the space, and touched Sassy on her knee, continuing, "It's okay. It has been an eternity since I have opened up to someone, might as well be you. Hanlon tried to get me to talk to him but he is a frightening man, with his deep voice and loud footsteps. Hanlon talks to me each Saturday and fills me in on what's going on around Rime. He doesn't talk to me about the past. He brings me groceries. Did you know that he owns my house? He bought it for me, after the accident. If it weren't for him I would have had to live in some home for handicapped people. I don't have any family really, I was an orphan as a child and moved from house to state house. I was engaged once to a cute boy down in Texas but after the accident he only stayed around for a little while. Hanlon did this to me and I have held a terrible grudge against him all these years. Did you know that I have never spoken to him, ever? I owe him so much and yet he did this. He made me blind. He took my sight, my world, everything from me. At the hockey game I saw the

glass shatter, and I remember it in slow motion. The glass was cracking, resembling a giant spider's web and then exploding outward like a million diamonds thrown into the crowd. I leaned back in my seat and that flying black puck hit me in the head. The next memory I had was in the hospital bed in darkness and I could hear voices. I could hear people's voices right next to me but I couldn't see them. I shouted, "Turn on the light! Turn on the light!" but nothing happened. There would never be another light again. Hanlon tries to right his wrong but what can he do? He can't turn on the light ever again. I'm sorry."

Elizabeth began crying and put her face in her hands. Sassy felt tears staining her eyes as she asked, "Elizabeth, it is time to forgive. That shot through the glass was an accident. Hanlon would take it back and loose his own eyes for you if he could. I know that man and I know his guilt has eaten him up like a cancer of his soul. Both of you have let guilt and anger and pain tear you up these last ten years. You both need to move on and cleanse your pain and guilt. Forgive Hanlon and assuage his guilt. Look inside yourself and began to live outside of these four isolated walls again. The world is still out there for you. Do not let your handicap stop you. Don't be contained in a small cocoon. Did you know that Jury Fello raises butterflies in a hothouse behind Shade's bar? Elizabeth you could be a butterfly. You are a very beautiful woman. Please listen to what I say. Think about the possibilities. Think about what is out there in the world for you before your life is just spent alone in these four walls. Get dressed and come with me to the Rime Wolverine Week dance."

She reached out and took Elizabeth's hand. She squeezed and Elizabeth squeezed back. Both women's eyes filled with tears. Sassy didn't even feel the cold wind when she left

Elizabeth's house, except for the chill of drying tears on her face. She felt like she and Elizabeth had made a pact, progress in the healing of Hanlon's soul, and a happy new start for their lives. Sassy slept soundly that night and didn't wake to the whistling of the cold wind on the roof of Hazel Trade.

The next day the hunters returned and hung the dead wolverine from a pole erected in front of Hazel Trade. The children practiced their hunting skills by shooting their BB guns at the dead wolverine. The town gathered around and Hazel and Sara put pine wreaths around each of the hunter's necks and the dogs were fed good venison from the storage house. Rex and his wife, Gerri, danced to his cousin's fiddle playing in the middle of the road. The townspeople clapped along with the music and Sassy came out to see the dancers. Rico clapped and other people started dancing their own little skip and jump dance to the energetic fiddle playing. The dogs howled and the people clapped and danced as if today they had won the lottery and lived in luxury. The townspeople had all they needed and a successful Wolverine Week was the height of extravagance. Sassy searched the crowd for Hanlon but he wasn't there, probably still with his wolves. Rebel waved to her and she saw Cynthia next to him waving also. Sassy went over to them and clapped and moved her feet in time to the music. The dancing and fiddle playing went on for about half an hour until people got tired or hungry and left the middle of the road. Sassy went back to her room and Cynthia followed her, stopping her in front of her doorway, saying, "I saw you went to visit Shy girl. Is everything okay?"

Sassy smiled back, Yes, Cynthia, everything is great. Everything is really great. You will see. Everyone will see."

Sassy winked at her, turned and went inside her room, closing the door on a bewildered Cynthia Horn.

By noon the entire town had crowded into the old church hall. The children ran around and screamed, chasing each other and slipping and sliding on the polished wooden floors. The hunters all told tales of the past wolverine hunts and Rebel spun a few wild stories of his own. Hazel took her place at the old wooden podium built by Osburg Snektz the first year Rime was founded. Seated on her left was Sara Kinch shuffling through a pile of papers and beside her were Jury Fello and his wife. To Hazel's right sat Marci Venturi and Rex Newberry, with a big box with a lid on it. The box contained the Snow Queen ballots. The ballots were counted at this very meeting, out loud, in front of the entire town of Rime.

Sara Kinch shuffled the papers and brought a new sheet and produced her writing pen. She nodded to Hazel and the red-haired matron of Rime slammed down a small gavel on the podium three times. The crowd immediately hushed except for a few lingering laughs and screams by the unruly children. Hazel said loudly, "We are proud citizens of Rime, bow your heads for the invocation."

After the prayer the town recited the United States pledge of allegiance and then Hazel continued, "We are proud that we have concluded another successful wolverine hunt and a glutton was killed without any of our own men getting hurt or killed. Sorry about the dog, Jake. So today, the last day of Rime Wolverine Week we celebrate by electing the Rime Snow Queen. The dinner will be later tonight, followed by the Rime Social Dance. Marci will you call out each vote and we will see who our next Snow Queen will be?"

Rex opened the sealed box and dumped all the slips of paper out on the table. Rex began handing Marci slips of paper, one at a time, while she read the names. Sara Kinch wrote down each name that received a vote and tallied the votes for each woman as they were read out loud. The first name was Lucy Anne Despardio followed by a vote for Cynthia Horn. Lucy Despardio got a few votes along with quite a few for Sassy Lilytrotter. Hazel even got a vote and laughed, saying, "Hey now, who thinks this is a ugly contest?"

Elizabeth began getting votes and Sara Kinch blushed when she received a vote. As the votes were called out, Hanlon entered the building and sat in the back watching the town counting the Snow Queen votes. He hoped Sassy would win, even though he had voted for Elizabeth. Finally the last ballot was called out, and Sara began counting her scores. She looked up and pushed her glasses back up on her nose as she said, "It is so close again this year...but...we have a winner, with twenty-two votes. Elizabeth Minking is the new Snow Queen."

Hanlon thought that last year had been a joke when Elizabeth almost won and now she was the winner. He wondered why so many people would vote for her when they never even talked to her. He guessed that the other women had all won so many times that maybe they wanted new blood, and she was without a doubt one of the prettiest women in Rime. He also thought that maybe if she was Snow Queen the town could draw her out of her isolation. Maybe that was the reason so many people gave her their votes. Whatever the reason Hanlon was still glad, even though Sassy didn't win. After all, Sassy was the new girl in town, Elizabeth had been living here for a long time. Shy girl wasn't present so they had to enlist someone to go and tell her that she had won. Hanlon was about to stand up and volunteer when Sassy raised her

hand, saying, "I'll go right by her house after we get out of here and tell her the good news!"

The townspeople all applauded but some had puzzled looks on their faces that Sassy, Hanlon's new flame would volunteer to speak with the girl Hanlon took care of. Sassy started out of the building and stopped when she saw Hanlon near the exit. She smiled at him and he thought she looked very pretty. Hanlon said, "You are going to Elizabeth's?"

She smiled and said, "Yes, I think I should tell her that she is the Snow Queen."

Hanlon didn't smile back but said, his cowboy hat pushed back to reveal his startling blue eyes that seemed like two cold slivers of ice on a rock face, "I think I should tell her, she doesn't like to talk to anybody really. I think I should be the one to try and get her to come out take her place as Snow Queen."

Sassy saw that Hanlon was very serious but she didn't let his determination prevent her from her task and she replied, "Elizabeth needs to hear it from a woman, Hanlon. I think I can encourage and persuade her of the honor that the townspeople had bestowed upon her."

Sassy quickly kissed Hanlon on the cheek before he could speak another word and she ran out of the church hall and down the street. Hanlon stood there like the frozen god of bewilderment and after Sassy was gone several minutes he pulled his cowboy hat back down low over his eyes and closed his heavy coat, walking out into the cold snow of the last day of Rime Wolverine Week. Hanlon headed for Shade's bar. He needed a drink to put a haze over his confused thoughts of Sassy and Elizabeth.

Hanlon had a few drinks and left for home, a slight buzz making his feet numb. He changed clothes and cleaned up, hanging his cowboy hat on the antler by the door. He wore his nice white shirt and his jacket, shined his boots and combed his hair back away from his face and ears. He looked once in the mirror and was satisfied he didn't look like a grizzly bear with muddy paws. Hanlon had planned on meeting Sassy at the Rime Social Dance and he looked forward to dancing on the slippery wooden floor sprinkled with sawdust. The band was comprised of a fiddle player, two men that played guitars, Rebels nephew played drums and Jury's oldest boy Everall, sang along with the other men. They could play a variety of old country tunes and ballads, and really were better at jamming things like hoedown music.

Hanlon was a fair dancer and usually dancing once a year was enough for him, but he did enjoy it. Every now and then when he would get a little drunk he would find himself in Shade's bar dancing with Cynthia or Lucy. He looked forward to dancing with Sassy. He wondered if she could dance well. He imagined how she would feel gliding around the sliding sawdust filled floor swaying to old country ballads. Hanlon stepped outside, thinking about Elizabeth Minking, as he started towards the old church hall. Thor and Sif saw him leaving and whined. He turned and walked over to their enclosure, letting the two wolves lick his hands. Hanlon scratched them on their heads and wondered if Sassy had talked Elizabeth into coming to the dance and getting crowned as the Snow Queen. He doubted that Elizabeth would even talk to Sassy, much less come into the old church hall to be crowned. He knew Elizabeth and she would not get involved in a social event. He petted the wolves one last time and turned and walked through the dirty snow heading towards the old church hall.

He could see many other people all coming from different directions, huddling together as they walked, all moving towards the largest building this side of town. He followed Lucus Simms carrying a guitar into the hall and Sara Kinch was right behind him as he held the door open for her. She was wearing a pretty tight red dress and her hair was down on her shoulders. Hanlon thought that Sara looked prettier than he had ever seen her. He wondered why she had never married again. Hanlon searched the small crowd for Sassy but didn't see her. He saw Rebel over in one corner talking to Cynthia Horn. Rebel had a nice black suit on but he ruined the cleaned-up image by wearing his beat up old confederate cap. Cynthia was truly a good-looking woman and wore a very low cut evening gown of pearl and peach lace. She and Rebel seemed to be laughing and cutting up and enjoying themselves. Hanlon searched the room and saw that most people were drinking the beer provided by Jury Fello and really enjoying the annual get together. Hazel walked up to Hanlon; her bright red hair piled high on her head, and said, "Hello, Hanlon. Sassy's not here yet. She will be though and you just wait until you see how she looks."

Hazel winked at him and she left him standing by the table serving beer. He looked at all the people he had known for the past eleven years and realized that he didn't really know them very well at all. They all looked different dressed up in suits and dresses than they did in heavy fur coats and hiking boots or jeans and cotton shirts. All these people, from many different backgrounds, had found their way into this tiny hidden pocket of the planet and adapted to the same way of life that lie outside of the normal hustling busy lifestyle of metropolitan areas and suburbs. All these people were different but they all lived here on common ground with many common

beliefs. Hanlon liked these people and he had not known that before this instant. It had somehow just now dawned on him that these people were his friends even if he hadn't let them be. Pondering these new thoughts and new found awareness he looked up across the room to the door as it opened and in walked Sassy Lilytrotter, looking more beautiful than Hanlon had ever seen her. Her dress was stunning and looked like it cost a thousand dollars. Hanlon saw her and fell in love with her again, harder and deeper, even across the room, he could fall into her eyes and get lost. He swam in her beauty and his love for her and then he felt his guts grow cold. He held his breath as Elizabeth Minking, Shy girl, followed Sassy into the old church hall.

It felt as if the world was spinning to Hanlon. Seeing Elizabeth step into the room had put him into a mild shock. Her hair was fixed differently than he had ever seen it. She had cut it in bangs that fell over her red scar, covering it. She wore a clinging tight dress that accentuated her athletic muscular but feminine body. Her dress was ivory and white with a few sequins and she shone and lit up the room. The two women, Sassy and Elizabeth, were both like snow goddess's entering the room of ordinary people. Hanlon watched as the entire room stopped talking and socializing as the two women made their entrance. Every man and woman stared in fascination and appreciation at Sassy and Elizabeth. Hazel stood behind the podium and smacked her gavel down on the wood, saying, "Citizens of Rime, she is here at last, Elizabeth Minking, the new Snow Queen!"

Sassy led Elizabeth by the elbow up to the podium where Hazel presented her with the shiny silver and gold crown. The room applauded and whistled for a few minutes and then Elizabeth spoke, "Thank you so much. I know I haven't

been the best neighbor all these years but that will change. I am truly blessed to have such a loving family here in Rime, Montana. Thank you!"

Tears filled her eyes. Hanlon felt his eyes watering up and dabbed at them with his fingers. Sassy guided Elizabeth to a table near Hazel and Sara and then headed towards Hanlon. She thought he looked especially handsome tonight and she was smiling brightly when she approached him. Hanlon was dazzled by Sassy's appearance and he was still in a shock from Elizabeth's display. Sassy said, as she hugged him, "Did I surprise you?"

He kissed her and said, "How did you do it? How did you get her to come out of her house?"

Sassy smiled and said, "I'm sorry Hanlon but I did it for both of you."

He looked serious and replied, "What do you mean, both of us?"

Sassy had a scary feeling in her stomach but she knew she had to be truthful. She said, slowly, "Hanlon, honey, I know about you and Elizabeth. I know about the Dallas Stars, the hockey, and the accident. I know you think you were responsible for Elizabeth's blindness. You both have been carrying so much pain and guilt and anger around inside. Hanlon you have to let it go. I shouldn't have looked through your things but I found the newspaper article and the pictures. I'm sorry, please forgive me. I thought you would tell me someday but you kept withdrawing into the mountains or with the wolves. Hanlon let Elizabeth and the guilt go. I truly love you."

Hanlon's eyes grew hard and he seemed to see right through Sassy. She felt his grip tightening on her arm. He clenched his teeth, saying, "You had no right to go through my things. You had no right to interfere with the past. She is

blind, Sassy! She cannot see anything but darkness! That is directly my fault! I did this to her and she is my responsibility! You should have stayed out of this! You were wrong to stick your nose in where you weren't asked! You are new to Rime and already you think you belong here! Go back to wherever you came from!"

Hanlon's voice had risen as he grew angrier and people heard his words and turned towards them. Hanlon opened the old church hall's door and slammed it behind him, storming out into the cold night of Rime, Montana. Sassy sobbed once loudly and then began crying so hard she could barely breathe. Cynthia ran to her and held her, hugging her and stroking her hair. Hazel motioned for the band to start playing and the fiddle player struck up a fast tune to distract everyone from the scene of Sassy and Cynthia. Cynthia talked softly to Sassy and they went into the restroom, away from the crowded dance hall. Hazel talked to Cynthia after she had walked Sassy home and had gotten filled in on the details. Every man in the town had to take turns dancing with Elizabeth and it was the most fun she had had in many years. Hazel walked Elizabeth home after the dance and explained what had happened to Sassy and Hanlon. Hazel left and Elizabeth curled up in her warm blankets and worried about Sassy, her new friend, and Hanlon Starky. Hazel walked home slowly in the dark, trudging through the snow as small flakes began to drift on the wind. She walked up to Hazel Trade and stood looking up at the pole with the dead wolverine hanging on it. Hazel had been in Rime for over thirty years. She thought about her husband, Ben, who had died of cancer right here in Rime. She remembered how he used to hunt deer and elk and always kept plenty of food on the table in those early years. Hazel never had any children of her own but she thought of all the children of Rime as her

grandchildren. She loved this place and she had flown the American flag outside of Hazel Trade every day since the day she opened the store. Hazel went to the flagpole and took down the flag, like she did every night, folding it just the way Ben had taught her. She could see the stars glimmering in the vast Montana sky, purple and cold above her. She thought about how much Sassy reminded her of herself when she had found Ben. She knew Sassy was the only hope for such a tortured soul as Hanlon. He would either choose his wolves and his solitude or he would find a way to choose Sassy Lilytrotter. Hazel closed the door to Hazel Trade behind her and turned off the lantern by the door.

Sassy and Elizabeth became close friends and visited often. Hanlon had disappeared for weeks at a time into the mountains. The winter brought Sassy and Elizabeth together in front of Elizabeth's fireplace for long talks. Elizabeth was even teaching Sassy to sew and stitch. Elizabeth told Hanlon that he didn't need to take care of her any more on Saturday nights. She told him that she could get her own groceries and that he shouldn't feel obligated to help her. He had brought her groceries the Saturday after the dance and she had told him, "Hanlon, don't feel that you need to protect me forever. I have forgiven you. It was an accident and I know that there wasn't anything either of us could have done to stop it from happening. Please don't help me become so dependent on you. I really can take care of myself. Thank you for all that you have done these many years. Please go back and find Sassy. She loves you."

Hanlon didn't reply, putting her groceries down on the counter, he walked out of her house and went straight to

Shade's bar and ordered his special GutMilk. Hanlon staggered home that night. Sassy came to his house and pounded on the door but he was so drunk that he had passed out, oblivious to the noise. The next morning Hanlon was gone. He stayed gone for weeks at a time, up in the mountains following the wolves. He hadn't seen Mist and Shadow since before the dance and he searched for them. He would only return home to re-supply and check and see if Rebel was taking care of Thor and Sif. Hanlon sometimes would stop into Shade's bar late at night and drink his GutMilk and then in the morning would disappear again into the mountains with the wolves.

Sassy missed Hanlon but she eventually got back into hanging out with Cynthia and Elizabeth and even Lucy and Lucy Anne. The winter's cold ended and the snow stopped falling as the bright sun ripped open the clouds over Rime and brought with it the Montana spring season. There were more bird songs in the trees and flowers began to bloom. The trees turned green again and the lakes shimmered with reflections of the mountains on their glass surfaces. Thor and Sif were filled with energy and Hanlon had decided it was time for them to go back to the mountains and the woods. Hanlon hadn't seen Sassy in months and he had stayed away from town, especially the Ice Bowl Café. He missed her but he felt she had betrayed him. Loading up his ATV four-wheeler, he attached his small trailer and carrying pen for the wolves. Hanlon tossed meat into the trailer and Thor and Sif ran inside. Hanlon talked to them as he closed the door and pulled the trailer with the wolves inside up the steep mountain trail. Hanlon drove for over an hour and the wolves howled and yipped as they looked out of the wire at the passing scenery, their nostrils filled with

so many new scents on the wind. Thor and Sif were excited and nervous as they rode behind Hanlon. Pulling the ATV to a stop in a clearing near Crow Lake, Hanlon unlatched the door to Thor and Sif's container. Both wolves peeked out cautiously and then bounded out of the trailer, running in the tall grass and flowers, swishing their long tails and playfully tumbling with one another.

The wolves never left Hanlon's sight as they explored their new world. He closed the trailer and sat watching them play. Thor and Sif seemed like the happiest couple in the world. He thought about Sassy and the times he had brought her into these mountains to watch the wolves. He put his hand into his pocket and felt his white rabbit's foot, remembering that Mist had found happiness too and had her own mate, Shadow. Suddenly Hanlon saw the two wolves stop running and jumping and stand still looking into the woods on the far hill. Hanlon walked to be closer to investigate what had caught their attention. That's when he saw the white wolf come out of the woods. Thor and Sif twitched their tails and their ears stood erect. The white wolf was Mist. She walked slowly out into the field, alone. Shadow and her surviving pup were nowhere to be seen. Hanlon knew that if Mist was alone it was because her mate and pup were probably dead. Mist approached Thor and Sif and the three wolves sniffed each other and circled around. Mist accepted the two new wolves and they had not attacked her. Hanlon walked to the edge of a cliff as the three wolves trotted off down into a ravine. He stood watching from the steep fifty-foot cliff as they trotted below him. Two wolves new to the woods and the mountains following a white female seasoned wolf. The three wolves that Hanlon had raised since they were just pups, were now on their own surviving and

living free. Suddenly he thought about Elizabeth and how he taken care of her just like the wolves. He should have released her to be on her own long ago. Both she and Sassy had been right. He knew there would always come a time to release from things and let them be on their own. Elizabeth had now made it, not because of him but because of Sassy. Sassy was like Mist. She came out of nowhere to help Elizabeth and show her the way into a new free world. Hanlon had been the blind one, not Elizabeth. He sat down on the edge of the cliff and watched Mist, Thor and Sif, disappear into the thick forest. A single tear ran down Hanlon's cheek. He made no attempt to wipe the moisture from his face. Hanlon sat on the cliff the rest of the day. At nightfall he drove the ATV back into the storage building at his cabin.

Hanlon went inside and took a long hot bath, listening to country music on the radio. He stood in front of the mirror after drying off and began to shave his heavy beard. He washed the rest of the lather from his face and stared into the mirror at the strange face of a man from another era. He remembered that this was the man who had made hockey his life. He recognized Hanlon Starky, not the wolf man, in the mirror. There were no more wolves in his back yard. There were no more skeletons in his secret past. He had shown the wolves how to be free and Sassy had shown Elizabeth her own way to freedom. Sassy Lilytrotter had shown Hanlon Starky how to be free. Hanlon looked in the mirror at his clean shaved fresh face and he looked like a twenty year old again. He took out scissors and cut the long unruly strands of blonde hair that hung down on his neck and in his eyes. He dressed in his best clothes and left his cabin. Hanlon went to find Sassy Lilytotter in the small town of Rime, Montana, a place where people usually come to hide away from their past but also a place where they can be found easily enough.

Doug Hiser
2131 Casa Rio
Dickinson, Tx. 77539
Also available from
Art-Escape.com

SHARDS OF LIES
SEVEN RAGES
WHISKEY MOON
TREASURED EMBRACE
SECRET GROTTO
CAVERN OF THE EGGSTONE
LOST OASIS
BITE THE MAILMAN

Made in the USA
Columbia, SC
03 August 2021